Nursing Dept 11/05

Nursing Dept 11/05

AGING IN AMERICA

BY **MID-CENTURY**, PEOPLE **OVER 55**
WILL **OUTNUMBER** PEOPLE **UNDER**
18 FOR THE FIRST TIME IN HISTORY.

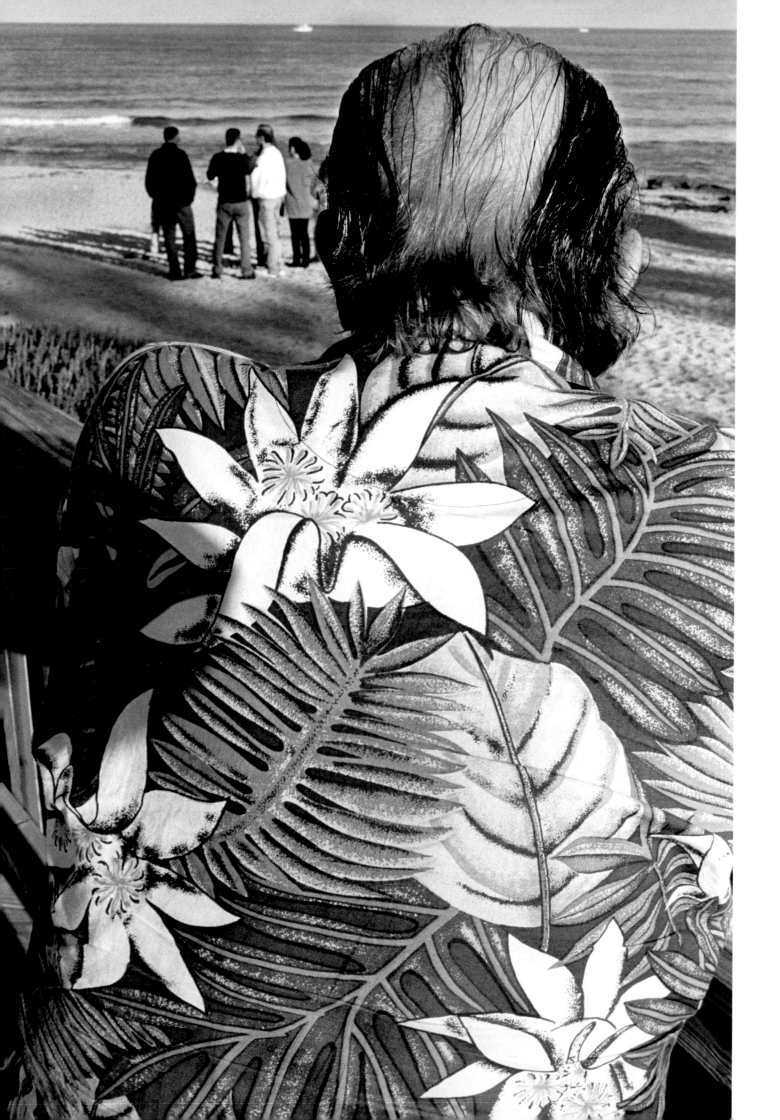

AGING IN AMERICA
THE YEARS AHEAD

Photographs by **Ed Kashi** Essays and Interviews by **Julie Winokur**

Foreword by **Doris Roberts** Preface by **Dr. Robert Butler**

pH **powerHouse Books**
New York, NY

previous page: A reflective moment at Deerfield Beach, Florida; following pages, first spread: One of the original lindy hoppers, Frankie Manning, celebrates his 84th birthday by dancing with Carla Heiney, and 88 other women; second spread: Ila Swan (right), an advocate for nursing home reform, pays a visit to Dorothy Deamondo. Swan speculates that Deamondo is being over-medicated by the nursing home because her mental state has rapidly deteriorated in just a few months; third spread: Vance Mayle, 61, is losing a 10-year battle with esophageal cancer. His last wish is to die at home, surrounded by family and friends; fourth spread: Two Lakota Sioux elders passing time on the Pine Ridge Indian Reservation in South Dakota; fifth spread: An elegant couple takes a moment off the dance floor at the Gold Coast Ballroom in Coconut Creek, Florida; sixth spread: At the 30th annual Seniors Rally in Sacramento, California, a participant waits by one of three buses that traveled from San Francisco; seventh spread: Senior delegates show their colors at a Democratic National Convention.

PREFACE
by Dr. Robert Butler, M.D.

We are taught to view old people as belonging to a homogenous group that has lived past its usefulness. Residing in a no-man's-land called "old age," their identities are blurred and their personalities reduced to stereotypes. Yet, discrimination against old people is profoundly ironic, because the very men and women who in their younger years discriminate against old people will, in all likelihood, eventually become old men and women themselves. It is clear that beneath the devaluation of old people lies a deep fear of aging and a reminder of our own mortality.

Fortunately, fine artists and writers throughout the ages have produced works that illustrate their fascination with all stages of life—from childhood to great old age. From Rembrandt's memorable self-portrait in old age to Simone de Beauvoir's entire body of work, which spans the whole life cycle, artists have continually demonstrated that as attractive as youth may be, it is in old age when character is truly revealed.

To depict the elderly without resorting to the clichés with which we have grown comfortable requires a sensitivity to nuance, and we need artists of all disciplines to help us see with a fresh eye the richness and variety of old people.

Aging in America gives the reader a rich panoply of what the later years have to offer. Both Ed Kashi and Julie Winokur have made a valuable contribution to our understanding of the culture and experience of growing old.

President and CEO, International Longevity Center-USA
Mount Sinai Medical Center
New York City, 2003

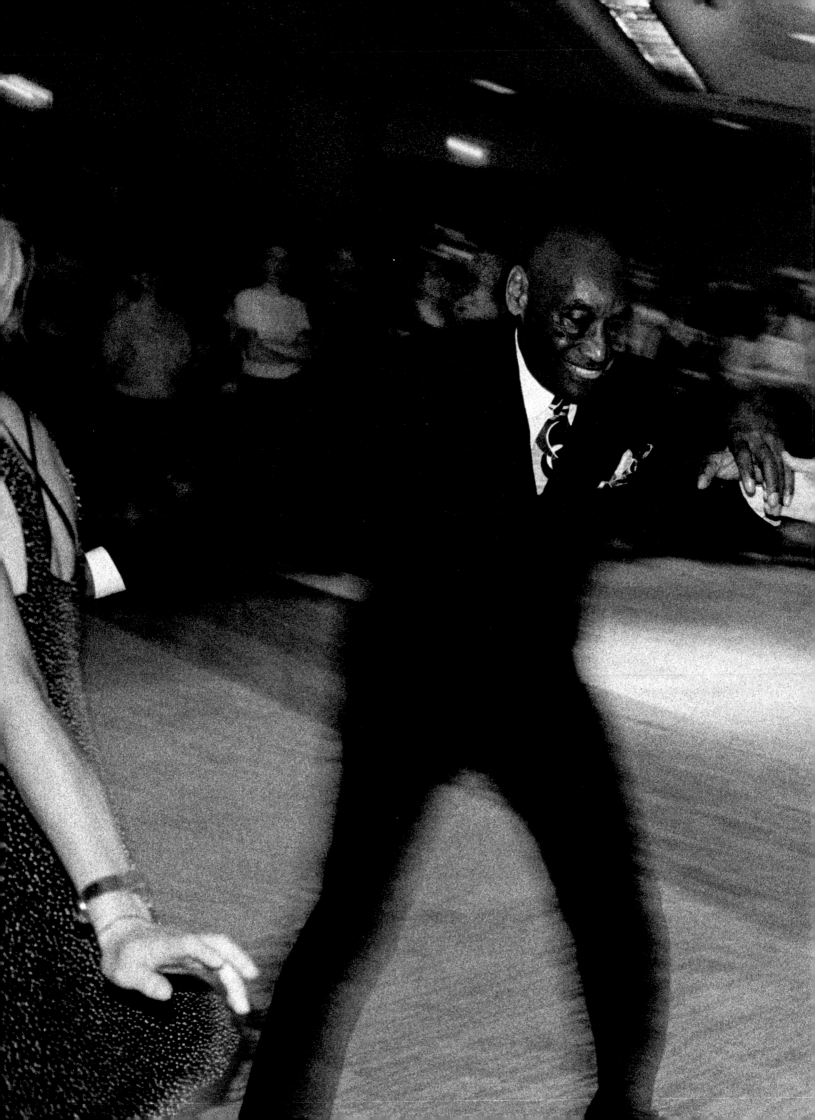

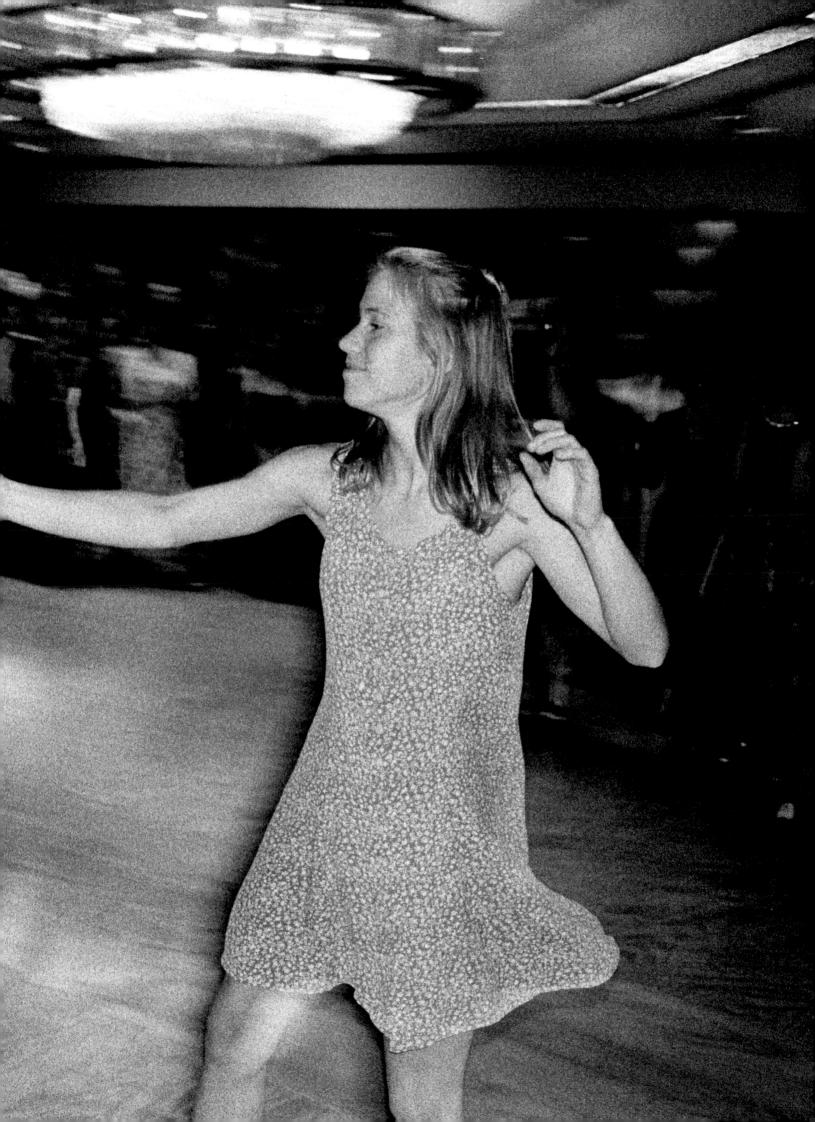

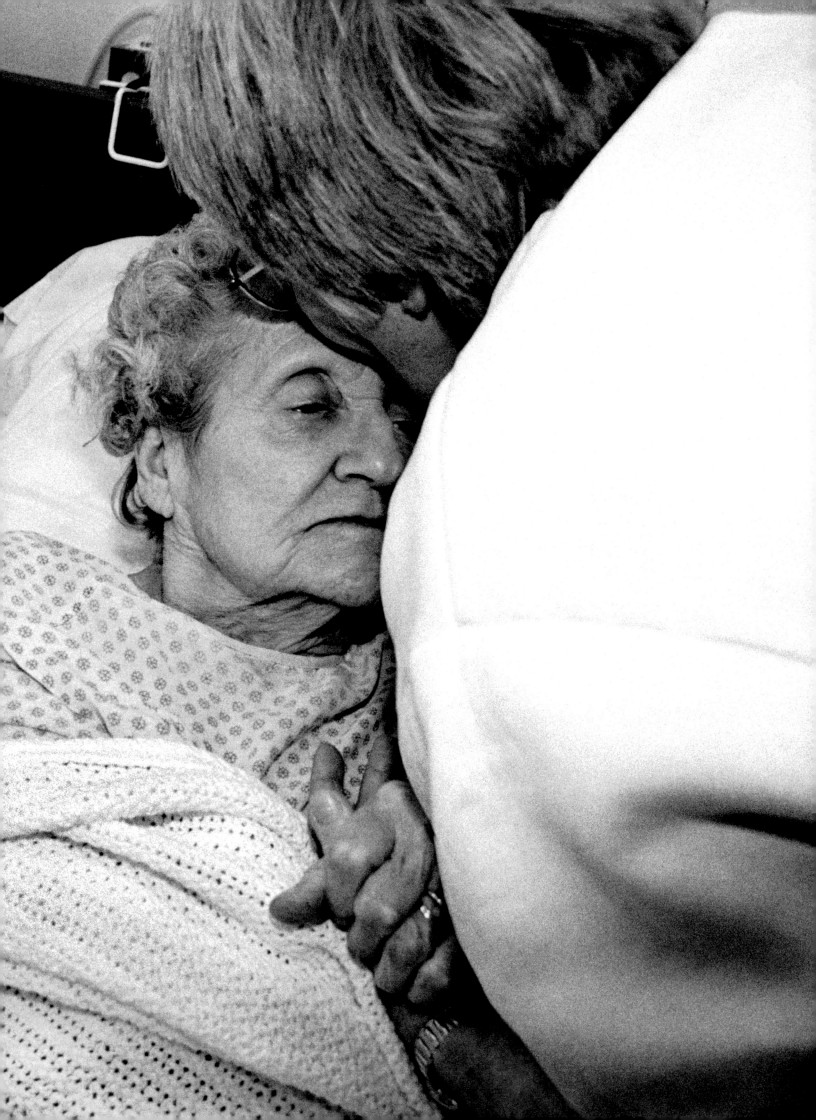

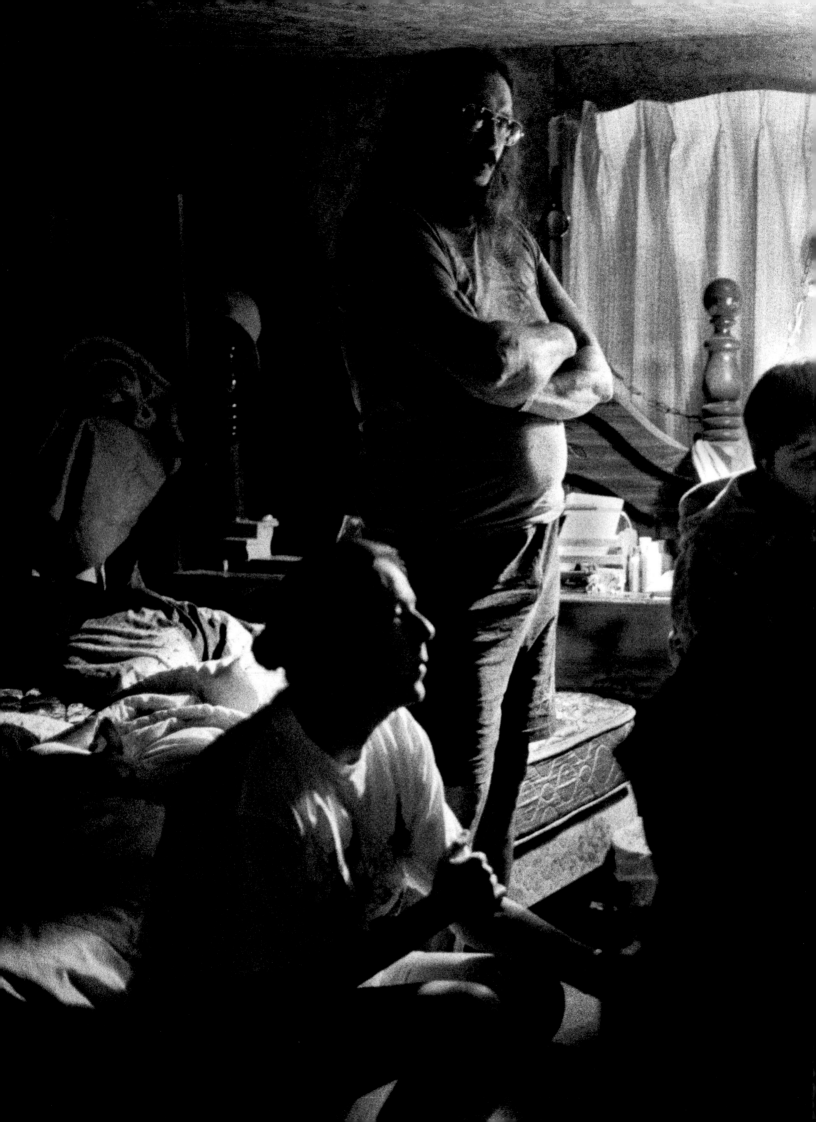

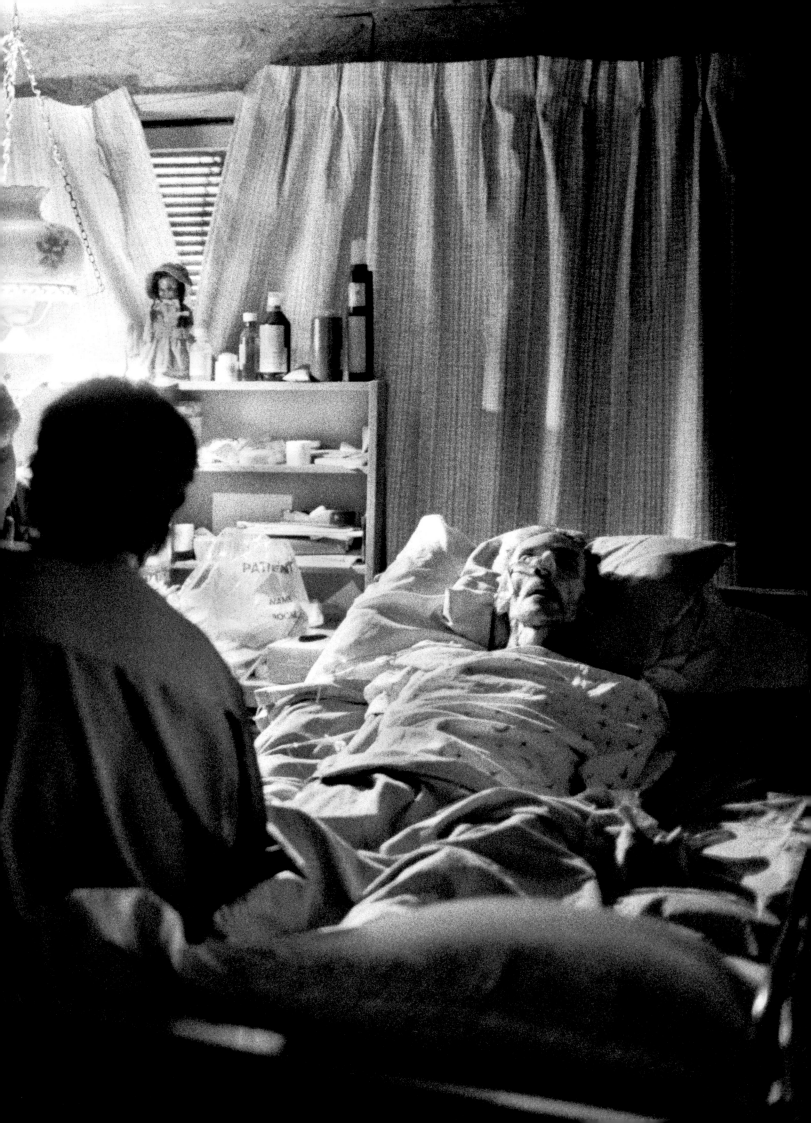

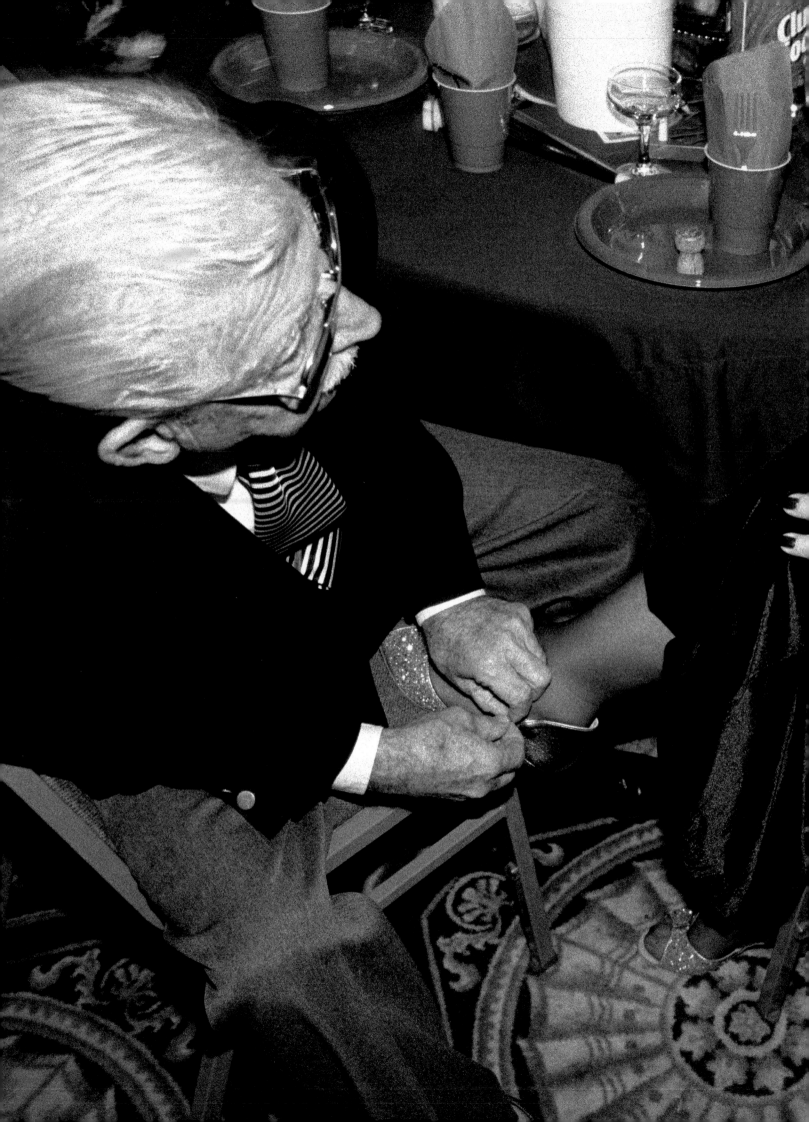

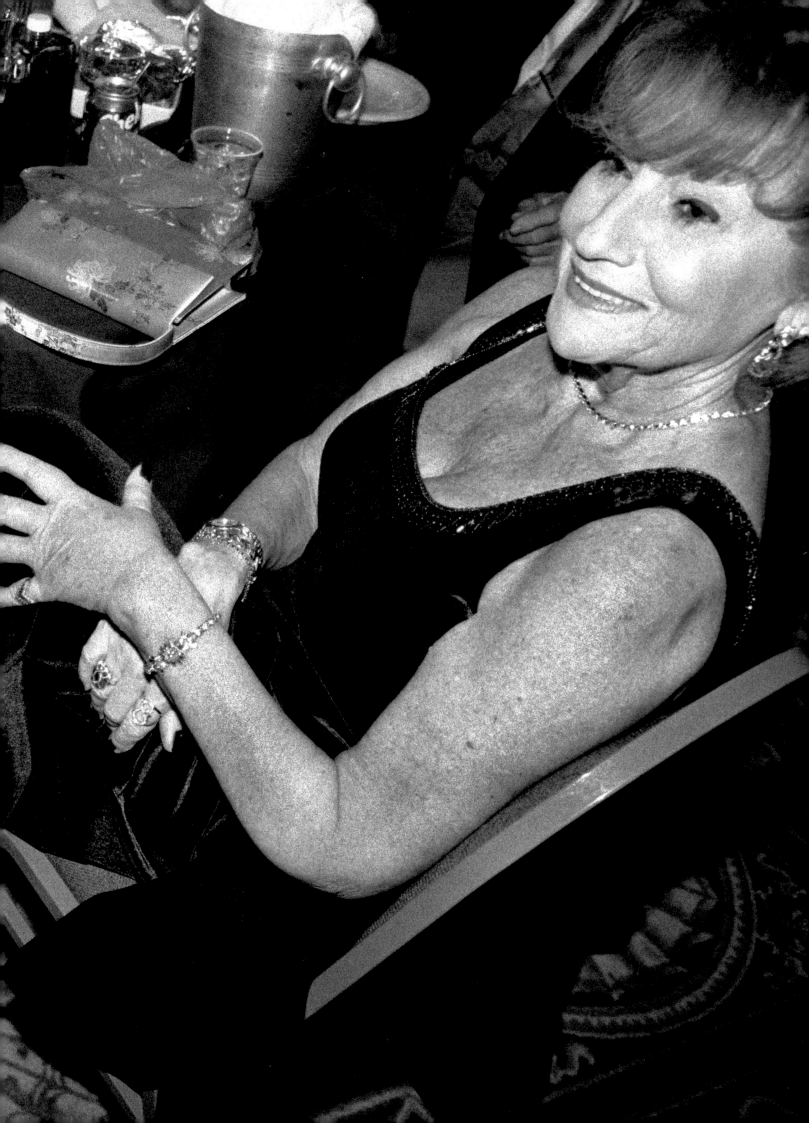

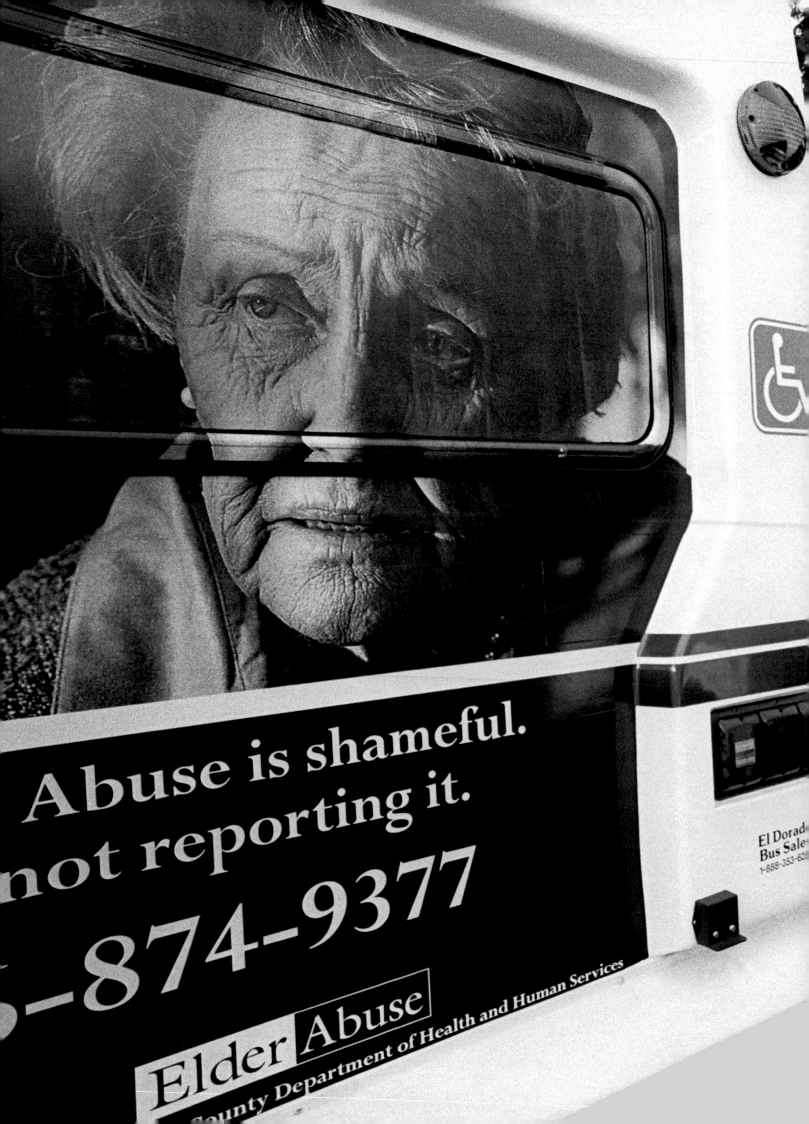

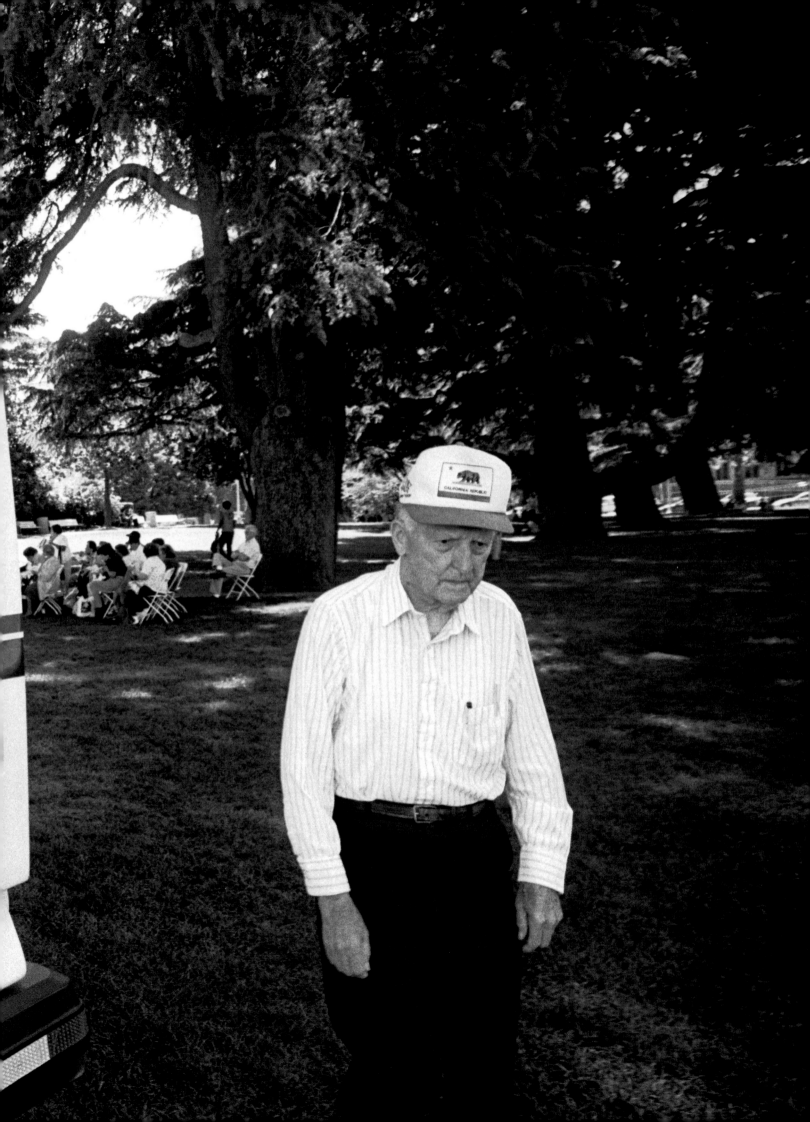

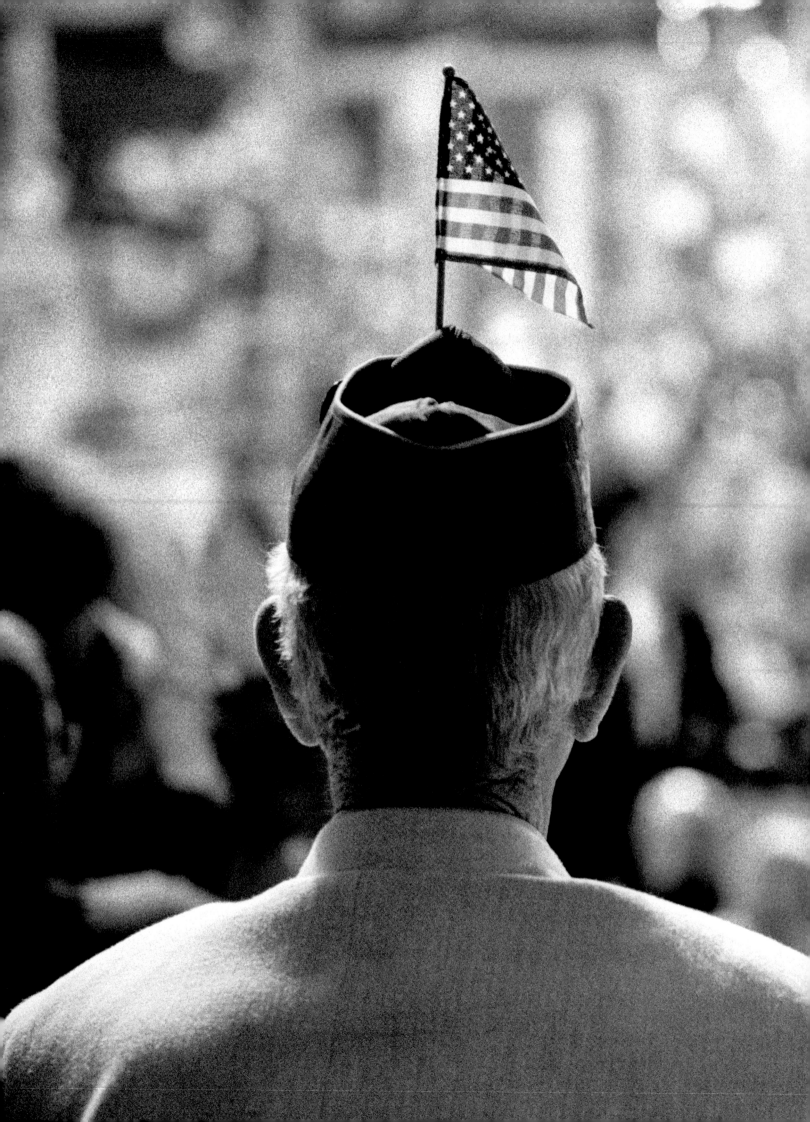

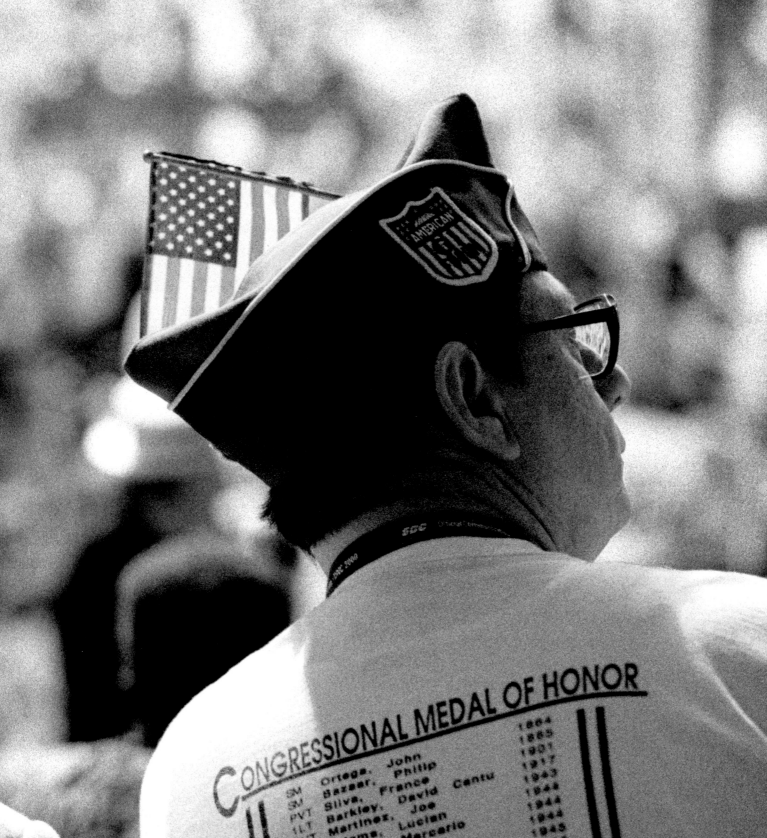

FOREWORD

by Doris Roberts

I am delighted to be a part of Ed Kashi and Julie Winokur's provocative look at aging in America, a subject about which I feel passionate and highly qualified to discuss. I am in my seventies, at the peak of my career—and at the height of my earned income and tax contribution. When my grandchildren say I "rock," they are not talking about a rocking chair.

Yet society considers me discardable, my opinions irrelevant, my needs comical, and my tastes not worth attention in the marketplace. My peers and I are portrayed as dependent, helpless, unproductive, and demanding, rather than deserving. In reality, the majority of seniors are self-sufficient, middle-class consumers with more assets than most young couples and substantial amounts of time and talent to offer society. This is not just a sad situation. This is a crime.

Age discrimination negates the value of our wisdom and experience, robs us of our dignity, and denies us the chance to continue to grow and to flourish. We all know that medical advances have changed the length and quality of life for us today, but we have not changed our attitudes about aging or addressed the disabling myths that disempower us. In essence, our assumptions about growing older have not caught up with the new reality. If it were up to me, I would have the adjective "old" deleted from our vocabulary altogether and replaced with the word "older." As it stands now, my contemporaries and I are denigrated all too often as old coots, old fogeys, old codgers, geezers, hags, and old timers. We deserve to be recognized as seasoned, mature, experienced, and vital members of society, not deflated remnants of our former selves.

In actuality, our later years can be some of life's most productive and creative. The average age of Nobel Prize winners is sixty-five. Frank Gehry designed Seattle's hip new rock museum at the age of seventy. Georgia O'Keeffe was productive well into her eighties. Add to the list Hitchcock, Dickens, Bernstein, Fosse, Wright, Matisse, Picasso, and Einstein, to mention just a few of the many talented and brilliant individuals who produced some of their best work when they would be considered over the hill by current standards.

My profession—the entertainment business—is one of the worst perpetrators of this awful bigotry, particularly when it comes to women. When I was younger, some of the most popular—and the most powerful—actresses were women past the age of forty. Women such as Joan Crawford, Bette Davis, and Barbara Stanwyck continued to work, getting better and better in their craft as they got older. Over time, they were able to play more complex female characters.

Not so today! To be over forty and an actress is probably to be unemployed with a rattled self-esteem. A recent Screen Actors Guild employment survey showed that there are three times as many roles for women under forty as there are for women forty years old and older, despite the shifting demographics in society at large.

This blatant ageism explains why younger and younger actresses are visiting the plastic surgeon. Actresses in their twenties are getting Botox injections to prevent wrinkles from forming, and

women start getting tummy tucks and face-lifts in their thirties to forestall the day when the phone stops ringing. I've been fortunate to be one of a handful of actresses who has continued to work throughout her career, but it has not been easy. When I was in my forties, I heard of a great part on a new series called "Remington Steele," but I wasn't considered for it because I was thought to be too old. I got a chance to read for the part only because I was friendly with the casting director, and I was very persistent. I know many of my friends who have begged and pleaded for similar favors from producers they've worked with over the years and have been turned away with that Hollywood euphemism, "We're looking for a different demographic." Even though a part may be described as appropriate for a woman in her forties, in reality the casting director wants someone in her thirties or a bit younger. I was indeed fortunate to land my current role on "Everybody Loves Raymond," but I consider myself the exception rather than the rule for actresses in television.

The roles for women my age frequently portray seniors in insulting and degrading ways, or as cartoons of the elderly. I recently turned down a movie role where I was supposed to play a horny grandmother who spewed foul language, exposed herself, and chased after young boys. Although I turned down the job, I know someone took that part. All too often we are forced to neglect our responsibility to portray realistic elders because we are desperate for any part in any production. There are public interest groups to protect the way every other segment of society is depicted in the media—from Italians to Arabs—but no one protects the image of our elders.

Hollywood is downright clueless when it comes to understanding today's seniors—blind to the advances in health, education, and personal income that have made us a force to be reckoned with. Twenty years ago it was accurate to depict a senior arriving for his checkup dragging his oxygen tank. Today, it would be more appropriate to show him with a tennis racket on one arm and a girlfriend on the other. But the youthful gatekeepers of the entertainment industry haven't caught up with these changes, partly because they refuse to hire older writers who could craft lines that reflect the reality of the new old age.

Twenty years ago, older, experienced writers past the age of fifty were the most prized in the industry, getting sixty percent of the jobs. Now that percentage has shrunk to nineteen percent. Just six months ago, I developed a project with an Emmy-award-winning writer and producer I knew from my days on "Remington Steele." When it came time to pitch the project to the studio, he refused to come with me. "When they see my gray hair, we're finished," he said. Why do they think that a man in his fifties has nothing to say about love or youth or relationships? I, for one, know he has a lot to say, if anyone would listen.

I pitched a project to a cable network a few years back and got a very enthusiastic response. The executives loved my idea, and wanted to take it directly into development. But once they found out that the director attached to the project was a woman in her fifties, they stopped returning my calls.

What these thirty-year-old executives don't realize is how impoverished their world is by focusing only on the limited perspective of youth. Yes, there is energy and excitement and enthusiasm in the young, but there isn't any less dynamism in those in their later years. That is, unless society is successful in its campaign to diminish our stature and deny our worth.

If the vitality of today's older generation isn't enough to convince Hollywood, then perhaps the numbers will. My peers and I control seventy-seven percent of the country's disposable income, and we're starved for images that reflect our real experiences. Nevertheless, the entertainment industry continues to treat aging like a communicable disease, one that we don't want to spread by granting it air time. It is small comfort to know that those who have perpetrated this ageism will some day face it themselves.

In recently speaking before the U.S. Committee On Aging in Washington, D. C., I said, "I address you as a person young in spirit, full of life and energy, and eager to stay engaged in the world and fight ageism, the last bastion of bigotry. It is no different from sexism, racism, or religious discrimination. It is a tyranny that suppresses us all at any stage and serves no one."

My inspiration was something General Douglas MacArthur once wrote: "Youth is not a time of life, it is a state of mind. Nobody grows old by merely living a number of years. People grow old by deserting their ideals. Years wrinkle the skin, but to give up enthusiasm wrinkles the soul. Worry, doubt, self-distrust, fear, and despair, these are the long, long years that bow the head and turn the growing spirit back to dust. You are as young as your faith, as old as your doubt, as young as your self-confidence, as old as your fear. So long as your heart receives messages of beauty, cheer, courage, grandeur, and power from the earth, from man and from the infinite, so long you are young."

Los Angeles, 2003

ANOTHER BABY BOOMER
TURNS 50 EVERY 8 SECONDS.

opposite: Bathers at Wynmoor retirement community in Coconut Creek, Florida

SLOW DOWN: AGING AHEAD

by Julie Winokur

We first met Virginia Magrath, eighty years old, in the cafeteria of The Granada, a single-room-occupancy hotel in San Francisco where she lived with her husband, John. During one of our early interviews she told me that old people feel invisible, as though they become ghosts long before they die. "It must be like when you're a child standing at the counter and the cashier helps everyone else before they help you," she explained. At the time, her husband was dying from a blood clot in his brain. Despite the fact that she was a retired nurse, the doctors spoke directly to her daughters. I would say the doctors ignored Virginia, but to ignore requires a conscious effort, implying that they had noticed her in the first place. Virginia, like so many elders, was indeed invisible to the young professionals around her. She didn't register in the fast-paced world she inhabits.

America thrives on speed; we're addicted to acceleration. But as we grow older, we inevitably begin to slow down. We start taking longer to get through our daily routines; we process new information less quickly; we pause between thoughts; we linger on the smaller details. Virginia even closes her eyes when she talks, as though searching for thoughts requires shutting out all worldly distractions.

Our goal when we embarked on this project many years ago was to look at—and really see—the Virginias in our immediate world. With more people living longer and healthier lives than ever before, we decided to confront aging face-to-face, and not shy away from its more unsettling aspects—nor exaggerate the achievements of young-oldsters. We committed ourselves to an unflinching approach, one that celebrates the gains of longevity and recognizes the agony of loss. The images in this book are at times humorous, at times uncomfortable, but they are all compassionate, and paint a sober and dignified portrait that addresses the range of experience our elders face. Paying homage to the evolution of aging, they challenge our attitudes toward growing old and raise questions about whether we are truly prepared for the looming "age wave."

As it stands now—and part of the reason we embarked on this journey—America is a society in collective denial of aging. We appreciate vintage in wine, not people; we "distress" furniture to make it look old, but we pay a fortune to erase the wrinkles that time bestows on our face. The anti-aging industry, a dubious enterprise indeed, reaps billions of dollars each year from people desperate to reverse time.

To appreciate our elders is to decelerate, to step off the fast track and regain an appreciation for nuance. As James Hillman writes in his book, *The Force of Character*, "Oldness is an adventure. Stepping from the bathtub, hurrying to the phone, or just going down the stairs presents as much risk as traveling camelback in the Gobi." He calls this "the adventure of slowness."

It is easy to feel frustrated with our elders. We want them to walk faster, talk faster, flow with the times. But our elders have a different relationship with time altogether. They're not rushing full speed ahead; they aren't ruled by the pressure of deadlines and the quest for achievement.

Despite the fact that their days are limited, they aren't racing against the clock to squeeze more into less, but rather they are inclined to do less with more time and feel tremendous satisfaction. This is the gift of age. It's hard to digest in our speed-worshipping, youth-obsessed culture, but it's that simple.

In his memoir, *On Turning Sixty-Five*, magazine columnist John Jerome writes, "The quality of our lives depends on the quality of our time. It is a simplistic little truth, but not so easy to live by, and it too is exacerbated by age. As time becomes more precious, one tries to slow it down. Curiously, this makes you more patient. It's a development I seldom think of when old folks—older folks, I should say—are impeding my progress in store aisles, parking lots, or on rural roads. Maybe the patience thing is what makes them so pokey."

What is old age—and when does it begin? There is no fixed year when a person crosses from middle age to senior citizen, unless you count airline discounts, free movie matinees, or membership to the AARP (American Association of Retired Persons). Even so, these indicators coexist on a sliding scale: the retirement age is on the rise while the minimum age for AARP membership has dropped.

In American society, aging implies decay. It suggests the point at which we stop improving and we start deteriorating. We equate the addition of years with the subtraction of youth. But old age is a privilege—a concept that is lost on us. The irony, of course, is that everybody wants to live a long time, but nobody wants to grow old.

As Nobel Prize-winning economist Gary S. Becker speculates, the extension of life expectancy is probably the single greatest achievement of the twentieth century. Ed Kashi and I began this project because we believe that the social impact of longevity is the single greatest challenge for the twenty-first century. The number of elders in America is growing rapidly, and we're only at the beginning part of the curve. There are currently thirty-five million people over the age of sixty-five; this number has grown elevenfold since the turn of the last century, and is expected to double in the next thirty years. As a result, we are facing circumstances that are unprecedented in human history. Never before have so many individuals survived into old age; never before have we had to prepare for a world in which senior citizens outnumber young people. Thanks to the wonders of modern science, we are living participants in a massive social evolution.

Tipping the scales of the impending age wave are the baby boomers, who are moving through the demographic chart like a pig in a python. The most commonly accepted number—seventy-six million baby boomers—is probably a gross underestimate if you take into account the millions of immigrant boomers who weren't counted when the birth certificates were tallied. Whatever the actual number, researchers speculate that a baby boomer turns fifty every eight

seconds. And as history has proven, where baby boomers tread, the nation follows. Just as they led us into the campaign for civil rights, the sexual revolution, feminism, and the New Age craze, the subculture of aging is guaranteed to take center stage as the boomers confront their own mortality.

Not only have birthrates in America declined, but our life expectancy has increased thirty years since 1900—an achievement that owes as much to declining infant mortality rates as to medical advancements. In real terms, that means an extra life within a lifetime.

Old age was anathema to our ancestors; few had the chance to reach the stage when the body and mind begin to retreat. Instead, they died young (by today's standards), still in the upward arc of life's curve. They also rarely had the chance to witness how, as the body and mind decline, old age and child-hood come full circle. Today's elders are the first generation to experience wholesale the mixed blessing of longevity. The reality of aging will force us to come to terms with the fact that longevity doesn't mean eternal youth.

The shifting demographics have already started to alter the American landscape. We're seeing concentrations of elders not only in Florida, but increasingly in the West and Southeast. In the meantime, rural areas are going gray fast because young people are fleeing the countryside to find work in the cities. The landscape is changing with elders inhabiting everything from private homes to nursing homes, from retirement communities to RV parks. The past decade also saw the growth of the long-term care facility and the geriatric prison ward. The situations depicted in this book are a window into the varied subcultures of aging, venturing into places where most of us don't have the time or inclination to linger, unless our advancing years or the plight of our parents force us there.

In the meantime, the government is losing precious time bickering over the privatization of social security and prescription drug coverage, while seniors hemorrhage their savings on healthcare or are forced to chose between medication and other basic needs.

The worst off are the middle class, who don't have enough savings for in-home care when they need it, but who have too much money to qualify for many social services. These people must choose between preserving their financial assets for some intangible future and spending down their savings now for immediate shelter. Younger people, and even many of the policy makers in Washington, don't realize that spending down is a strategy millions of seniors are forced to take to survive their old age. Medicaid won't cover them until they are literally so poor they would be on the street without government assistance. Once they find themselves in a state-subsidized, $50,000-per-year nursing home, there's no going back.

Clearly, there has to be a fundamental shift in the social policies as well as in the culture of aging in America. When Ed and I set out to chronicle this social evolution, we didn't look for people who defied aging by skydiving and rock climbing. While inspirational, these human case studies perpetuate the notion that the autumn of our years should be spent trying to outdo youth. This feeds into the mentality that, with a little effort, we can somehow dupe Father Time. Ed and

I focused instead on the flag bearers of their years. We were looking for people who ascribed to retired newspaper columnist Melvin Maddocks' philosophy: "Let me grow old—let me grow up. Give me one last chance to take life seriously." He castigates those baby boomers whose "credo on modern immaturity" is based on the "simplistic assumption that being young is the same as being happy."

Old age is not synonymous with limitation, immobility, or stasis. Nor is it a time to patiently wait for death. As Frances Collins, eighty-three, told me, "We only have two gears: slow and stop." She wasn't exaggerating either, considering that she had driven herself to an RV rally in southern California soon after undergoing heart surgery in preparation for having a massive tumor removed from her throat. She tromped through the RV park with an oxygen tank on her back as though it were a backpack full of trail snacks.

Frances Collins and her traveling companions

To address the extended stages of life, we really need a new lingua franca that reflects the complex and diverse experiences of our elders. Just as childhood includes infancy, toddlerhood, and adolescence as distinct stages of development, so should old age have several tiers that reflect its progression from vitality to deterioration, from freedom to dependency. In her book, *Another Country: Navigating the Emotional Terrain of Our Elders*, the psychologist Mary Pipher distinguishes between young-old and old-old age, the stage between which is good health. Another new term—"healthspan"—marks the difference in the quality and the quantity of one's years. Once health starts to fail, old age becomes a terminal sentence. Until then, it is uniquely rich, filled with flexible time and enough life experience to know what you want to do with your resources. Rather than a time of limitation, it is a time of liberation.

Frances Collins is one of many elders in this book who have taught us that old age is a stage of life, not death. They are pioneers on the frontier of aging, reinventing what it means to grow old and demonstrating that vitality is the new signature of old age.

> *With more people living longer, healthier lives than ever before, today's seniors are exploring a degree of freedom that younger generations can only fantasize about. Our elders have fulfilled their work and family obligations, so their time is now their own. Couple that with the fact that today's elders are less likely to be poor than in the past, and you have a greater degree of freedom than any other generation has ever experienced.*

Unlike the old-fashioned notion that retirement is what Theodore Roszak branded "a withdrawal into inconsequentiality," this phase of life is now filled with unprecedented potential. In fact, older adults represent the single greatest, untapped resource in America. As John Gardner, founder of Common Cause, once said, "What we have before us are breathtaking opportunities disguised as insoluble problems." Volunteer organizations like Civic Ventures, Habitat for Humanity, and the National Senior Service Corps prove that our elders themselves constitute a phenomenal asset with invaluable contributions to make. They just need more opportunities.

Political activist Agar Jaicks, seventy-six, sums it up this way: "When you get to be my age, life expectancy will be ninety-five, maybe even crowding one hundred. You're going to tell me that you're going to sit around on your behind and do nothing? Contemplate your navel from sixty-seven, or whatever time you retire, up until ninety-five? I don't believe it." For many of those like Jaicks, retirement is a time to accomplish some of the most meaningful work of their lives. Longevity has given these people the opportunity to turn dreams into reality, and to apply their wisdom in the way seasoned artisans finally master their crafts.

It is impossible to talk about young-old and old-old age in the same context. The young-old are volunteering to take care of people less fortunate than they themselves, they're running for political office, teaching dance workshops, and revving up their motorcycles, literally. The old-old are struggling to remember what they had for breakfast. Numerical age isn't the benchmark that separates these two phases. Rather, it reflects the physical and mental limitations that health doles out.

Seven months after meeting Virginia, her health started to decline. She became short of breath and fatigued easily. Her daughters lived several hours away, so she asked us to accompany her to the doctor. For years she had been legally blind, but only recently had started using a cane, and she seemed more feeble than just a few months earlier. As we walked to her appointment, she told us she was convinced she had lung cancer—in fact, was hoping she had lung cancer—for which she would refuse all treatments. "It's a good way to go because you can treat the pain," she said wryly. She entered her doctor's office with a strange mix of conviction and satisfaction.

A friend suggested to me that perhaps Virginia, as a devout Catholic, was looking forward to joining her husband John in heaven, to which I had to laugh. They had had a troubled marriage, and Virginia had even contemplated divorce decades ago. She was dissuaded by a Catholic priest who himself confessed many years later that he had made a terrible mistake. If she thought the afterlife would mean eternity with John, her will to live might have been stronger. Instead, she seemed to embrace the notion of death itself. It was an air of surrender that I have seen many times in the course of this work.

After years of nursing, hospice work, and helping care for her aging neighbors and friends, Virginia had seen enough variations on death to decide which one would suit her. In her opinion, prolonging death was an unnecessary evil. Throughout her career, she had confronted the end stages of life like a soldier, dispassionate and determined. She had decided long ago that she would rather die from cancer than endure years of dementia. "If they could figure out how to treat

dementia, old age wouldn't be so bad," she told me. "But dementia is like a sentence that goes from bad to worse. I don't want to live that long." Fortunately, Virginia didn't have lung cancer. She was suffering from a highly curable form of pneumonia. But her perspective reflected the downside of longevity–the Faustian compromise elders make with the shadow of death.

Despite gains in longevity, dementia is still a cruel thief pilfering from the wells of memory and distorting forward momentum. Alzheimer's is its most insidious accomplice, robbing its victims of a lifetime of accomplishments, and stealing from them the relationships that give life relevance.

Short term memory loss presents a challenge for an interviewer because it makes some elders remarkably unreliable narrators. They think they moved to town only six months ago, instead of two years ago; they complain no one has visited them for a long time, despite a daughter's home cooked meal sitting warm on the counter. Perhaps to compensate for the distorted recollection of the present, the mind makes the distant past palpably clear. For example, during our conversations Isaac Donner often relived the moment his father threw him out of a synagogue eighty-seven years ago; Phillip Smith slipped in and out of his dementia to recount ten months as a prisoner of war in Germany during WWII as though it were last month.

While interviewing elderly veterans in Washington, D.C., it became apparent to me that the war was very much alive in these men's minds. It wasn't as though they still thought the war was underway, but rather as they grew older, they found themselves fighting the demons in their minds, struggling with the emotional wounds that had been inflicted decades ago. They were still in active combat, but it was the battle waging in their minds—one between the past and present. Whether elderly people are lucid or suffer dementia, these defining moments become vividly sharp, becoming part of the present. It's as if there's a spring cleaning of memories during which the more mundane details

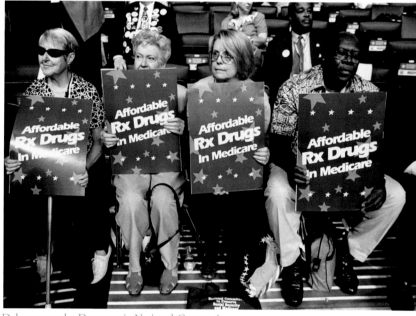

Delegates at the Democratic National Convention

are discarded, making space for the more pivotal life events. These defining moments dominate one's mind as living memories, often usurping events that took place this morning or even an hour ago. This is yet another indication of our elders' unique relationship to time.

It was with a mixed sense of dread and enthusiasm that we met with our frail elderly subjects. In them we saw our tragic demise, a gradual deterioration of mind and body that seemed to undo all the accomplishments of a vigorous life. On the other hand, we greeted them with enthusiasm, eager to peel back the layers of their lives to indulge in their cumulative experience and absorb their knowledge. This is not to say that age equals wisdom, but age does imply accumulated knowledge. Like an encyclopedia, our elders are full of information, not full of answers.

When I interviewed most of the people in this book, I asked them what they looked forward to at this stage in life. In the depths of my heart, I felt it was a rhetorical question. Repeatedly, my subjects' response would be, "I don't look forward to anything. I'm just taking it one day at a time." Initially, I found this response depressing—a confirmation that old age was a waiting game with death. Gradually, I started to listen. It finally dawned on me that I wasn't paying attention to their words, only to my own prejudicial filter of the answer.

My subjects were telling me in no uncertain terms that they were living in the moment. This, I finally realized, was the greatest gift of longevity, the ultimate wisdom that we inherit if we live long enough. As we age, most of us finally close the chasm between what should have been and what is, and we allow ourselves a moment of respite in which to embrace the present.

John Jerome, in *On Turning Sixty-Five*, writes, "My evidence so far is that, loss of function aside, everything else about aging is a gain. And I suspect that it is specifically the mortality part— enforcing finite discipline, perhaps eventually replacing panic with a certain philosophical calm— that gives the fourth stage the possibility of being the richest and most rewarding of all."

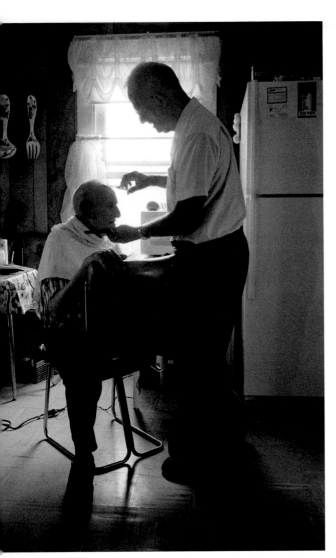

Warren Dewitt gives Arden Peters a haircut.

With few exceptions, old-old age brings with it pronounced physical, mental, and emotional needs. These needs often transcend the individual's experience of aging to generate a larger impact on society. It can be argued that the success of a society is gauged by its treatment of the very young and the very old. With so many people surviving into old-old age, the bar will steadily rise.

If most people could witness the conditions in nursing homes across America today, I would expect a profound disillusionment with our claims to being a civilized society. According to the Government Accounting Office, more than a quarter of all nursing homes cause serious harm or even death to patients. Understaffing is the main culprit, as minimally-trained aides receive substandard wages and patient loads they can't possibly oversee. Unfortunately for millions of people—especially the oldest old—there is no alternative to these warehouses of neglect.

We in America have a divisive, internal conflict between responsibility and burden. This is one of the only places in the world where the moral imperative of caring for an elder is considered optional. Although one in four households in this country cares for an older relative or friend, many more people prefer to be cared for by professionals rather than "burden" their children. Burden is a word I never heard used as frequently as during our work on this project. It has

been spoken by at least half of the subjects I interviewed, always in the context of wanting to spare adult children from an unsavory task.

For those who take on the challenge of caregiving, the rewards are immense. They perform hands-on chores that take care of bare physical needs while unearthing the purest emotions. They recognize that it is an opportunity—not a burden—to stand face-to-face with mortality and to rise to the occasion. Our work examines the commitment of family members to nurse their own, and the dedication of professionals whose careers are devoted to the care of strangers. These are the people who have the fortitude to journey into life's most fearsome destinations, and who survive the experience greatly enriched.

There is no escaping the immediacy of these images. In every wrinkle we see our own youth passing, in each diaper we suffer another humiliation, through each photograph we are forced to address our own aging process, our own mortality. The most powerful and wrenching photographs in this book expose the fears we share about losing control of our bodies and our minds.

At times, these images are unsettling even when they depict optimistic solutions to the inevitable demands of old-old age. They also drive home the harsh reality that as the population ages, legions of people are going to need much more care.

Not only do we need to restore a place of dignity to dependency, but we need to inspire far more professionals to dedicate their careers to gerontology and geriatrics. As it stands now, we are ill prepared to handle the looming demands. Currently, of the one hundred and twenty-five medical schools across the country, only three have geriatric departments, and less than one percent of nurses are certified in geriatrics. More than half of all social workers will work with older adults, despite the fact that they have no special training to handle their needs.

We started this project by identifying a major social issue and observing it through an objective lens. In the course of our work on the project, we underwent a personal as well as a political transformation. It altered our lives to the point where we can no longer separate ourselves from the issues confronting other baby boomers. It has taken a psychic toll at times, but it has also rewarded us tenfold by expanding our perceptions to include the whole cycle of life, not just the part we inhabit in the youth-driven culture that confronts us daily. Unlike the work we've done in foreign countries, even impoverished or war-torn ones, this project forced us to confront our own mortality each day. It has been a tutorial on how to live one's life, and what to avoid. Our society treats the elderly like two-dimensional cut-outs. We hope that through our efforts we can reveal them in their three-dimensional grace.

We have become intimately involved with many of the people in this book. We have celebrated birthdays together, helped change soiled bed pads, and been present for several deaths. We have laughed over meals, and cried over funerals. Our relationships have extended well beyond the timeline of this project, and permeated our own family life as well as theirs. We would like to believe that our experience has been mutually rewarding, expanding our world while bringing a new and appreciative perspective to theirs. One thing, though, is for certain: the people whose

lives we intersected have been grateful that someone wanted to listen, and that the curse of invisibility Virginia Magrath complained about was broken, if only temporarily.

We hope that by sharing this work, we will be able to impart a greater acceptance for the aging process. Growing old is not the domain of the elderly; they don't have a monopoly on this phase of life. Aging is, after all, the universal human experience. Not only do our elders live in our midst—sometimes in our own homes—but the aging process is taking place inside each and every one of us, even as we read these words.

> *Life comes. Life goes. In between is this majestic arc of experience. We happen to be living at a time when the arc's final curve has been given a graceful extension. We're still struggling to figure out what to do with it.*

This book is populated by heroes who have been brave enough to open their lives to us in their most vulnerable moments, and who have inspired us to appreciate the complex twists along the path of aging. We have tried to convey that poetry using words and photographs. Through these stories we can peer into the universe of our elders—or better yet, into our own future. I urge you to look at these images with fresh eyes and see that there is liberation in maturity, there is such a thing as a beautiful death, and there is pride in a son who can care for his father.

Our work challenges the perceptions and attitudes that have made growing old one of the great taboos of the twenty-first century. But despite seven years of in-depth coverage, this is by no means a definitive study of aging. It is a very selective and subjective account. It is meant to be a starting point, a baton we are passing on to others to help them navigate the uncharted terrain of longevity.

"My grandmother never could have done this. As a matter of fact, my grandmother was old when she was thirty," said Gail Rich as she stepped off the softball field. This grandmother of fifteen and great-grandmother of two was competing in the Senior Olympics with a team of sixty-plus sluggers. "I think if you want to grow old you can, and if you don't want to you don't have to. You can grow up and die, but you don't have to grow old and die."

San Francisco, 2003

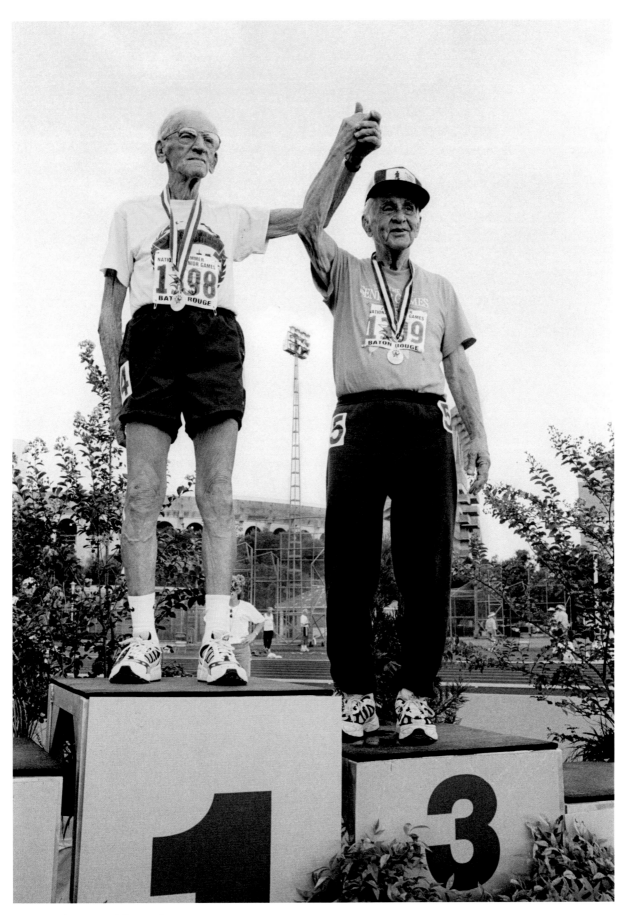

Victors at the National Senior Games

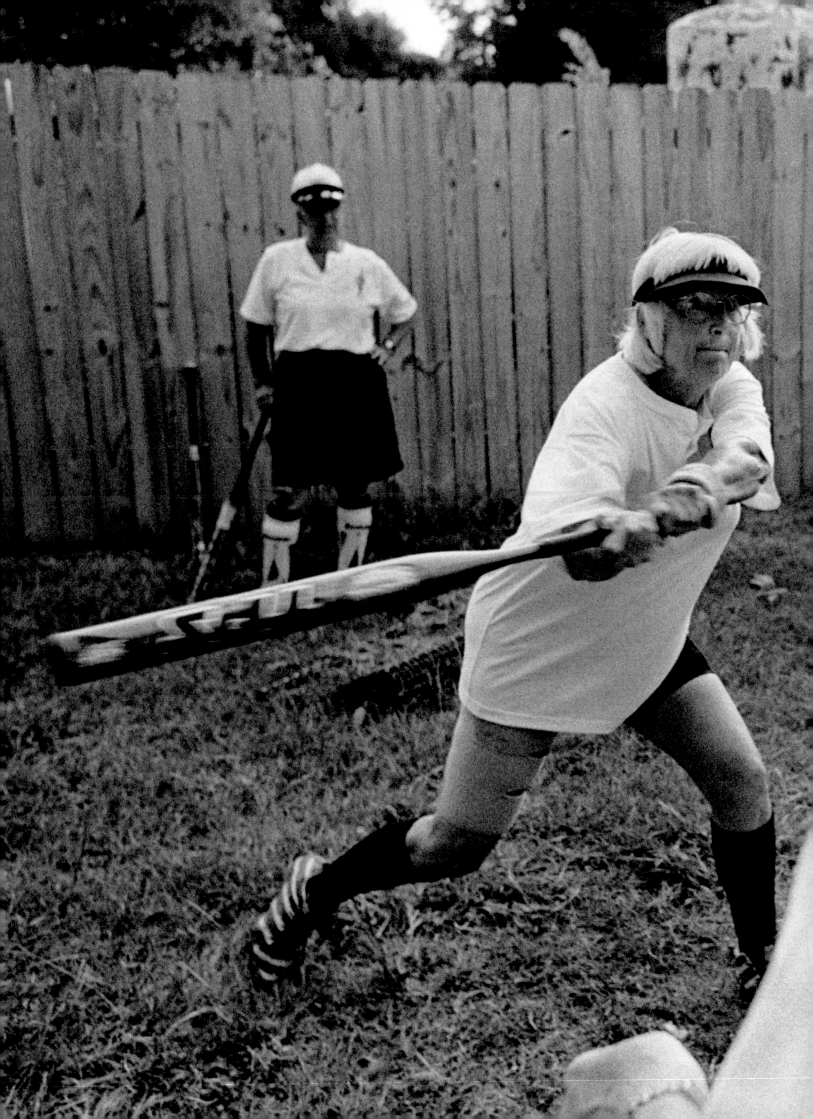

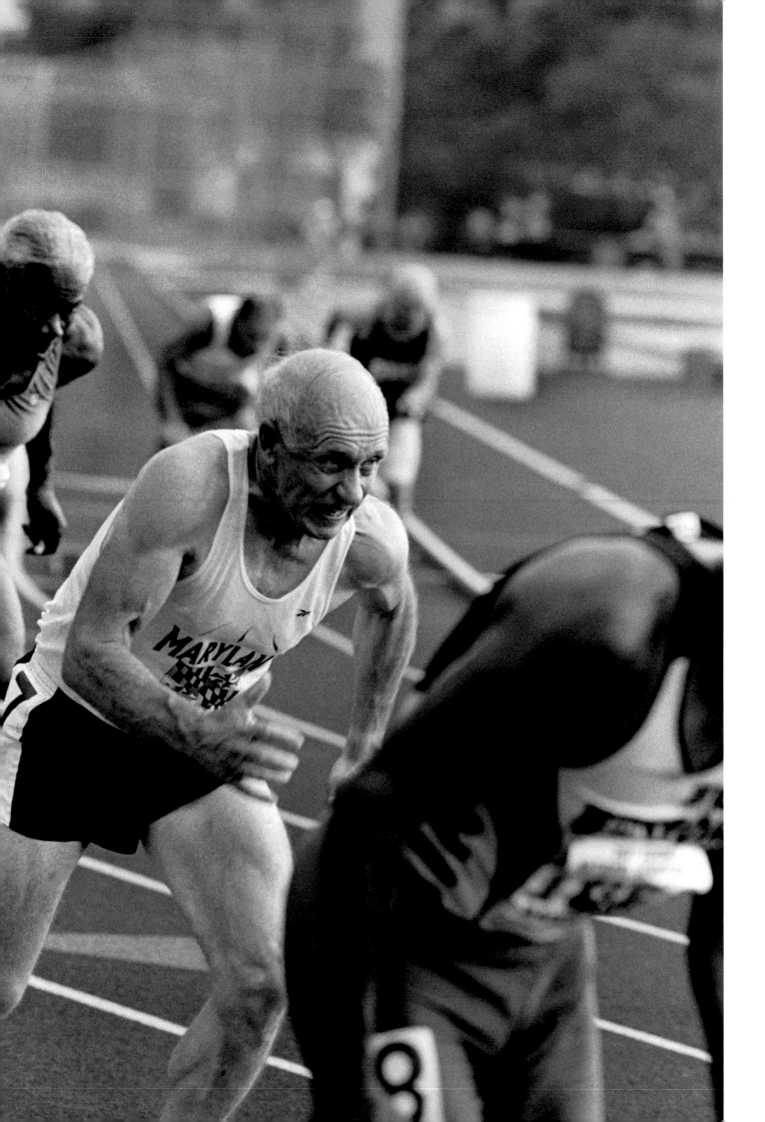

previous pages: Batting practice for a 60+ softball team at the Senior Olympics
opposite: Competitors in the 2001 Senior Olympics in Baton Rouge, Louisiana

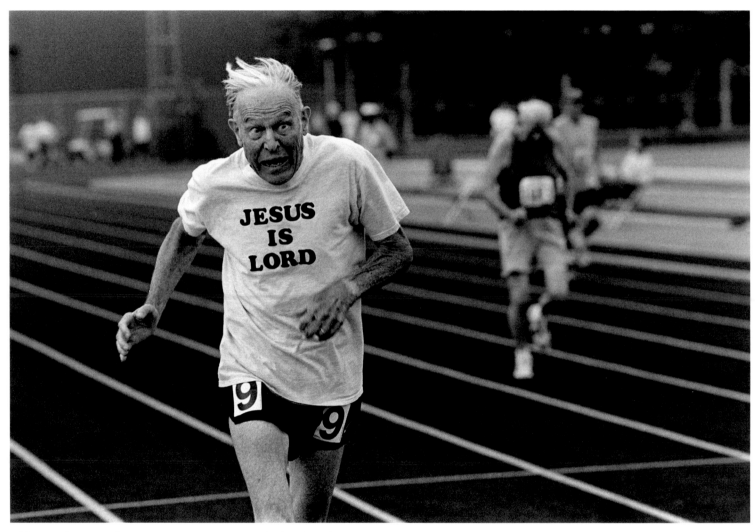

Athletes in the Senior Olympics compete in age groups broken down by 5-year increments.

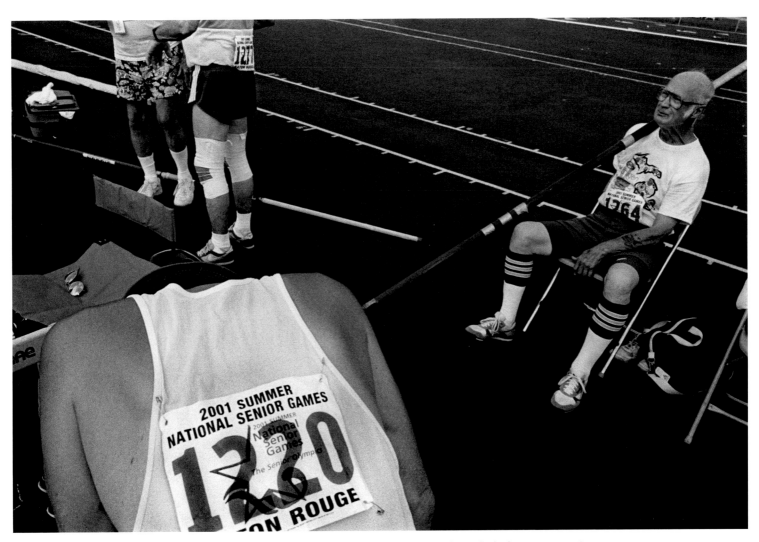

Pole vaulters in the 75+ category relax as they wait for their turn. Natural attrition thins the ranks in the highest age categories.

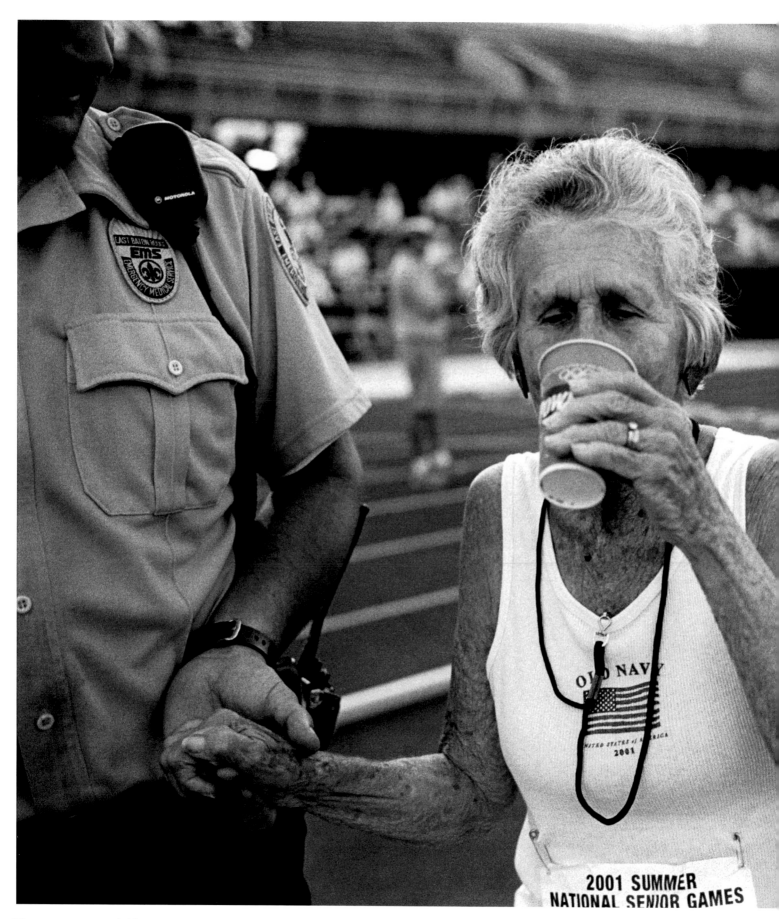

The 2001 games were held in Baton Rouge, Louisiana, where athletes battled 90° heat to set new world records.

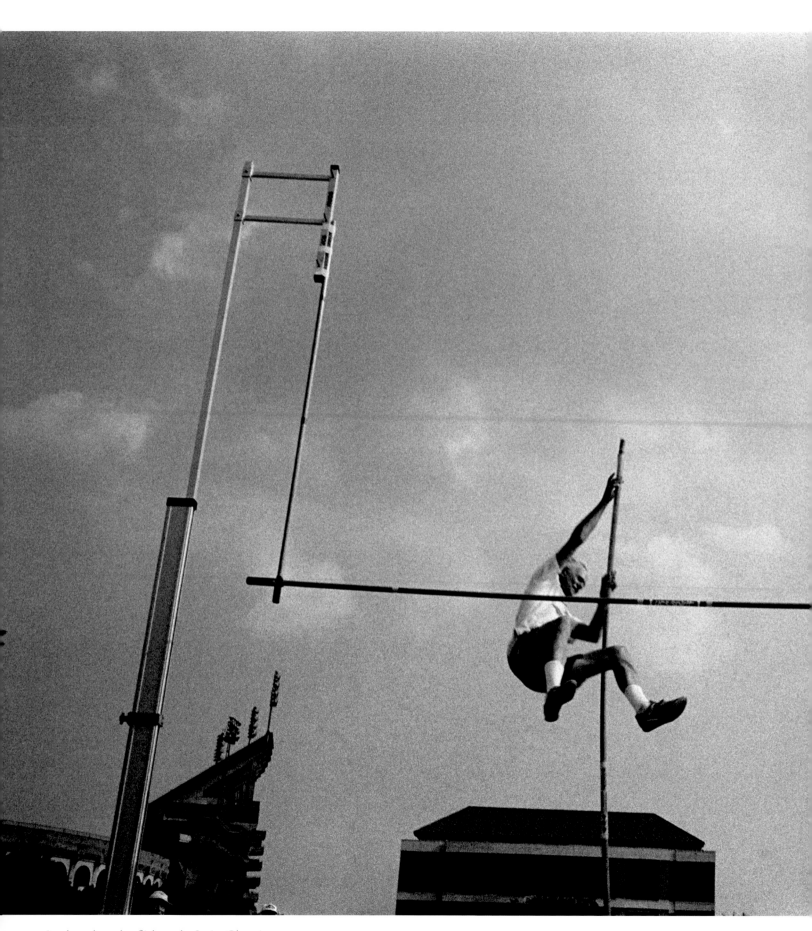

A pole vaulter takes flight at the Senior Olympics.

DESPITE THE EVIDENCE THAT PHYSICAL FITNESS IS KEY TO A HEALTHY OLD AGE, **1/3 OF ALL OLDER ADULTS LEAD A SEDENTARY LIFESTYLE**.

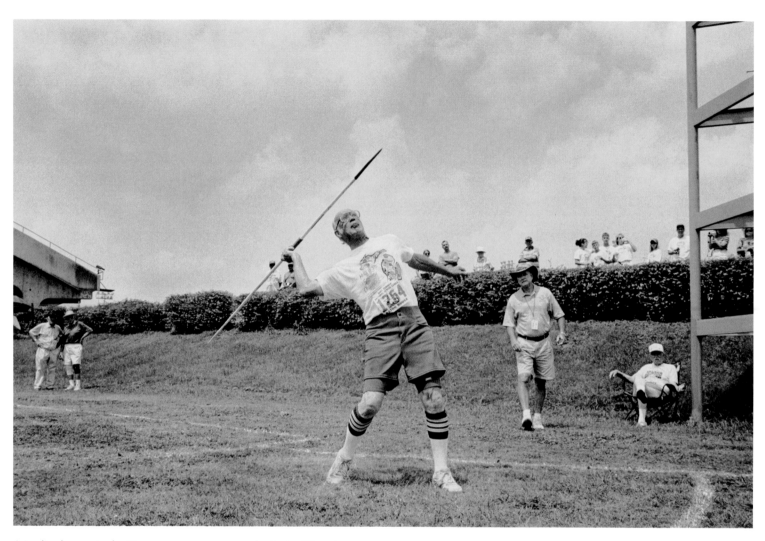

A javelin thrower in the 75+ age group competes at the Senior Olympics.

STUDIES SHOW THAT **PHYSICAL FITNESS IS THE SINGLE MOST IMPORTANT FACTOR** IN HEALTHY AGING, MORE SO THAN EVEN HIGH-RISK BEHAVIORS LIKE SMOKING OR A HIGH FAT DIET.

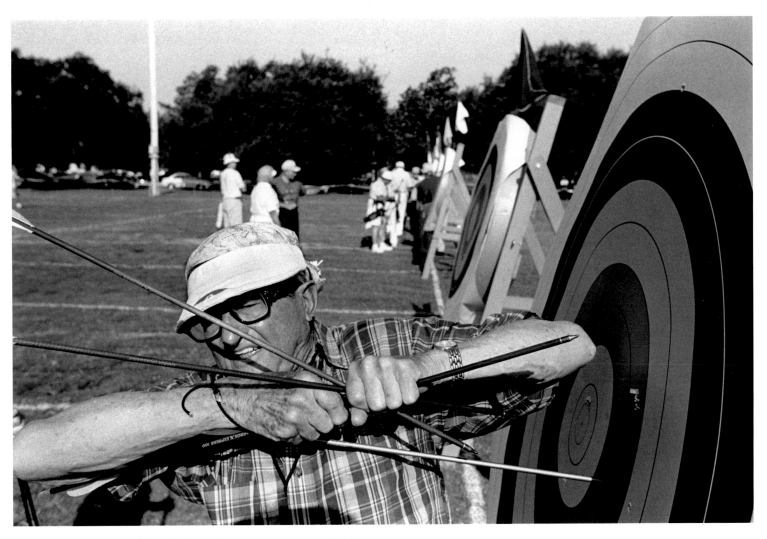

Fred Webster, 85, is nearly blind, but he still competes in archery and skiing.

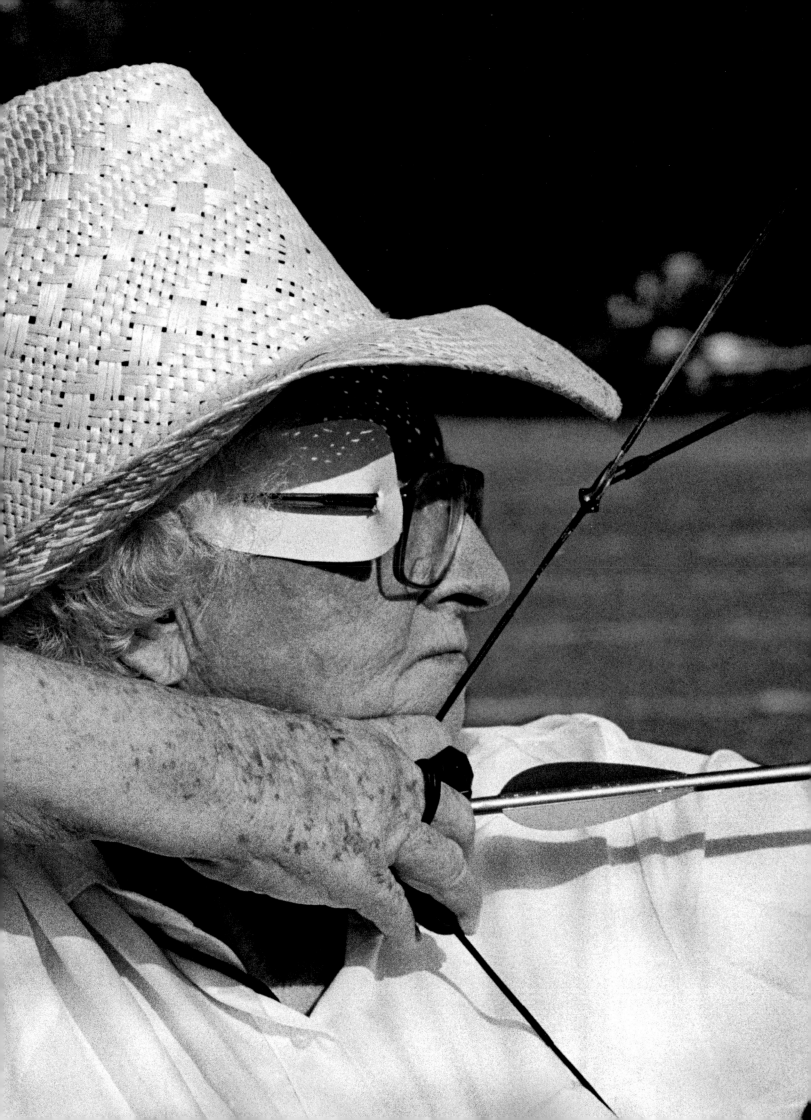

OLDER AMERICANS ARE **FINANCIALLY BETTER OFF** THAN EVER BEFORE. THE **MEDIAN INCOME** FOR MARRIED COUPLES OVER 65 **NEARLY DOUBLED** IN THE PAST 30 YEARS.

Sunbathing at Deerfield Beach, Florida

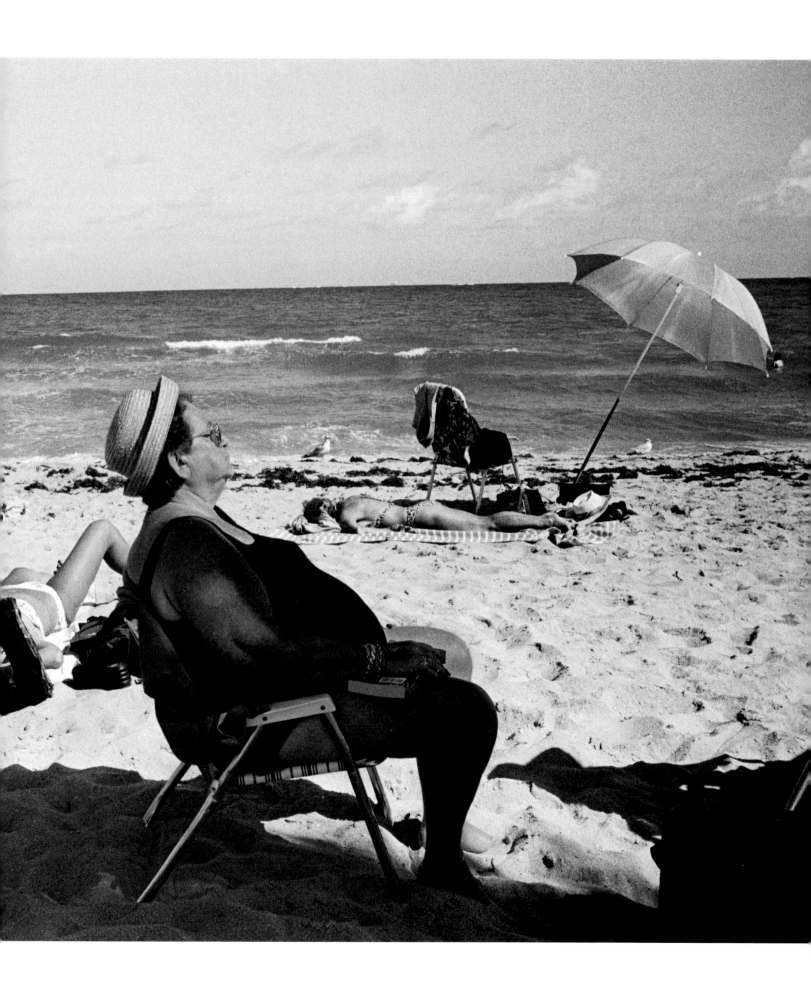

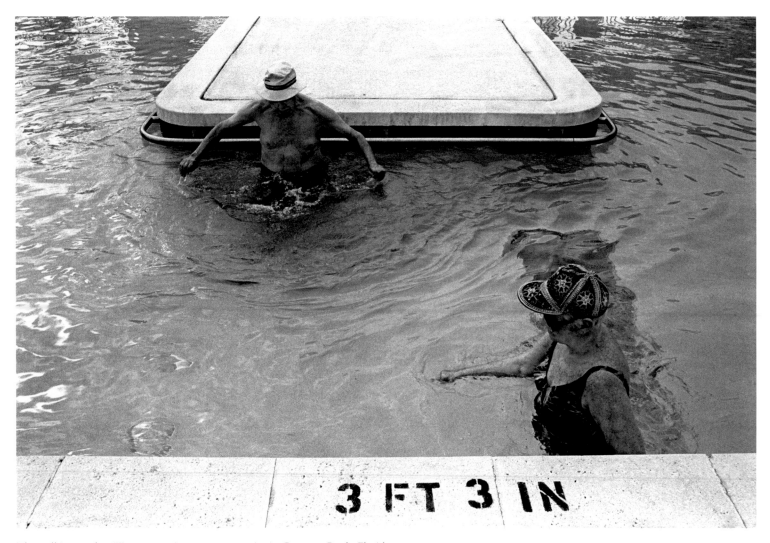

The walking pool at Wynmoor retirement community in Coconut Creek, Florida

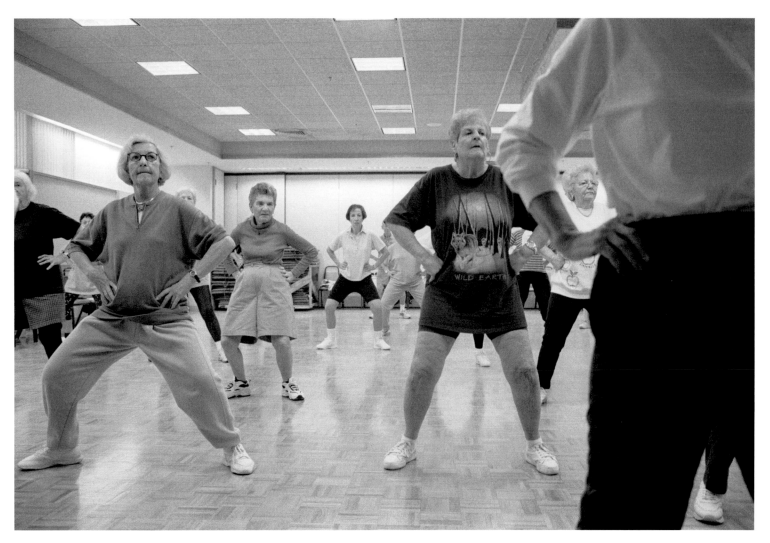

Wynmoor caters to active seniors.

NEARLY HALF OF ALL **PEOPLE 65 AND OLDER** CONSIDER THEMSELVES TO BE **MIDDLE-AGED OR YOUNG**.

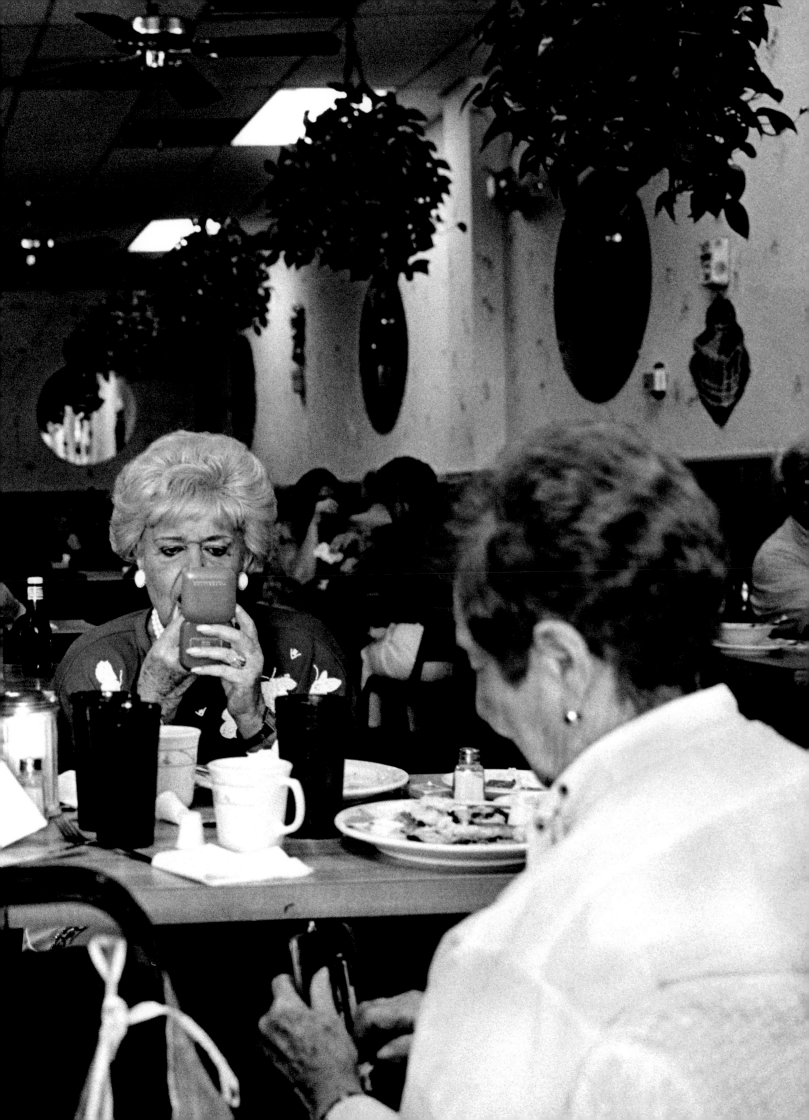

After losing their spouses, Ruth Wirth and Herb Winokur both lived alone in New Jersey. They were introduced by a mutual friend, and have been dating for four years. Although they maintain separate homes, they spend several days a week together, travel regularly, and spend the holidays with each other's families. But after more than thirty years of previous marriages, owning their own homes, enjoying two separate circles of friends, and having financial independence, they are reluctant to completely fuse their new lives together. An arrangement that was once branded as "living in sin" has become commonplace among America's older generation. "Sometimes I feel like I'm a bad role model for my grandchildren by not getting married," says Wirth. Nevertheless, she is not prepared to wed.

Herb Winokur indulging in his favorite pastime as he waits for his girlfriend Ruth Wirth to get ready to go out.

ALMOST HALF OF ALL WOMEN OVER 65 ARE WIDOWS, AND **THE RATIO OF WIDOWS TO WIDOWERS IS 4.3 TO 1**. WITHIN 25 YEARS, SOME DEMOGRAPHERS PREDICT, **THE GAP COULD WIDEN TO 10 TO 1.**

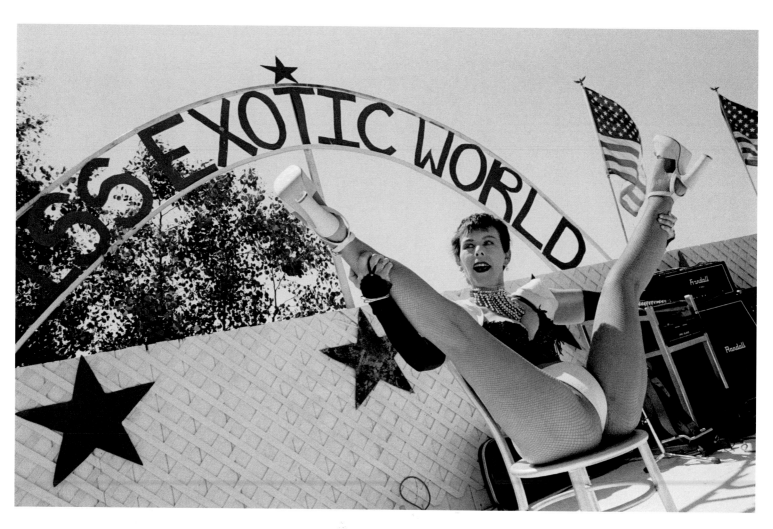

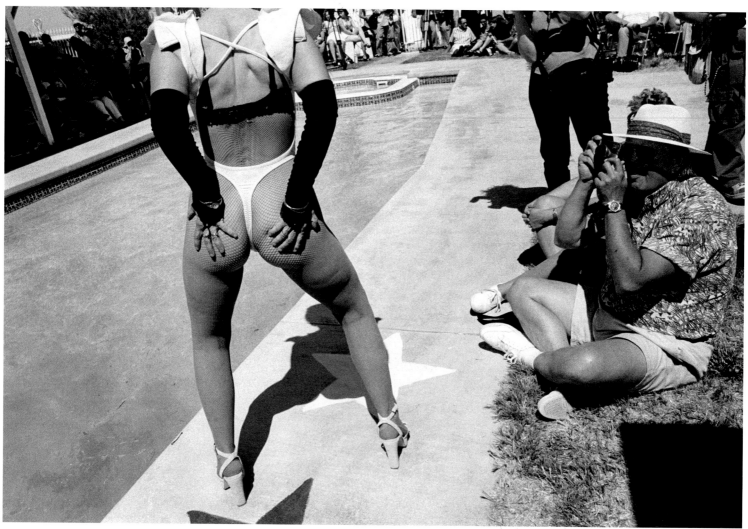

As women, we have an even deeper fear of aging than men do because our identity hinges on our looks and the way the world responds to our looks. The burlesque dancers at the Miss Exotic World competition challenge the very notion of body image and whether a body is still beautiful once it begins to sag. When we've shown these images to people on occasion, they are uncomfortable at best, and more often deeply disturbed. That's too much information, they say. But if we are going to be realistic about nature's agenda, these bodies must be considered beautiful in their own right. They were carefully sculpted by time, molded through experience and shaped by gravity. They are models for "ageless beauty."

opposite: Sadie Burnett, 58, performs at the Miss Exotic World competition in Helendale, California. Sadie still works in clubs in Texas, and teaches yoga on the side.

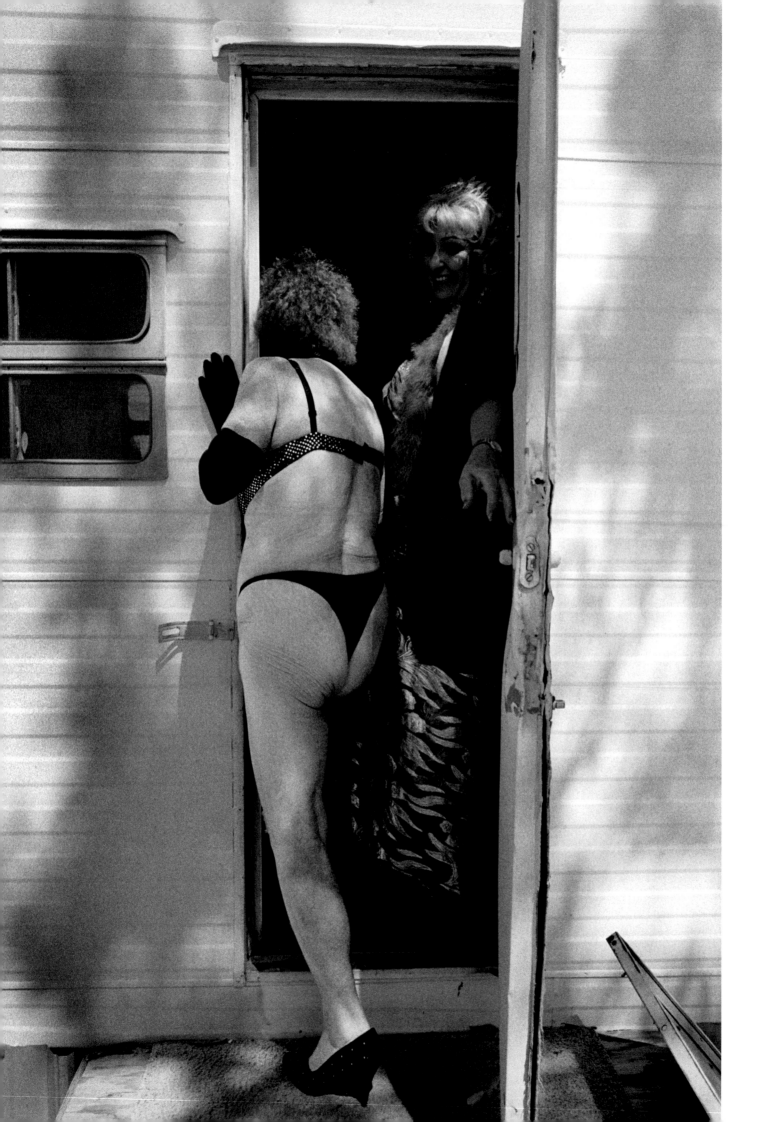

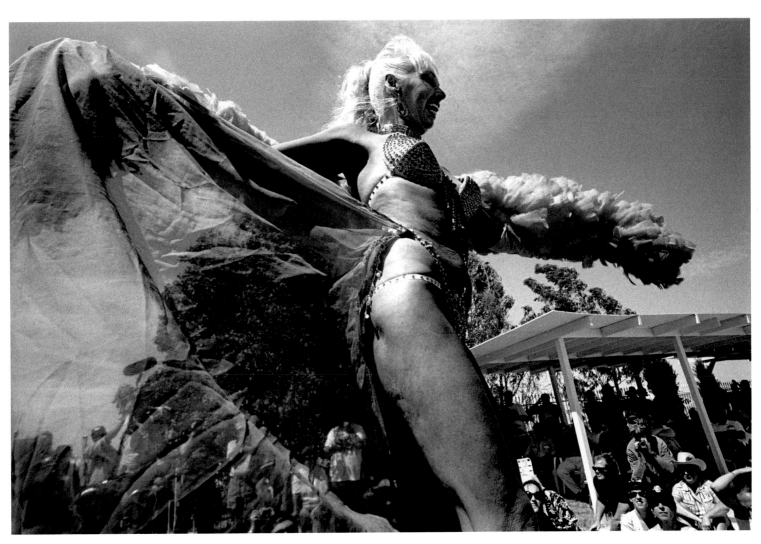

Daisy Alexander performs for an adoring crowd at the Miss Exotic World competition.

opposite: A seasoned dancer slips into her dressing room.

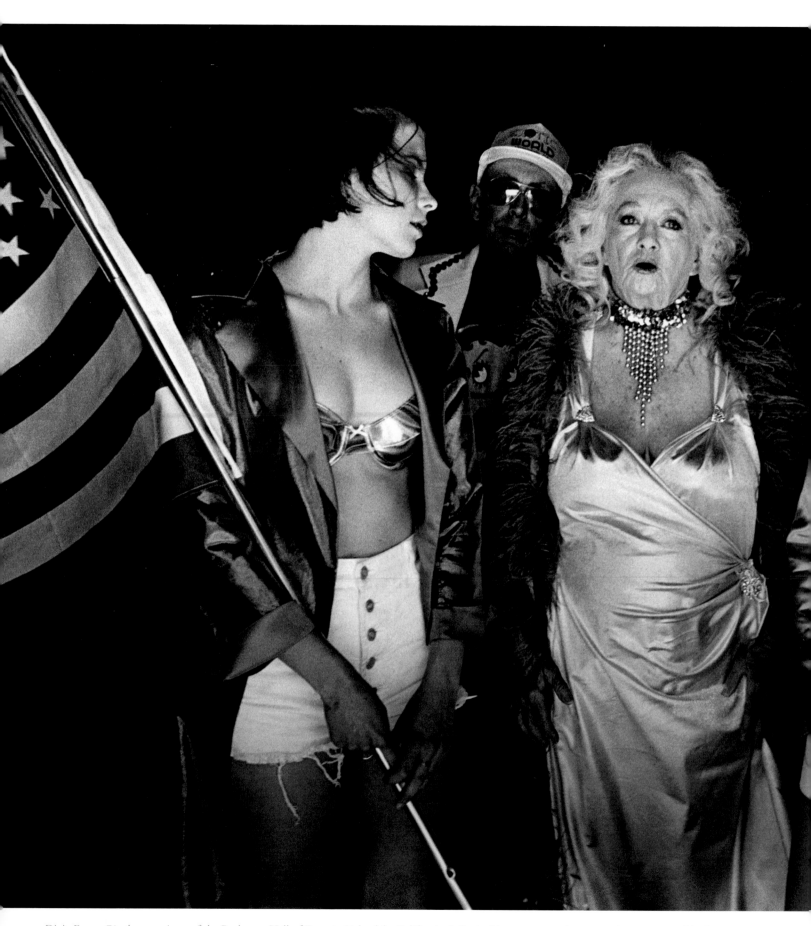

Dixie Evans, 71, the proprietor of the Burlesque Hall of Fame in Helendale, California, is flanked by two young dancers as she prepares to hit the stage.

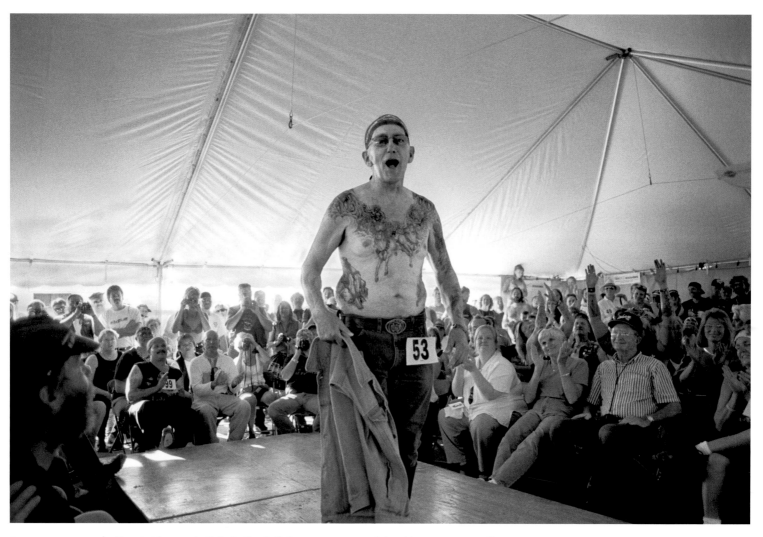

A tattoo contest at the Sturgis Motorcycle Rally in South Dakota went to one of the oldest contestants. Once the domain of young rebels, this rally of more than 400,000 bikers is going gray.

opposite: Pat Ulen, 66, and her husband started biking 7 years ago. When this picture was taken they were on a 3-month tour of the U.S. and Canada.

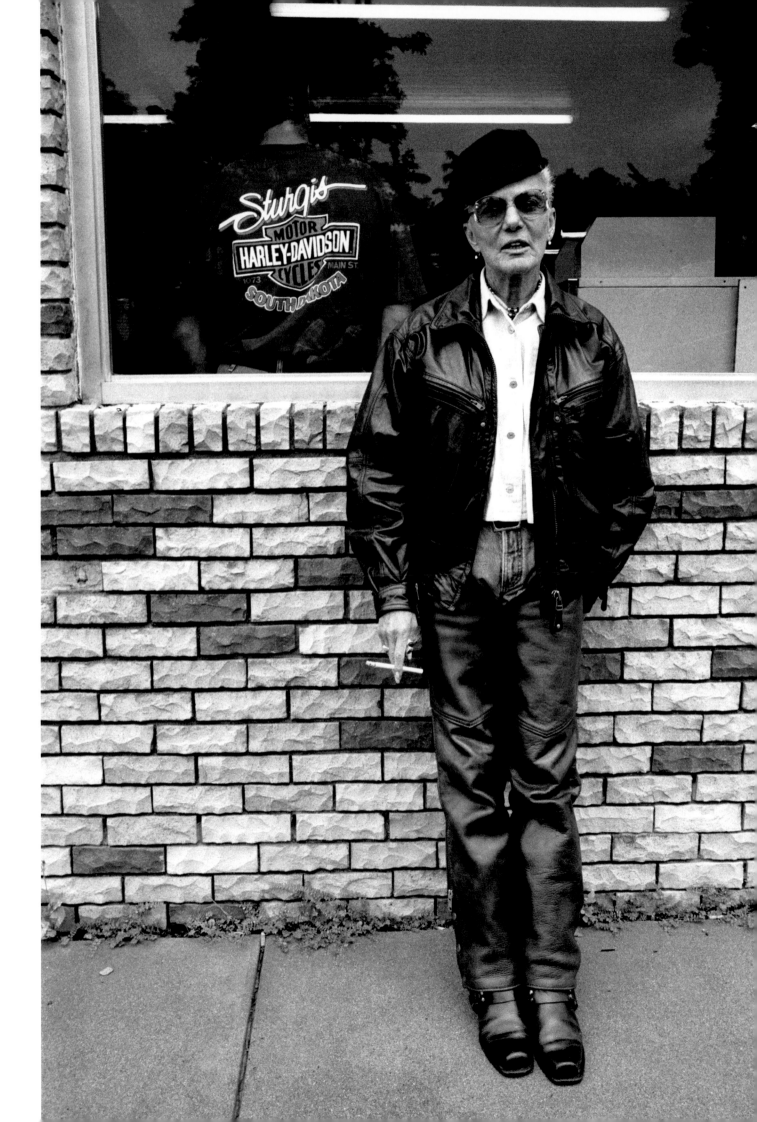

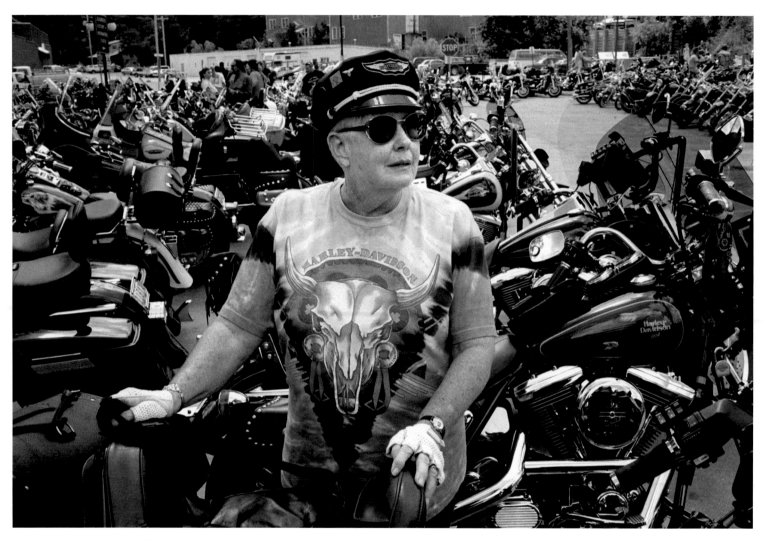

Marlene Patton, 67, is one of the founders of Retreads Motorcycle Club International.
She is pictured at the Sturgis Motorcycle Rally where she was crowned queen in 1977.

THE **AVERAGE AGE** OF HARLEY-DAVIDSON
CUSTOMERS **HAS REACHED 52**.

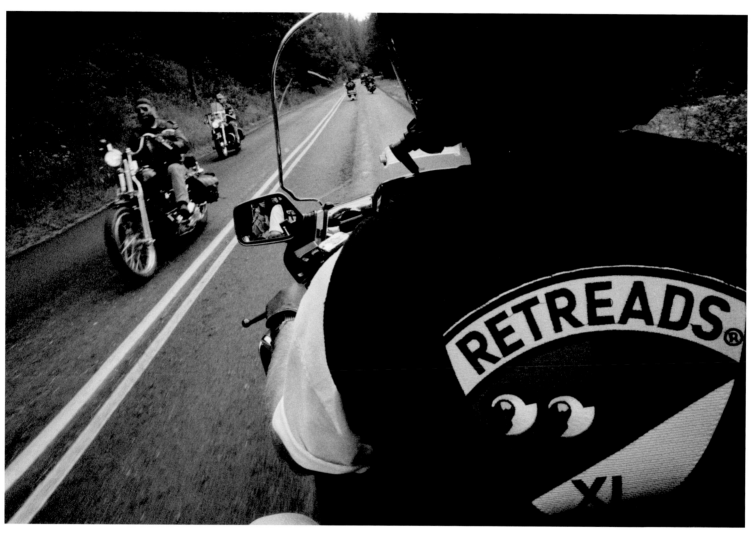

Members of Retreads take a tour to Devil's Tower during the Sturgis rally.

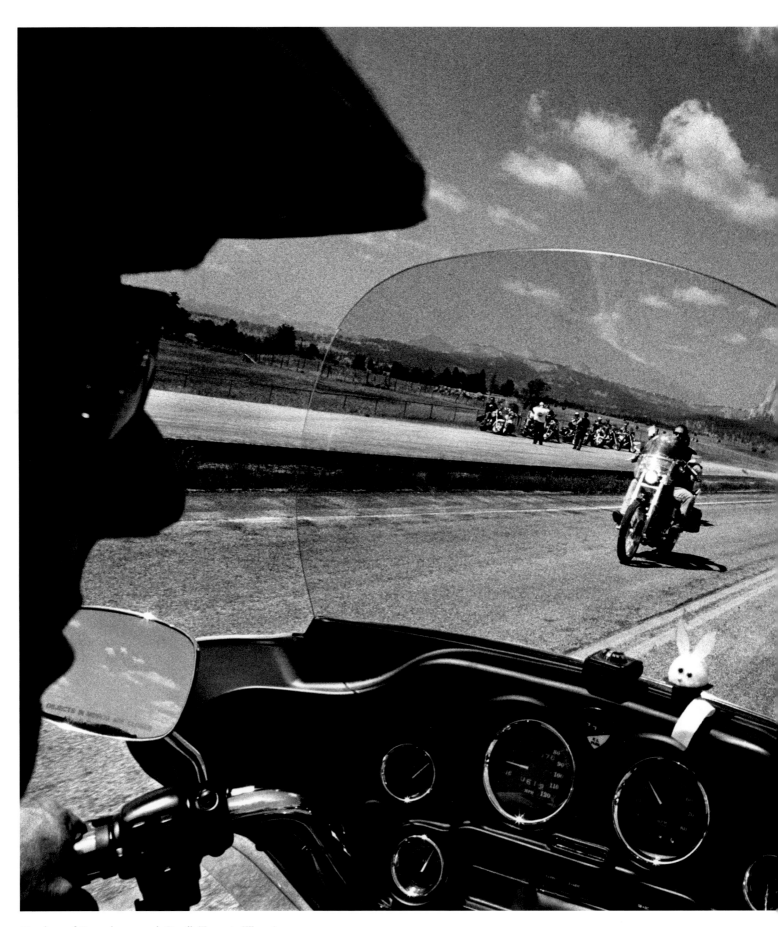

Members of Retreads approach Devil's Tower in Wyoming.

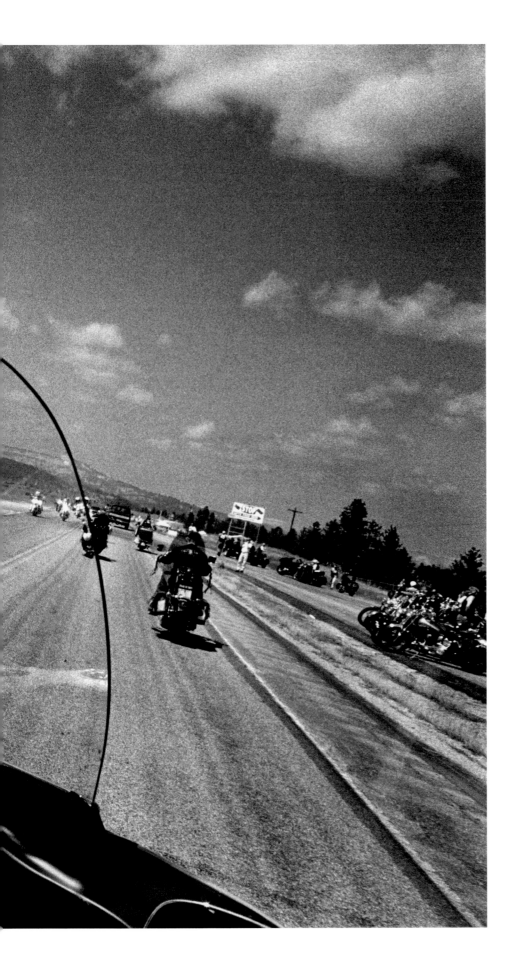

The Retreads Motorcycle Club International has two requirements: minimum age of forty and a love of biking. With chapters all over the country, the club has some 24,000 members who are living proof that growing old doesn't mean retreating into a retirement community.

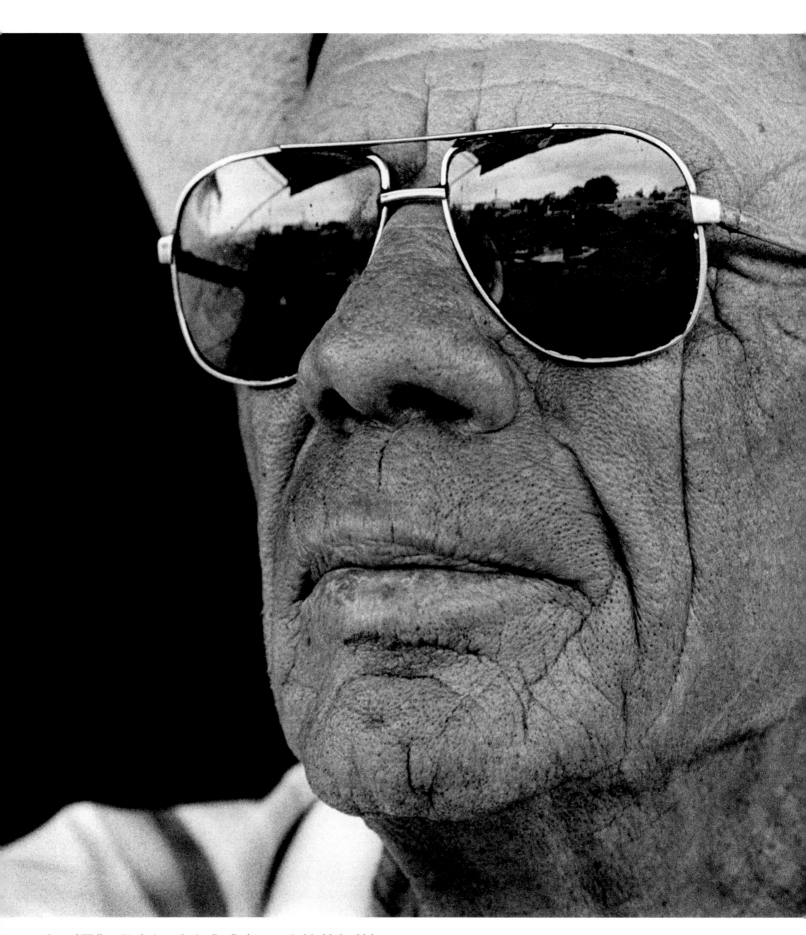

Lenard Walker, 68, during a Senior Pro Rodeo event in Mud Lake, Idaho

"Lenard is just now getting to realize his dream come true, to travel with the Senior Pro Rodeo. When he was younger, his friends would go and win all these things and go all over the country, and he'd have to go sit on heavy equipment each day and dream of wanting to do it. So when he retired, one of the first things he did was to buy a motor home and get ready to travel the rodeo circuit. That was when he turned sixty-two. And he hasn't missed a year yet. Even when he broke his collar bone, he was only out for six to eight weeks."

Barbara Walker

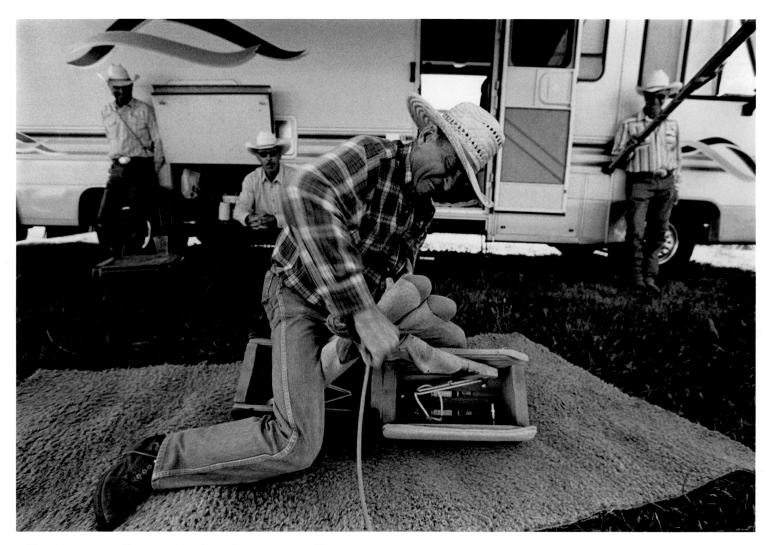

Behind the scenes, a calf roper practices his trade on a wooden calf.

Rodeo is beyond sports, it's a lifestyle—from living in a dusty camper to hauling the horse trailer cross-country, from the bruises of a rough ride to the post-performance camaraderie. You don't retire from a lifestyle. The National Senior Pro Rodeo Association, founded in 1978, gives old cowboys and cowgirls a place to pursue their passion. It's obvious when a seventy-year-old calf roper grabs his prey by the horns and throws it to the ground that his competitive spirit hasn't waned, only his flexibility and speed have betrayed him. It's not unusual to see a cowboy, hobbled by arthritic hips, struggle onto his horse and then ride as though his body were this year's model.

With more than a thousand members nationwide, the NSPRA sponsors over eighty annual rodeo performances in the U.S. and Canada, with more than a million dollars in prize money at stake. Members compete in separate age divisions for each event; the oldest contestants are often relegated to team roping. The nationals, held in Reno each year, carry a bounty of hundreds of thousands of dollars in prize money—and a gold belt buckle for the grand champion. The NSPRA, which is as much a social club as a competitive circuit, also has a "Cowboy Crisis Fund" to help fallen cowboys weather the toughest of times.

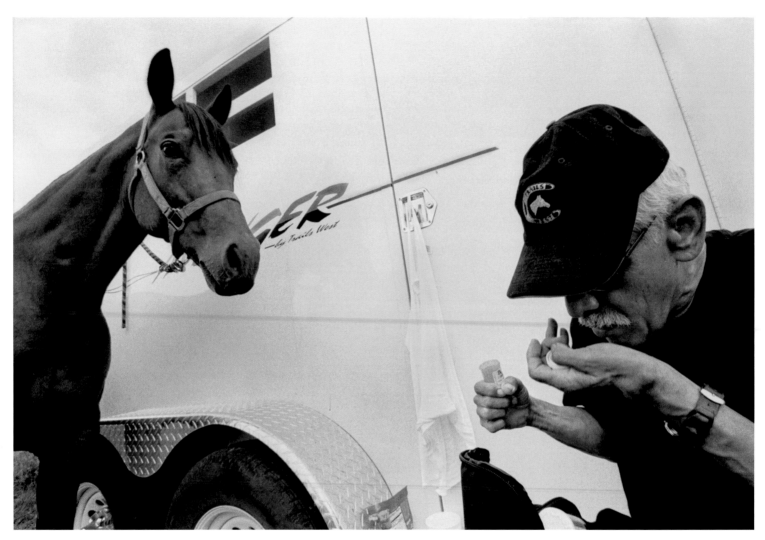

George Lopez, 61, takes his medications before a rodeo performance. He is diabetic and has an amputated leg, but he still competes in team roping in the Senior Pro Rodeo.

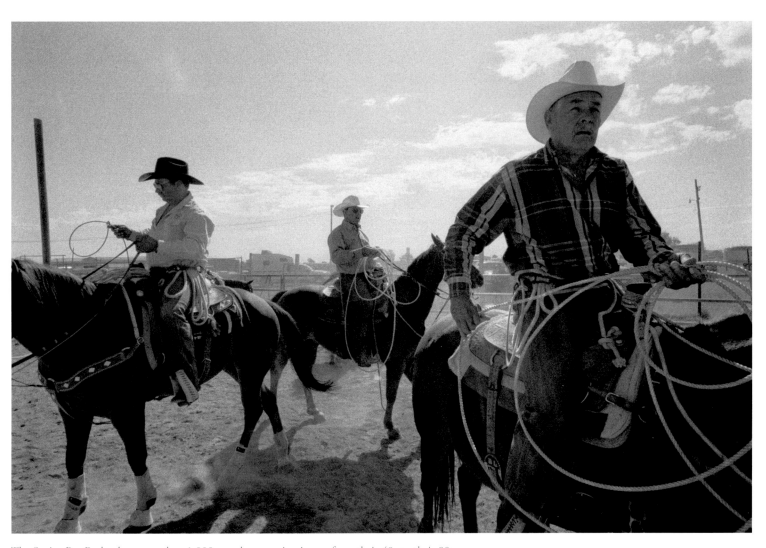

The Senior Pro Rodeo has more than 1,000 members ranging in age from their 40s to their 80s.

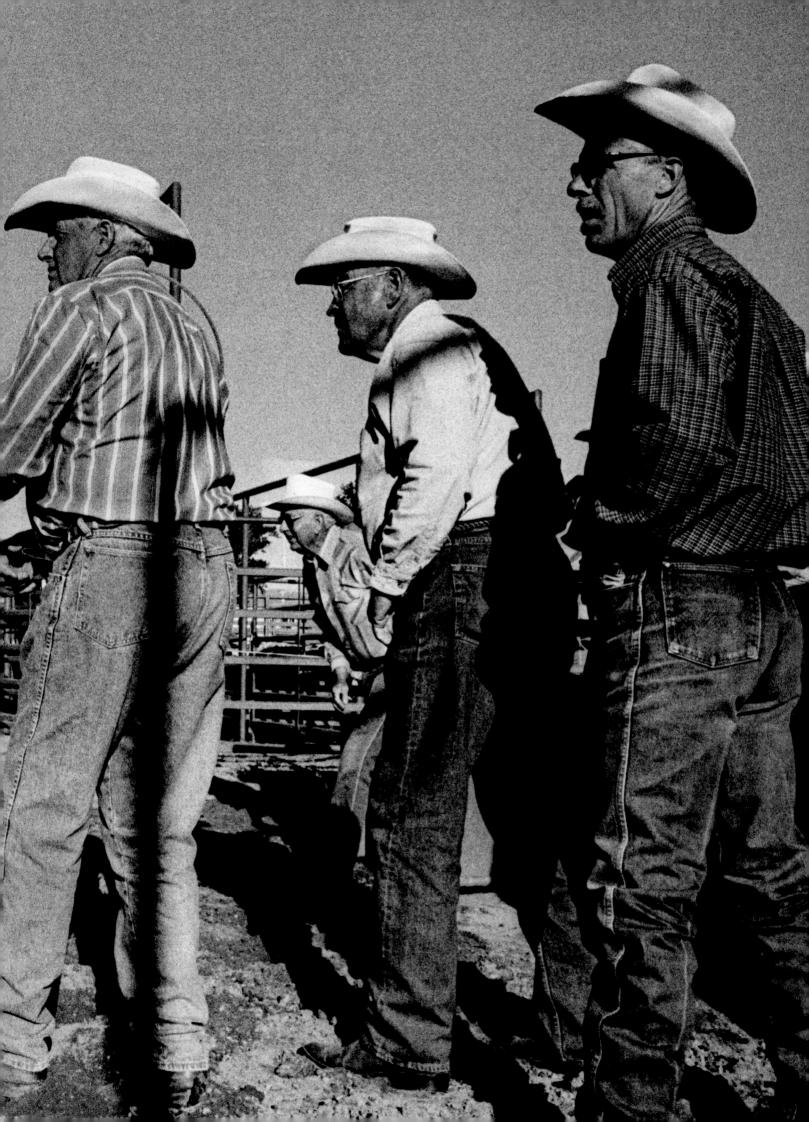

On her way to an audition in New York City, model Gloria Barnes turns a few heads.

Gloria Barnes modeled in her early twenties, and then picked up her modeling career again in her sixties. After raising her children, she joined the Ford Classic Division, an agency dedicated to older models. Since then, she has appeared in such glossy publications as *Vogue, Glamour*, and *Marie Claire*, and has been an extra in several movies. In the past, older models were relegated to commercials for pharmaceuticals and retirement communities; increasingly, they are used for fashion and glamour.

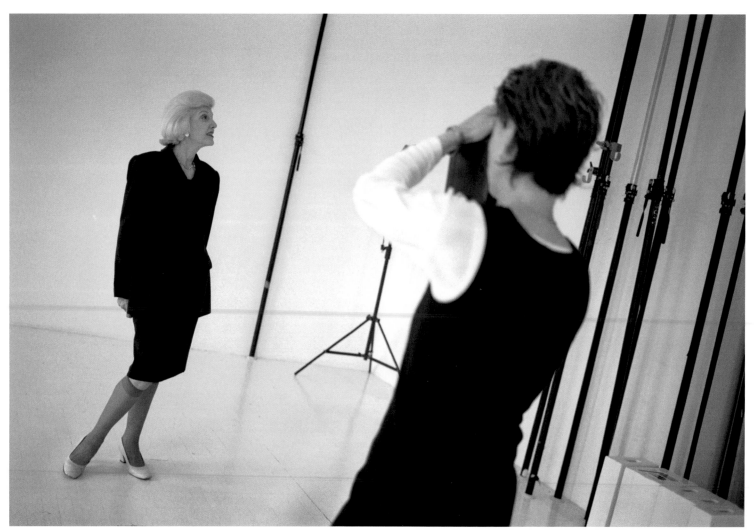

Gloria Barnes at a test shoot

Gloria keeps a strict workout schedule.

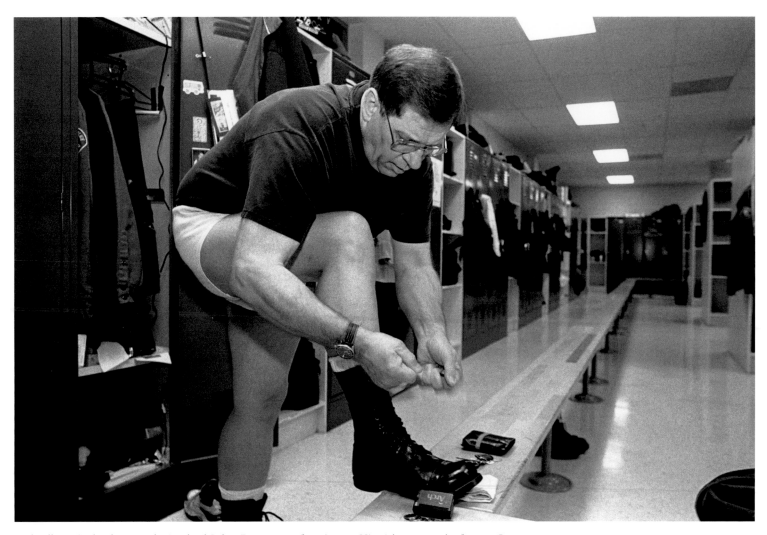

Carl Rilling, 60, has been on the Portland Police Department for 36 years. His nickname on the force is Gramps.

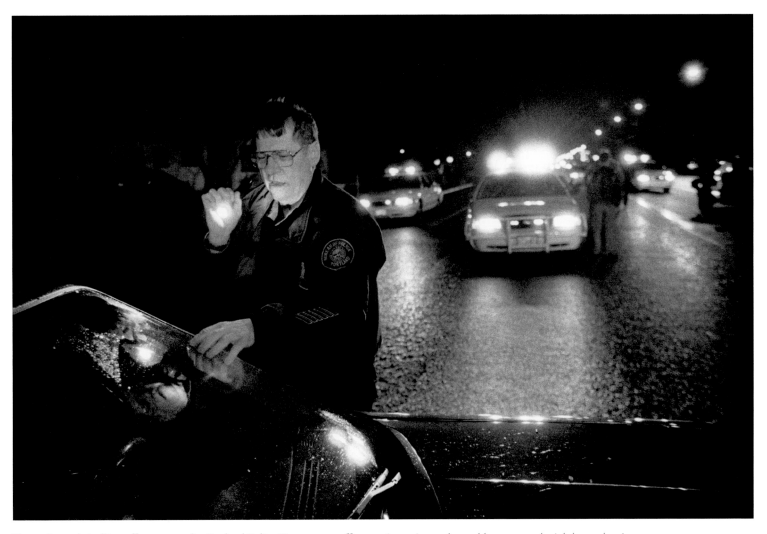

To combat a dwindling officer corps, the Portland Police Department offers pay incentives to keep older cops on the job beyond retirement age.

AMONG PEOPLE AGED 55–64 WHO STILL WORK, **95%**
PLAN TO GET ANOTHER JOB AFTER THEY RETIRE.

The Bonne Bell factory in Lakewood, Ohio, is a metaphor for the aging American landscape. To the outside world, this family-run business is known for its inexpensive cosmetics and the ever-changing variety of its products. But inside company walls, the workforce is getting grayer. Of the dedicated assembly line of older workers at Bonne Bell, these "retirees" now account for some twenty percent of its workforce.

In 1997, during a holiday crush, Bonne Bell CEO Jesse Bell called in the reserves—the company's former workers—who helped dig him out from under a mountain of orders. That week he realized that older workers were loyal, dedicated, and more reliable than a lot of his younger employees. In fact, their reliability now saves him a million dollars every year. They work in four-hour shifts, don't require health insurance (thanks to Medicare), and rarely miss a day. Not only that, they appreciate the opportunity to stay engaged.

THE NUMBER OF **WORKERS OVER 65** IS NEARLY 4 MILLION AND **RISING**, WHILE THE NUMBER OF **WORKERS AGED 25–44 IS FALLING**, GUARANTEEING A FUTURE LABOR SHORTAGE.

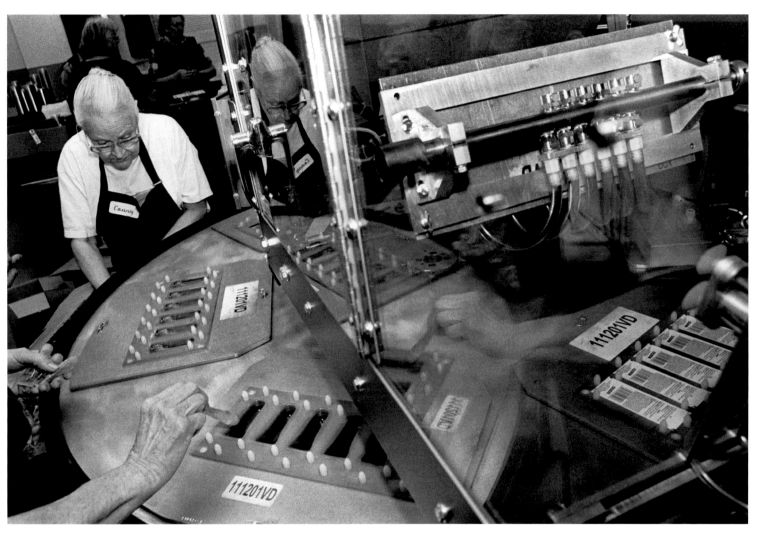

Ruth Connie Bowen, 71, learns how to use a new packaging machine at the Bonne Bell factory in Lakewood, Ohio.

"*Everybody thinks when they retire they're just going to sit back and do nothing. That's the worst thing to do. The best thing to do is just like all these people here—get active, give back something. Most people have been given a gift, so give it back and don't expect nothing for it.*"

Charles Damon, Care-A-Vanner

The Care-A-Vanners are a group of retirees who drive around the country in their RVs and help Habitat for Humanity build homes. They are shown at a build site in Mandan, North Dakota.

Walter Burnette, 90, still works 40 hours a week as a heavy machine operator at a sandstone quarry in Virginia. Walter tried retirement once, but it lasted only 3 weeks due to boredom.

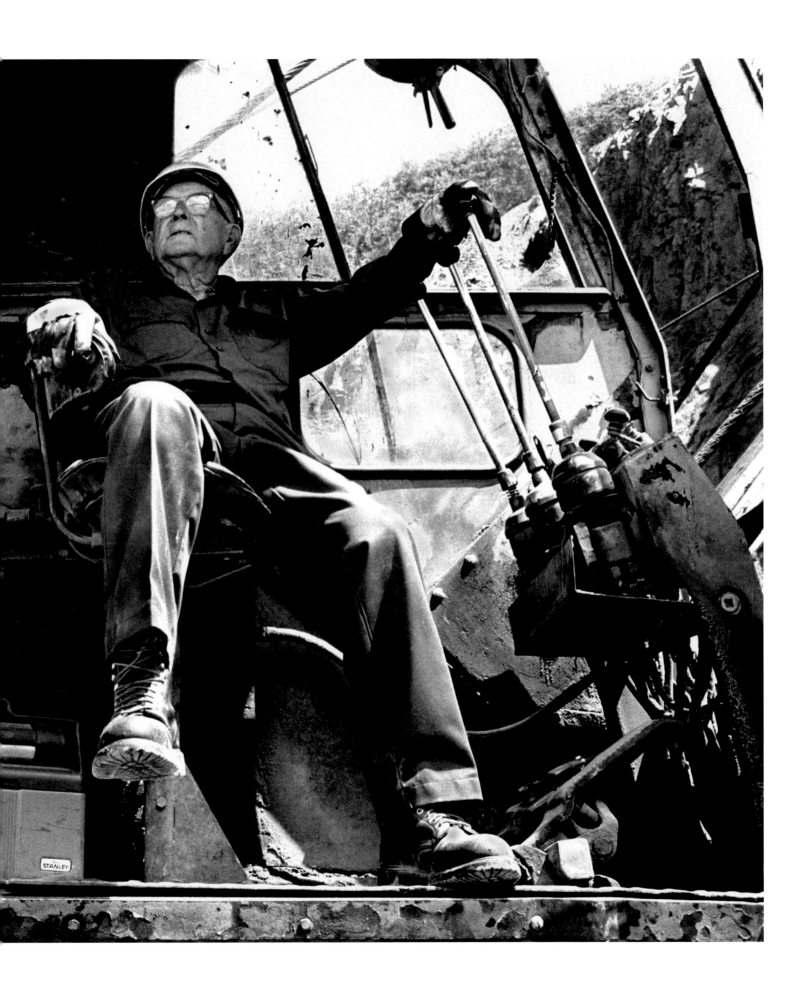

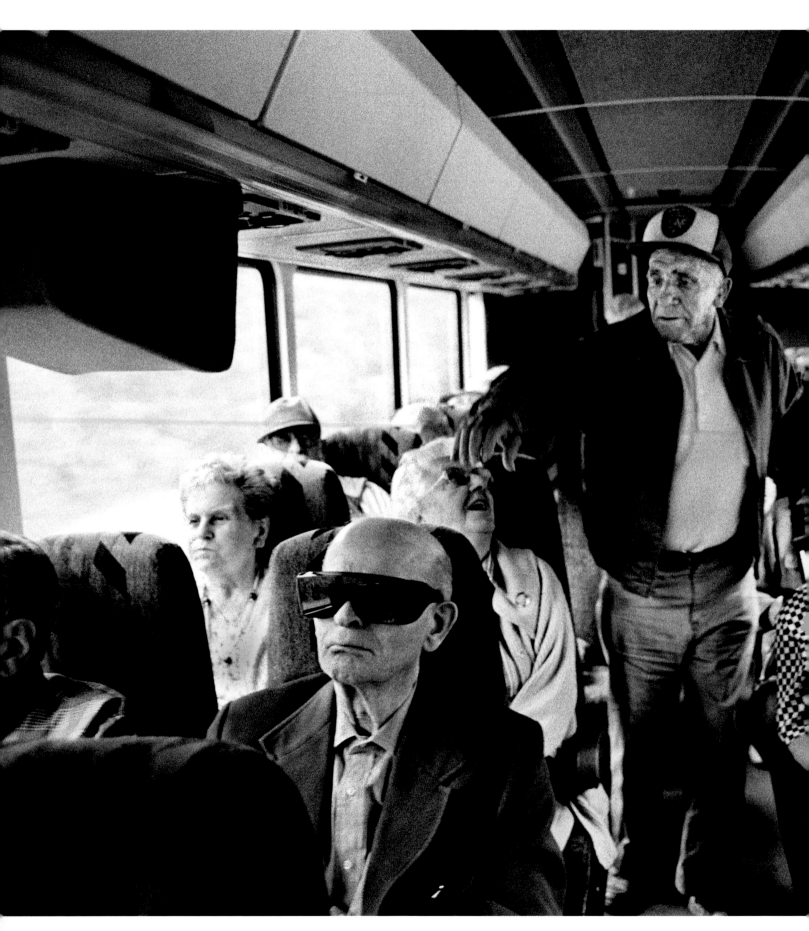

A busload of seniors heads to Atlantic City.

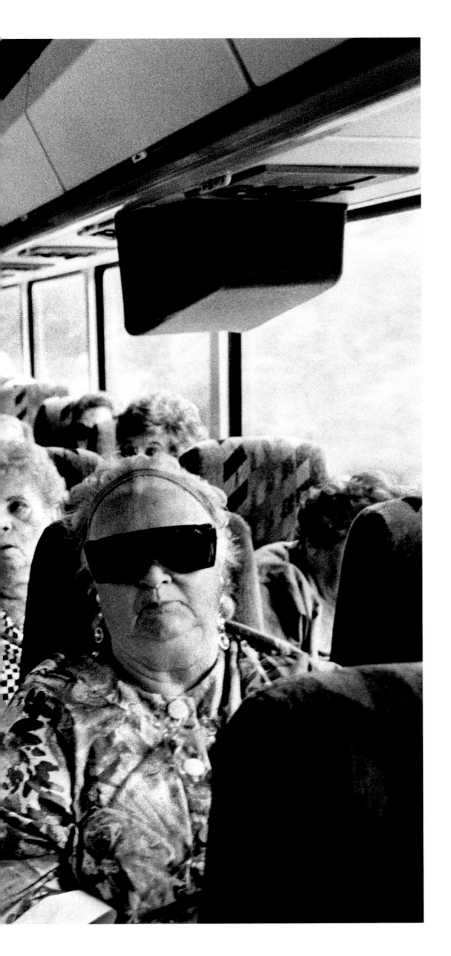

The seduction of the slot machine has America's elders flocking to casinos in droves. They eagerly descend from tour buses such as this one, and like pilgrims to Lourdes, they are instantly healed of their loneliness and boredom. They are greeted at the front door by free tokens, buffet tickets, and warm welcomes leading them inside. There, in the bustling din of the casinos, they feel alive again.

For the first time in history, as people grow older, they're gambling more. In general they prefer the low stakes of the one-armed bandits, bonding to lucky slot machines that have insatiable appetites, losing their money nickel-by-nickel.

The ranks of senior problem gamblers is on the rise, and according to the Florida Council on Compulsive Gambling, the average debt reported is an astounding sixty thousand dollars. For those on fixed incomes, the loss can be devastating. With free time to fill and heightened social needs, the elderly have become easy prey for the gaming industry, which offers discounted hotel rooms, free meals, and even prescription drug discounts to lure them in…by the busload.

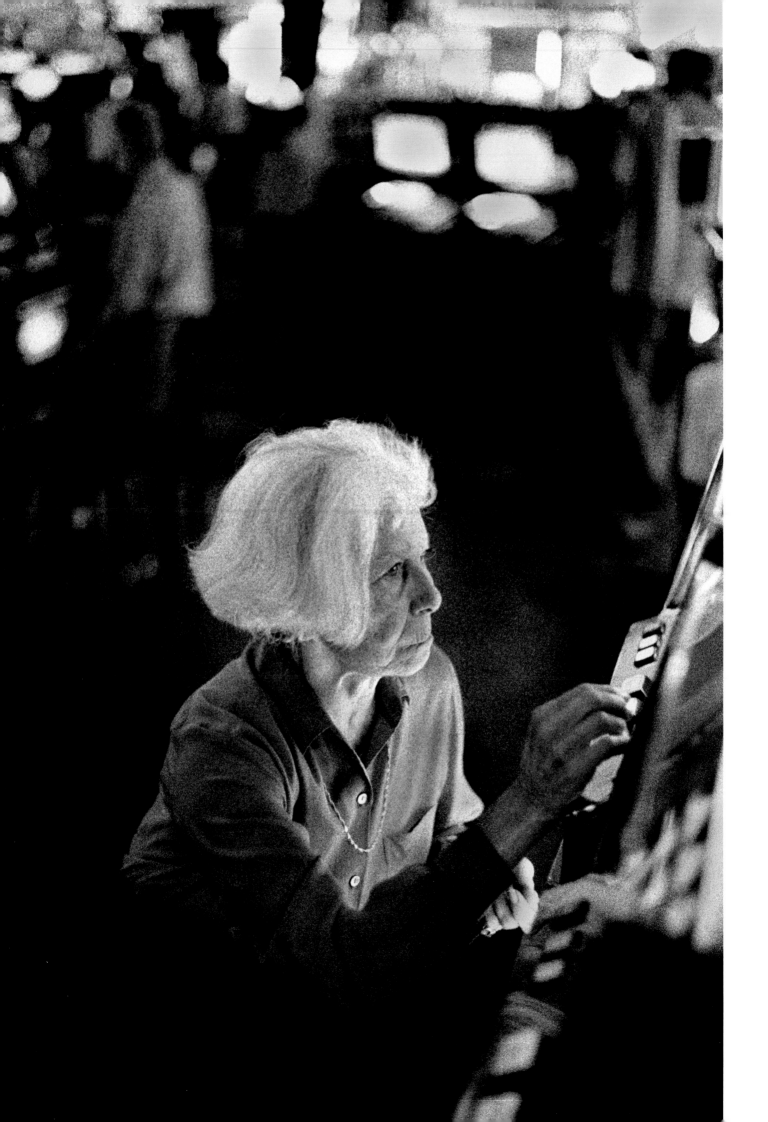

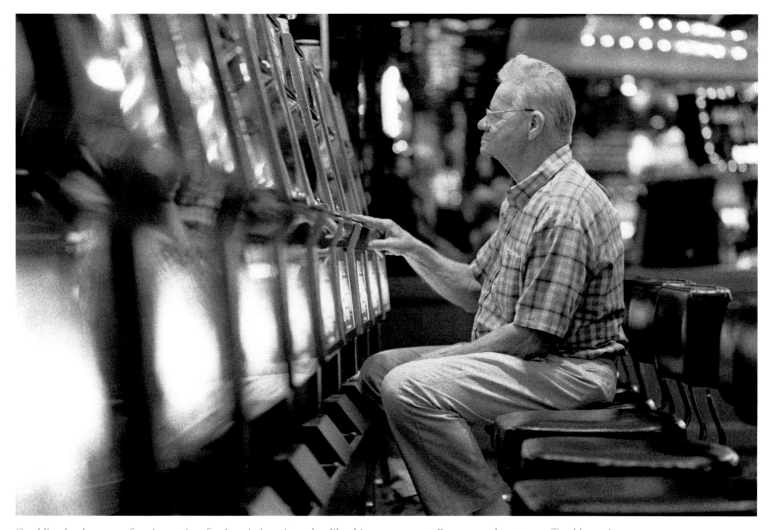

Gambling has become a favorite pastime for America's seniors who, like this man, come to Reno on package tours offered by senior centers.

opposite: Isabel Feliciano, 79, communes with her slot machine
in Reno during a trip arranged by her senior center.

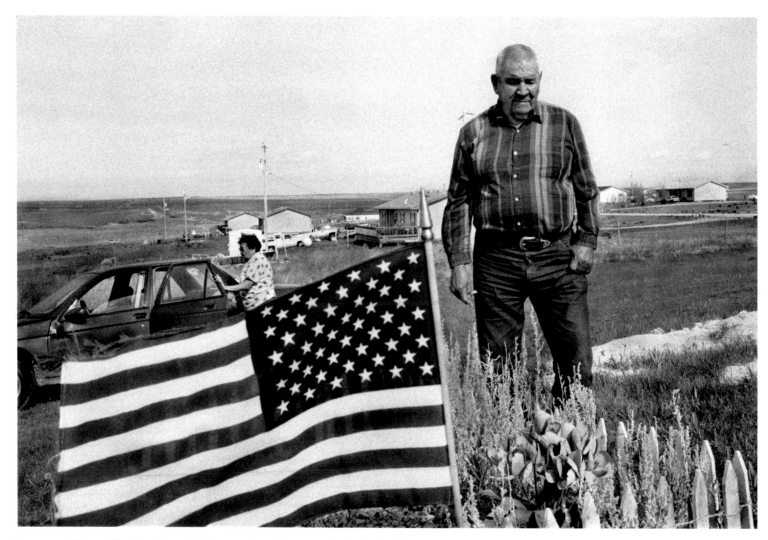

Jimmy and Eleanor Charging Crow visit the gravesite of their son, Floyd, who died from a heart attack in his 40s. Eleanor, 68, has been an emergency medical technician for nearly 30 years; her son died in her arms in the ambulance. The couple is now raising two of their grandchildren.

DESPITE THE FACT THAT **THE NUMBER OF OLDER AMERICANS LIVING IN POVERTY DROPPED TO 10%** BETWEEN 1959 AND 2000, NEARLY 60% OF **NATIVE AMERICAN ELDERS LIVE 200%** BELOW THE POVERTY LINE.

Nellie Two Bulls lost her daughter and all three of her sons to alcohol and diabetes. Jimmy and Eleanor Charging Crow lost their son to a heart attack in his forties. Oscar Jealous of Him lost his three sons to suicide. On the Pine Ridge Indian Reservation in South Dakota, far too many fresh graves are filled by untimely deaths, and rare is the elder who hasn't lost one or more adult children.

The history of Pine Ridge is a study in loss. Once the most powerful nation of the northwest plains, the Oglala Sioux were forced off their land, herded like cattle, and ultimately decimated by the American army. The massacre at Wounded Knee, where nearly two hundred Sioux were murdered in cold blood, was the worst of many insults inflicted on the tribe. Today, elders still remember traveling in their grandparents' wagons to Wounded Knee to feed the spirits. It's a lesson of suffering that courses through their veins and is passed on like genetic code.

Pine Ridge lies in the poorest county in America. The life expectancy here is twenty years short of the national average. Resources are scarce, and elders are largely dependent on tribal and federal assistance. They are also responsible for supporting the younger generations due to rampant unemployment. Many of the elders are raising their grandchildren because their own children have succumbed to domestic violence, alcoholism, and general apathy.

At Pine Ridge, the elders represent the link between the old ways and the new. They are perhaps the last generation to speak Lakota as their native tongue, a language that might barely outlive them. Since most of the culture is passed down orally, they are the repository of Sioux history. They are also the last generation to have experienced the traditional way of life. Today's elders have beat the odds of survival, only to watch the systematic demise of their culture. In the end, there is no such thing as a leisurely retirement on the reservation.

following pages: During the 4th of July Wakpamni powwow, Sadie Janis, 89, and her sister, Zona Fills the Pipe, 91, are joined by a young beauty contestant.

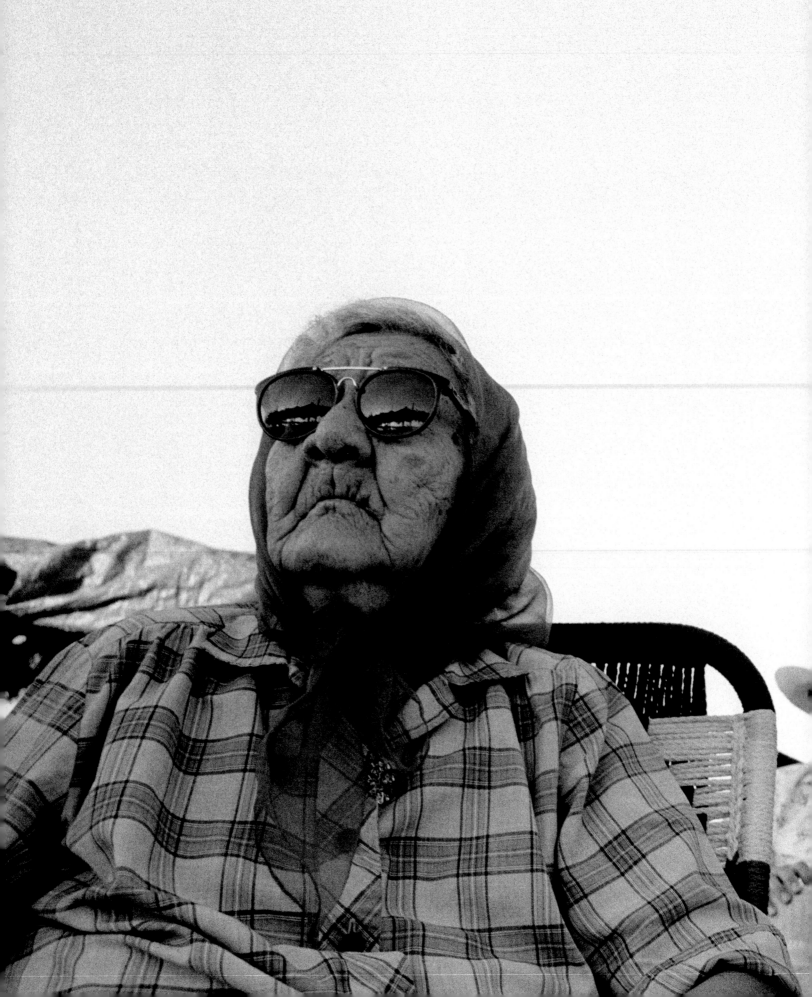

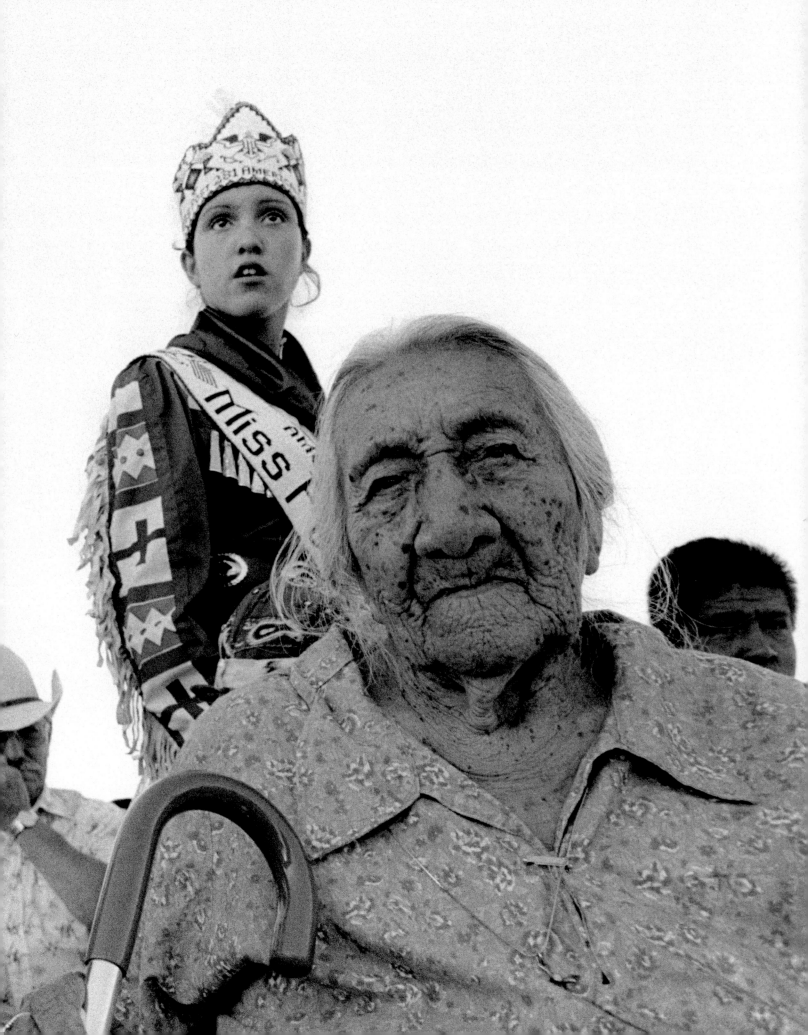

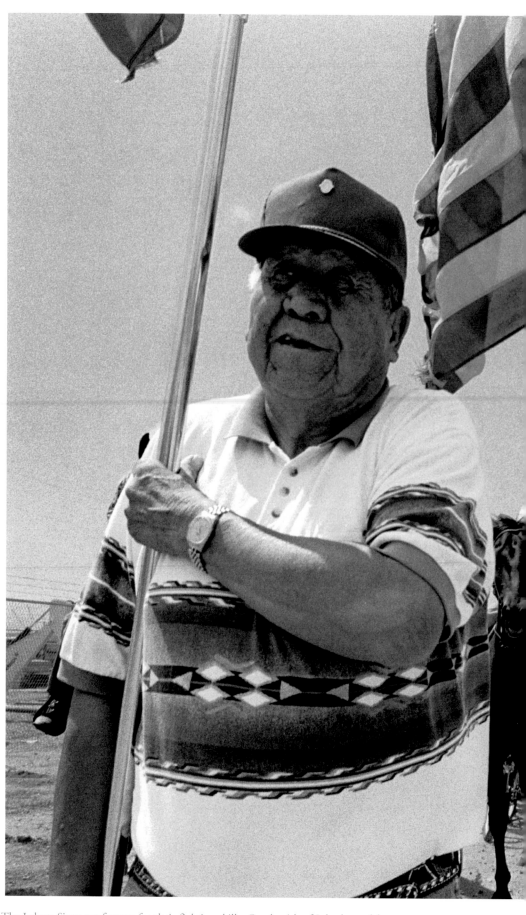

The Lakota Sioux are famous for their fighting skills. On the 4th of July they celebrate their warrior status as Indians and as proud veterans of the U.S. military.

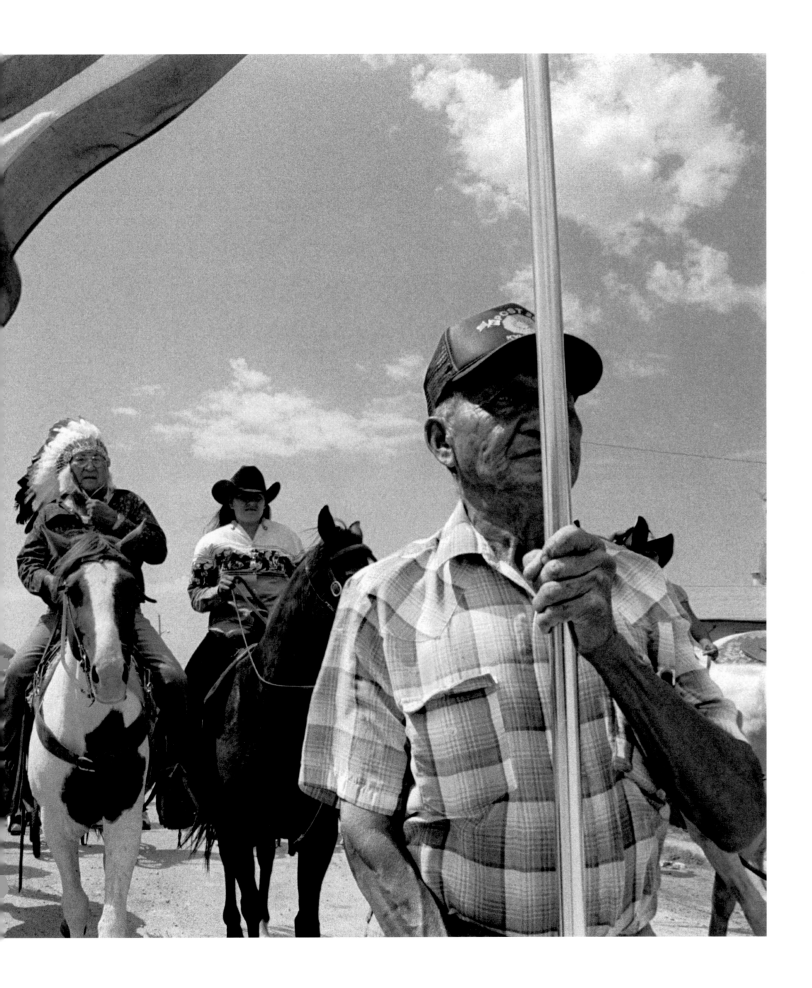

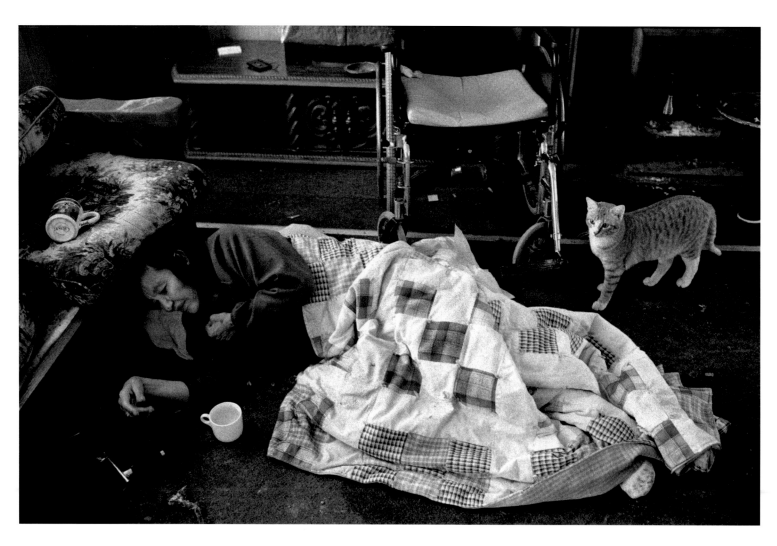
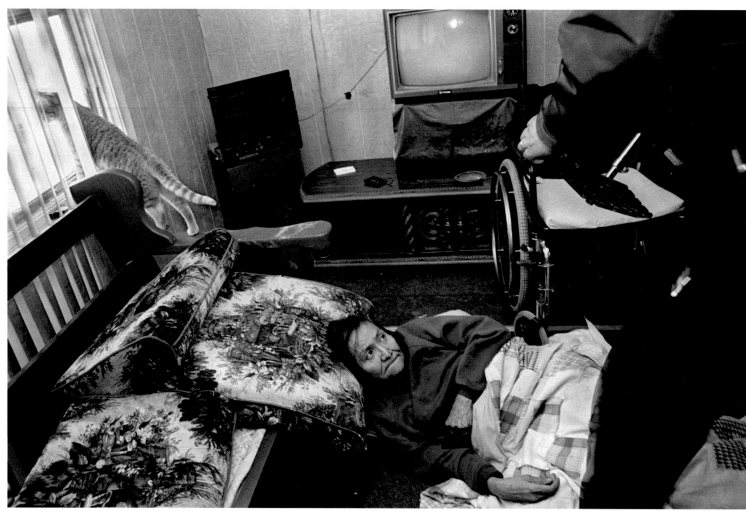

While making the rounds with Meals-on-Wheels, we came across another unfortunate elderly soul on the reservation. Behind the unlocked door of a small, white house, Lucille Bull Bear was passed out on her living room floor. She was semiconscious, curled in a fetal position next to her wheelchair, her diaper strewn on the floor nearby. The kitchen table was piled with Budweiser cans and the ashtrays overflowed with cigarette butts. On the counter, USDA rolls of ground bison had been left out so long that they had started to bleed, leaving a crimson streak on the Formica. It appeared that Lucille, her son, and a group of his friends had indulged in a night of partying. Her son and his friends were long gone, but Lucille didn't recover so easily. Ed got her a glass of water, but she refused to drink. She wanted to be left alone.

It was below zero outside, so we reported Lucille's condition to the tribal health authorities. An hour later she still hadn't moved. Her food sat untouched and nobody had come to help her. We finally called 911. The ambulance churned its way through the mud that lined Lucille's driveway. When the emergency medical technicians entered through the front door, Lucille barked, "Go away. I'm not goin' no place. I have to die first."

A big, burly Indian told Lucille he had a court order to place her under public guardianship. "I'm going to tell the judge you're forcing me," she yelled. "I'm not goin' to no old age home. I'm goin' to overdose myself." The health workers hoisted her against her will onto a stretcher and collected all her medications in a plastic bag. Lucille was taken to a nursing home off the reservation, where she got medical attention and plenty of detox time. When Ed visited her there several months later, she was doing so well she was unrecognizable.

opposite, top: Lucille Bull Bear was left stranded on her living room floor after a night of drinking.
bottom: An ambulance eventually comes to take her to the hospital.

105

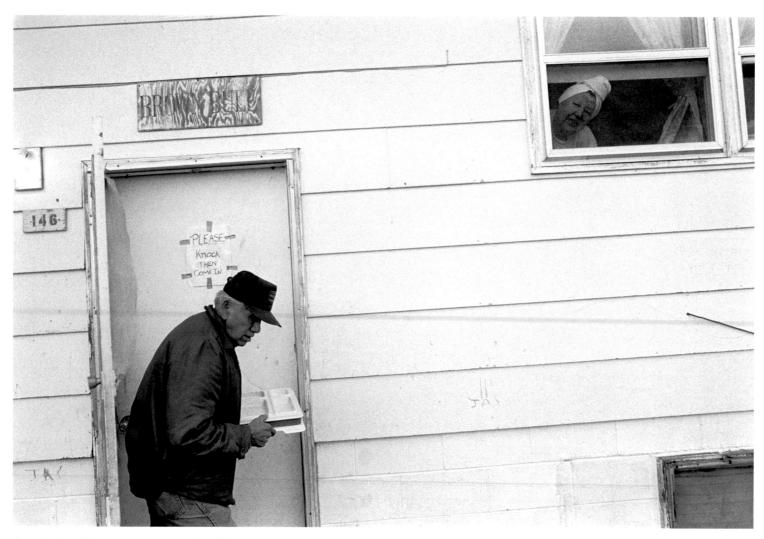

Oscar Jealous of Him, a senior citizen himself, delivers meals to housebound elders.

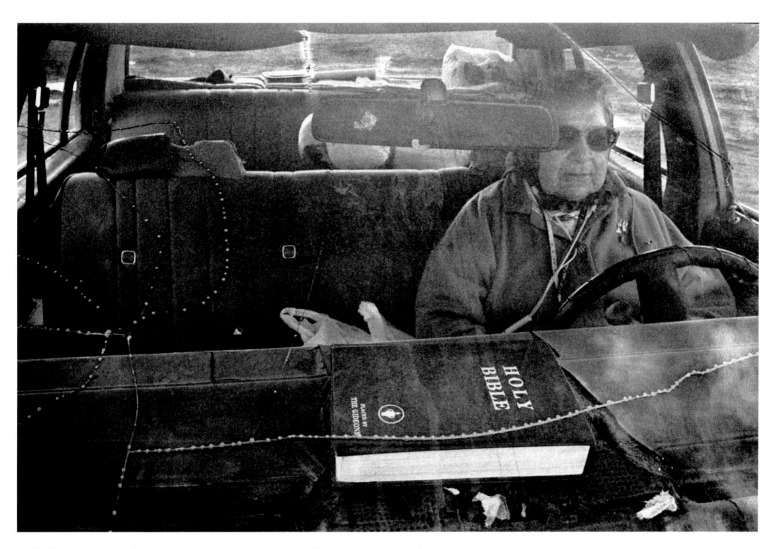

Lilly May Red Eagle, a devout Episcopalian, is an outspoken elder who talks on a weekly
radio show for seniors. She also works in a Headstart program as a foster grandparent.

Wednesday is eviction day in San Francisco, a city where the economy lives in the stratosphere and the elderly can scarcely afford to leave their homes. When real estate values soar, the elderly become vulnerable. Their low-rent apartments, the ones they've occupied for decades, become the front line of a turf war.

Most elders who face eviction don't wait for the Sheriff's Department to come knocking on their doors; they resettle before events turn tragic. But the Sheriff's Department in San Francisco is better prepared than most to handle the worst-case scenarios through a unique, progressive program. They assist with everything from contacting social service agencies to hauling possessions down the street in shopping carts if necessary. By the time Wednesday rolls around, there's no alternative but to move on. But to where?

IN SAN FRANCISCO, WHERE REAL ESTATE
PRICES RANK NUMBER ONE IN THE NATION,
SOME **500 ELDERS ARE EVICTED EACH YEAR**.

opposite: An elderly resident being evicted from his home is assisted by the San Francisco Sheriff's Department.

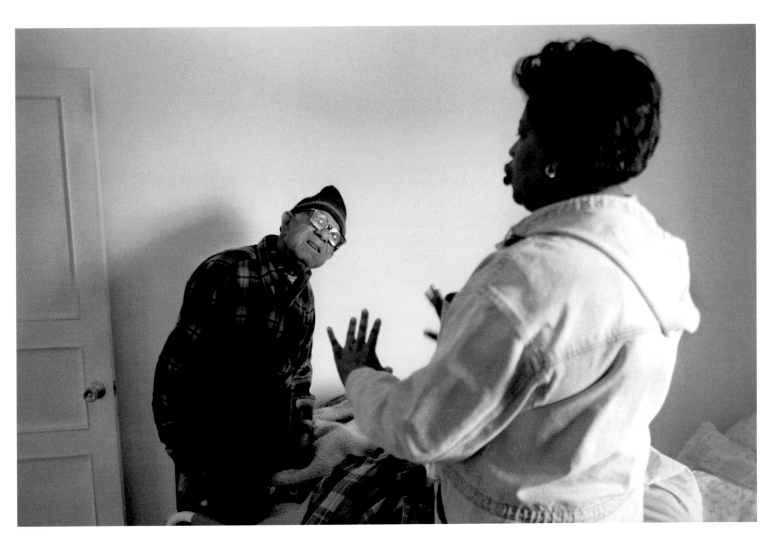

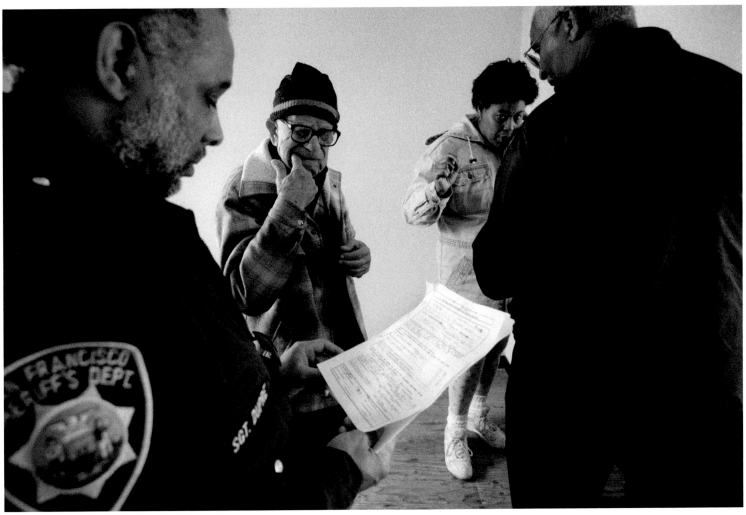

There's an unspoken pact concerning veterans which says that in exchange for serving their country, their country will always serve them. But how can America make good on its promise when more than half of all men over sixty-five are veterans? That's exactly the dilemma the U.S. Department of Veterans Affairs is facing. In addition, rising drug costs have sent veterans to seek VA assistance in record numbers. In recent years, the VA has been forced to kick Alzheimer's patients out of nursing homes and schedule thousands of doctors' appointments three years in advance because their services are strained.

In an attempt to stave the flood, the VA is working more closely with community medical clinics and moving away from bricks-and-mortar-based care. One innovative program, Home Based Primary Care, has been helping veterans in the Washington, D.C., area to "age in place." By providing home visits from nurses, dieticians, physicians, occupational therapists, and social workers, the program defies the traditional model of institutional care and makes good on the nation's social contract with its war veterans.

opposite: Nurse Joan Trelease helps veteran Bob Ray stretch his limbs during a Home Based Primary Care visit.

"My son comes at least three times a week and he takes me upstairs and I get a shower. If I have a fall, I don't have nobody I can contact.

"I don't like to sit outside by myself because of people walking up and down. I don't know what they might try to do to me. I had an attempted break-in one time while I was sittin' here. I had the door locked. They tried to get in the back, but they couldn't. That's why I'm kind of scared sittin' out there by myself.

"The only benefit I have is TV. I don't get out to go nowhere, to see nothin'. I try to get somebody to come by once in a while to take me out for a short ride. When my wife was livin' she had two, three people comin' to see her every day. Now ain't nobody comin' around to visit. I had one brother tryin' to come around a little more than the rest do, but he's givin' me excuses. 'I'll be there. I'll see you in a little while,' and all that. I been tellin' 'em you can't keep on promisin' me you gonna' come. Somethin' gonna happen and it'll be too late.

"I have a family as large as two hundred and fifty. We all get together once a year at the family reunion. But since I stopped gettin' out, I hardly see any of them."

James Bowlding

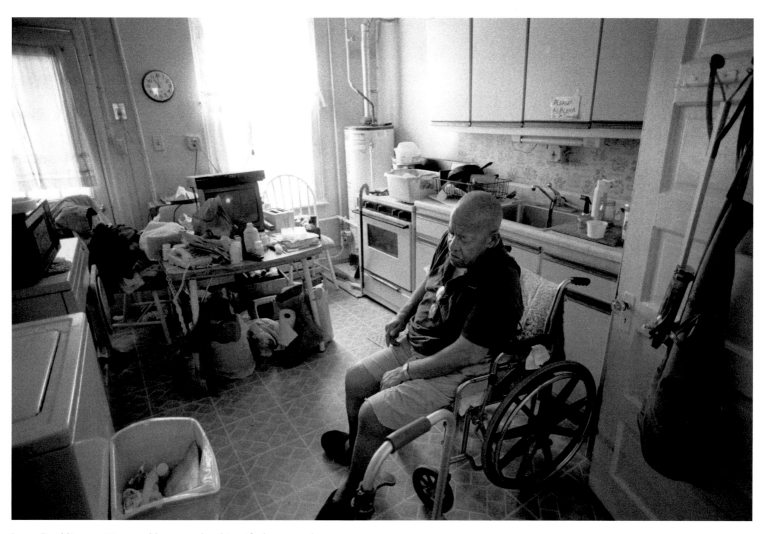

James Bowlding, an 81-year-old veteran, lost his wife three months ago.

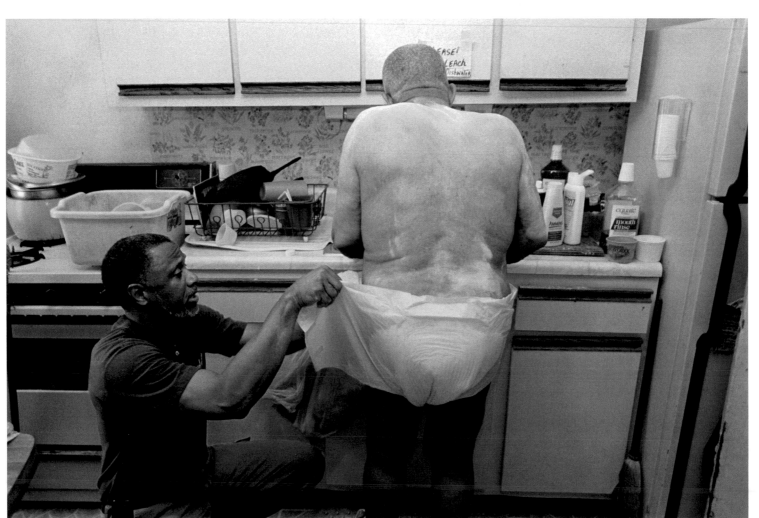

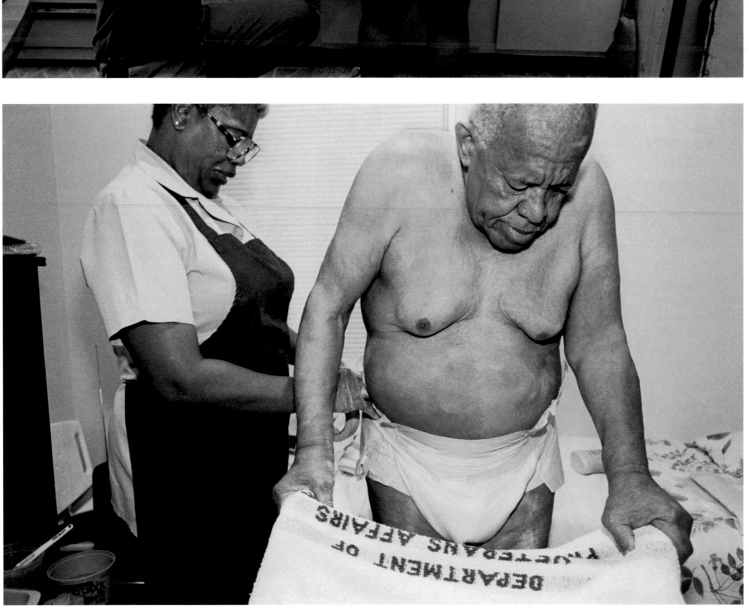

Other than two stints in the navy, James Bowlding has lived in the same neighborhood for his whole life—first in his family home, and then two blocks away in the house where his wife grew up. Just three months ago his wife died, leaving him completely rudderless. Through his tears and his stroke-paralyzed lips, he can barely form the words to express his pain.

Mr. Bowlding suffers from multiple ailments: high blood pressure, arthritis, hypertension, and the aftereffects of a stroke. He can't bathe or cook for himself, and he is completely dependent on others to take him out—or even up the stairs in his own home. His son, shown at top left, leaves work early to bathe and dress him. Like the majority of America's elders, he has aged in place, but he is quickly approaching the point where independence seems unsustainable.

For the past three years, the VA has sent home health aides and nurses several times a week to Mr. Bowlding's house, and he has had dinner delivered six days a week by Meals-on-Wheels. But once his wife died, even these support systems weren't sufficient. It quickly became apparent that Mr. Bowlding could no longer live alone. The VA's home healthcare team considered antidepressants to get him through the toughest part; they then intervened with family members to find an alternative living arrangement for him. He eventually moved in with his grandson's family, who receives nine hundred dollars per month from the rest of the Bowlding clan to help with the expenses.

opposite, top: James Bowlding's son, Michael, comes to his house to bathe and dress him.
bottom: As part of its Home Based Primary Care program, the VA sends a home health
aid to care for James Bowlding several days a week.

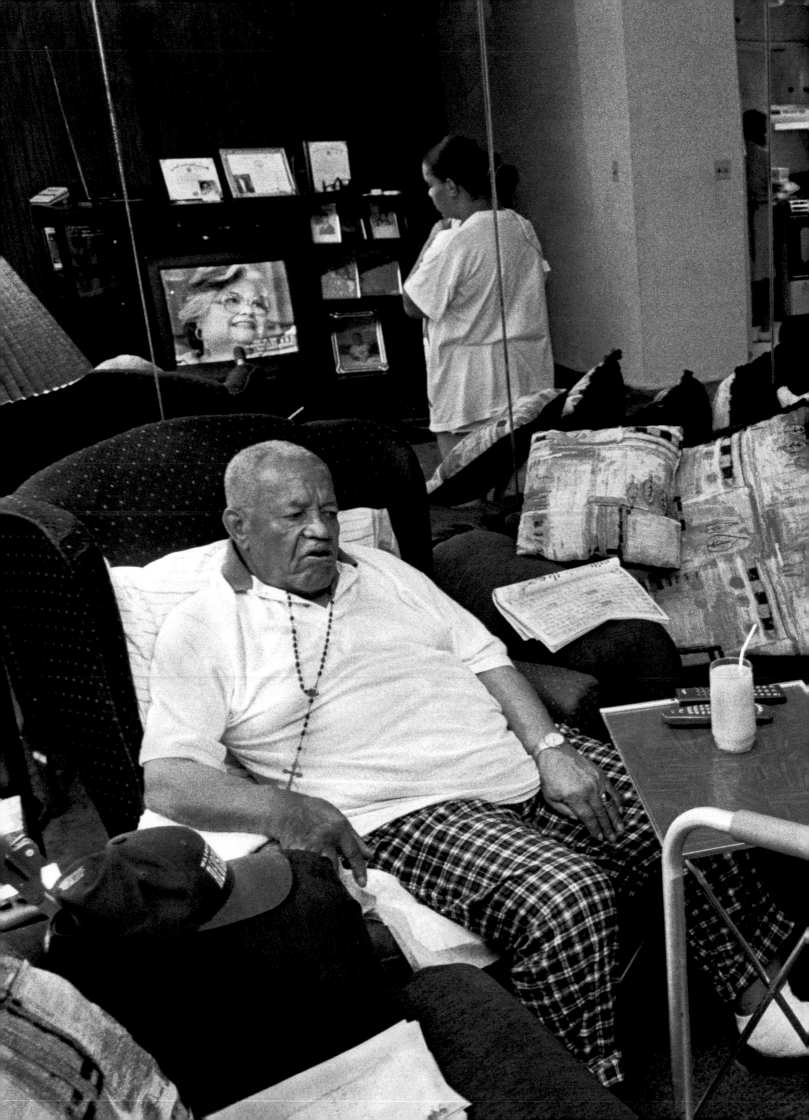

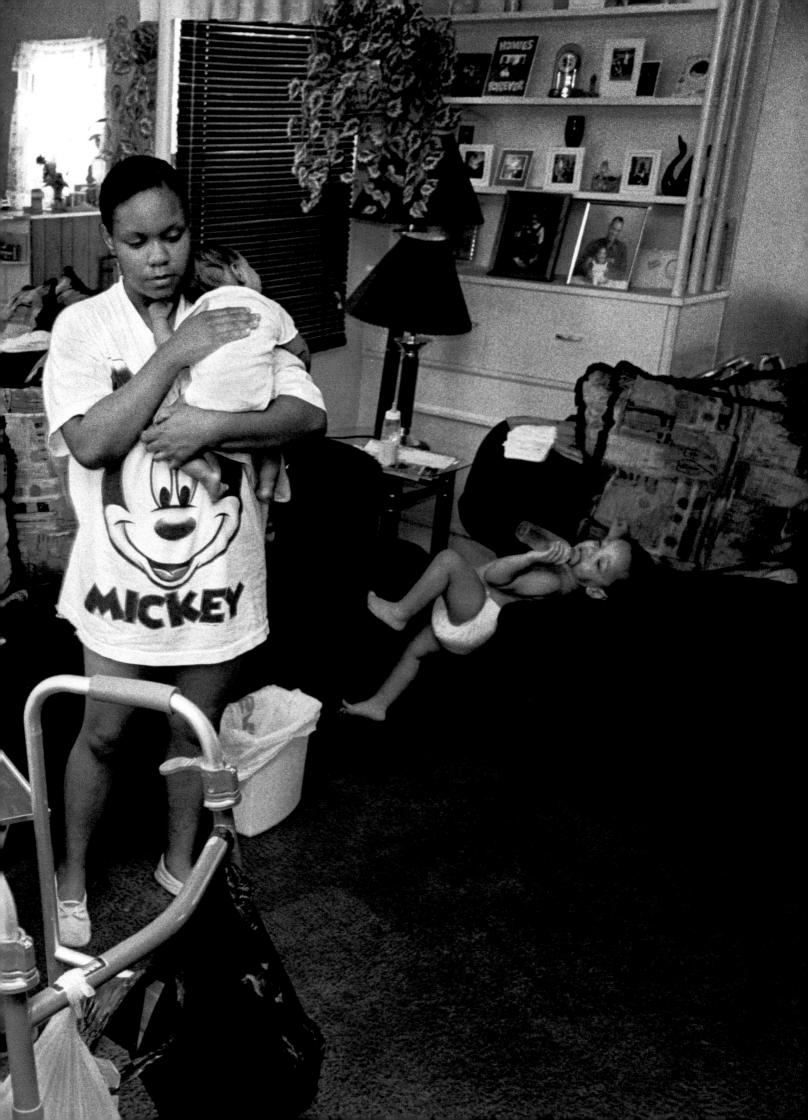

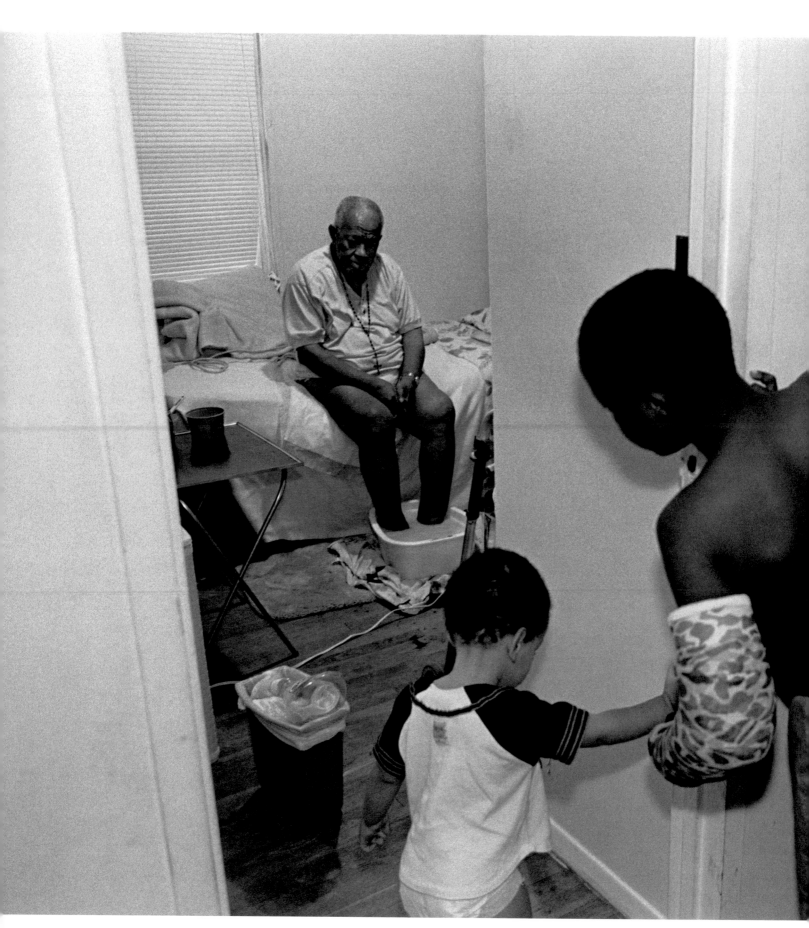

James Bowlding eventually moved into his grandson's house because he couldn't manage on his own.

AFRICAN AMERICANS, ON AVERAGE, DIE
6 YEARS YOUNGER THAN CAUCASIANS.

WHILE ONLY 9% OF WHITE OLDER
AMERICANS LIVE IN POVERTY, 26% OF
BLACK OLDER AMERICANS ARE POOR.

"Though I am a double amputee and confined to a wheelchair, I am not despondent. Each morning following my bath, I say a silent prayer for this is new beginnings. I don't worry about what I can't do, but I do what I can do. That's my creed.

"Unfortunately, some of us develop Alzheimer's or Parkinson's disease, but we are all human. We should be respected like that. We have paid our dues. Regardless of what we did in our early life, we did the best we could. Seniors should be respected. We're not asking for love—all we're asking for is care. A few minutes a day, a cheerful smile goes a long ways."

William Scott

AMERICAN BUSINESSES LOSE AN ESTIMATED **$11 BILLION** EACH YEAR **ON LOST WORK AND DECREASED PRODUCTIVITY** FROM FULL-TIME EMPLOYEES WHO ARE **CARING FOR OLDER ADULTS**.

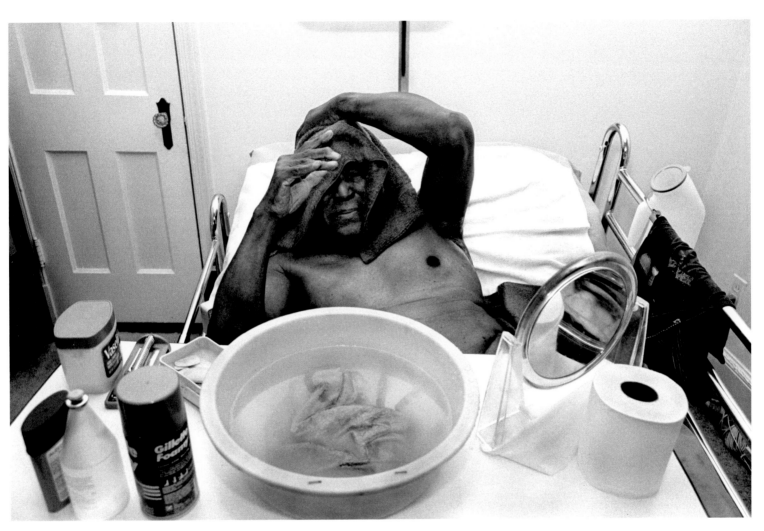

When William Scott became a widower, his son, William Jr., moved into the apartment downstairs from him.
William Jr. wakes up at 3 A.M. each morning to bathe and dress his father before he leaves for his government job in Virginia.

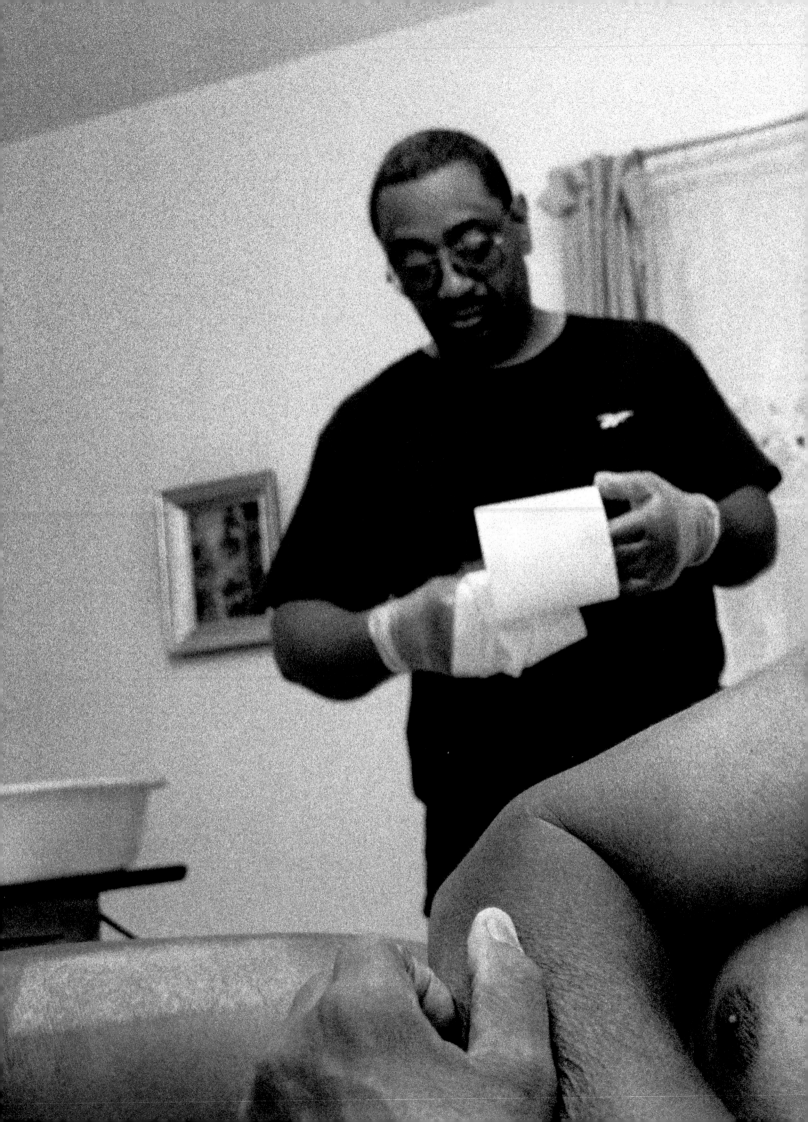

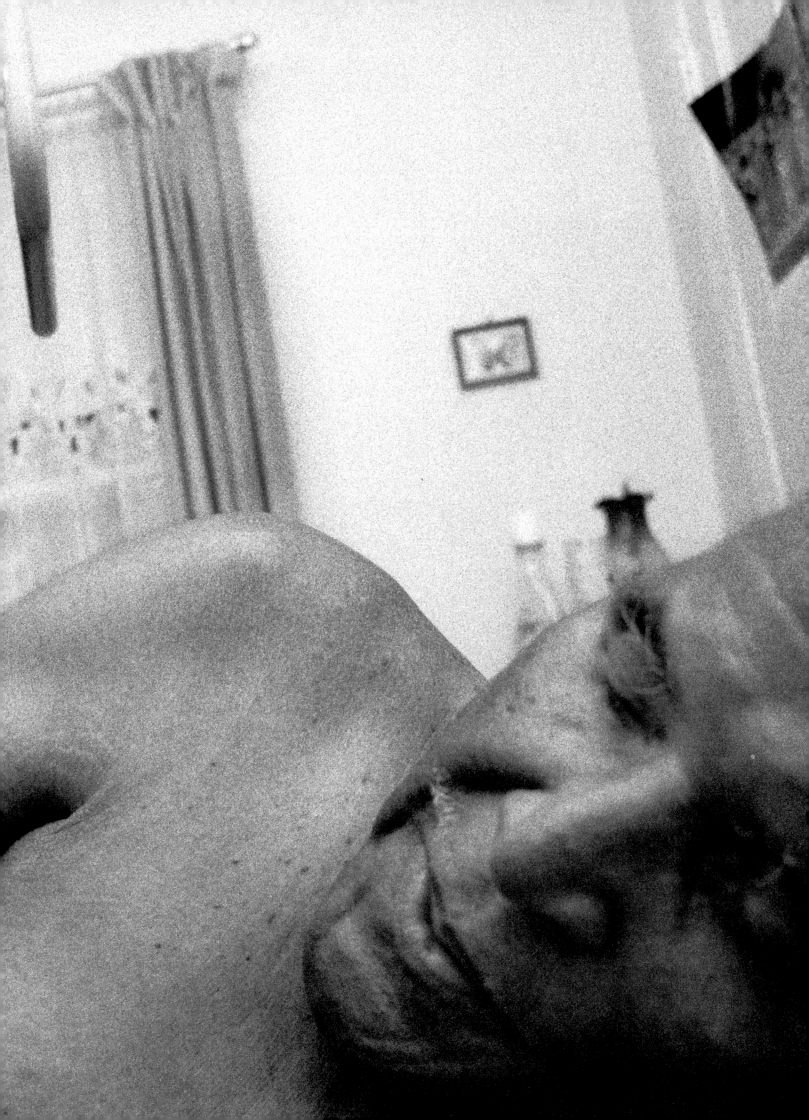

William Scott, 83, is a WWII veteran who relies on the the VA's Home Based Primary Care service in Washington, D.C.

80% OF ELDERLY AMERICANS WHO NEED LONG-TERM CARE **LIVE AT HOME** OR IN COMMUNITY-BASED SETTINGS.

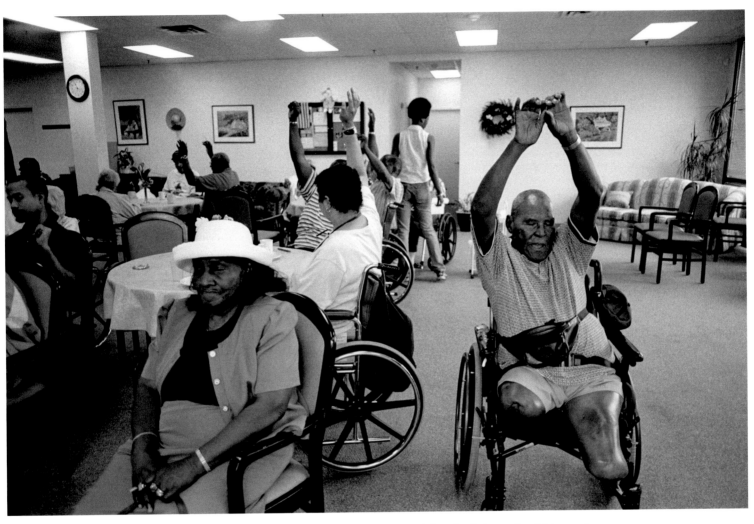

The VA sends William Scott to the We Care daycare center in Maryland three days a week for stimulation and social interaction.

"When I first started going up to the Peters' farm, she was able to get around some. Believe it or not, she was able to walk with a walker until a year ago. Now she can't make a step. She got arthritis so bad she can't hardly move. She's completely helpless. She can't move her arms. She can't turn her body. She can't do anything.

"The doctor was wantin' to put her in a rest home, and of course she didn't want that. They were going to force her husband out of the house and take her against her will. The doctor did say that if they had someone twenty-four hours a day, she could stay at home. I said, Pap, why don't we tell him that Dolores (the paid caregiver) is going to be here in the daytime and I'm going to stay with you the rest of the time. So that's what we done. And it's been that way ever since.

"I don't think she would get this kind of care in a rest home that she gets here now."

Warren Dewitt

opposite: Maxine Peters, 90, suffers from Alzheimer's, Parkinson's, and arthritis.

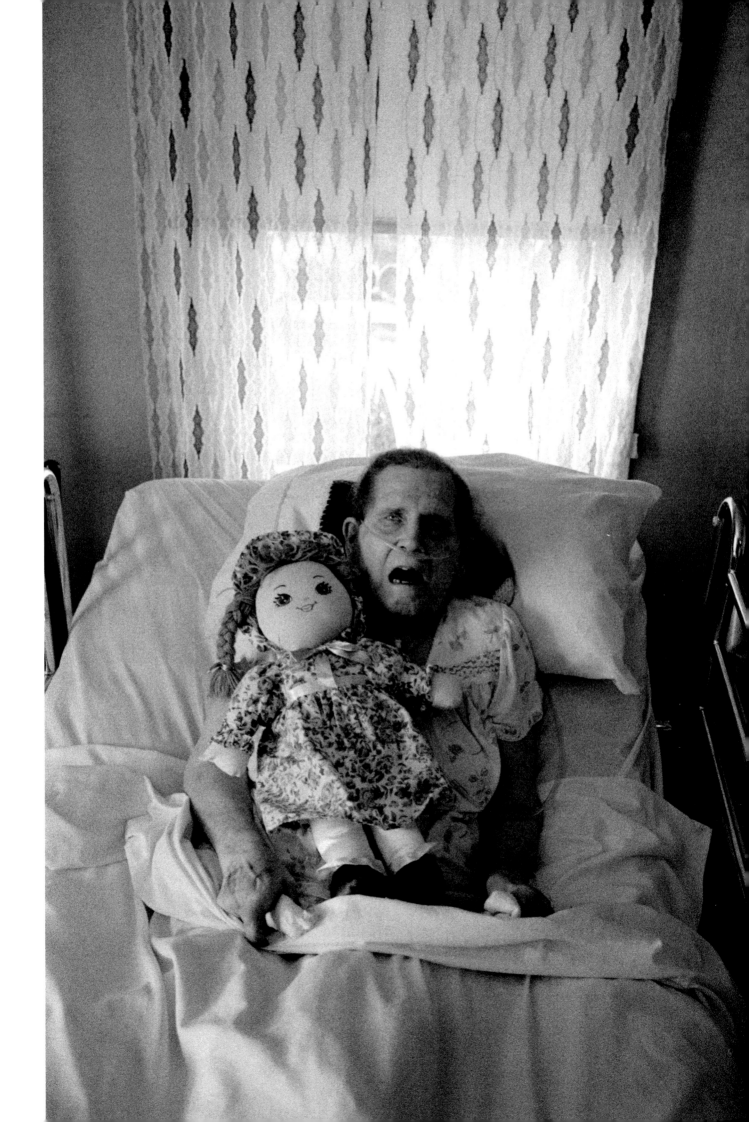

Warren Dewitt (right) helps Arden Peters shop in the Wal-Mart where they met.

Warren Dewitt, seventy-six, lives with Arden Peters, ninety, and his wife in the couple's West Virginia farmhouse. For more than a year Warren has lived with the Peters, cooking, cleaning, and maintaining the grounds and the residents inside. "I'll never leave him," says Warren, who himself suffers from back and heart trouble.

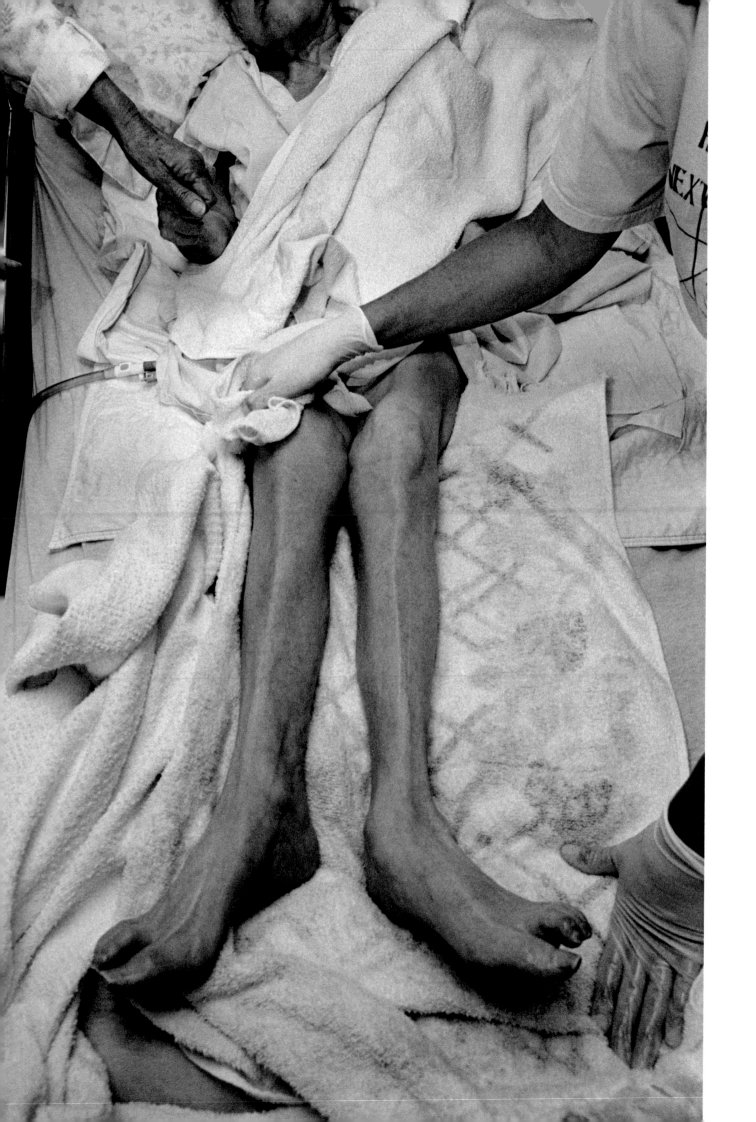

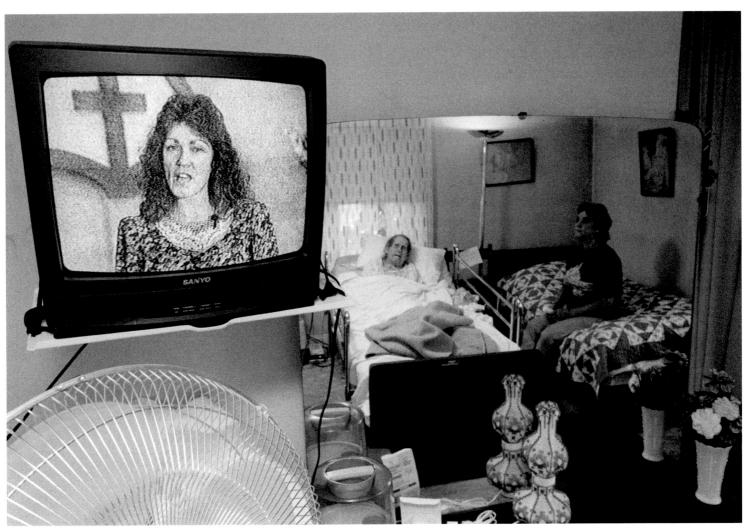

The Peters pay out-of-pocket for full-time caregivers. Last year it cost Arden $30,000 to run his home, most of which was spent on Maxine's care.

ONE OUT OF EVERY FOUR HOUSEHOLDS IN AMERICA ARE **INVOLVED IN FAMILY CARE-GIVING** TO ELDER RELATIVES OR FRIENDS.

opposite: Maxine Peters' legs and feet are ravaged by arthritis.

At Wal-Mart, Arden waits with Warren for a prescription to be filled.

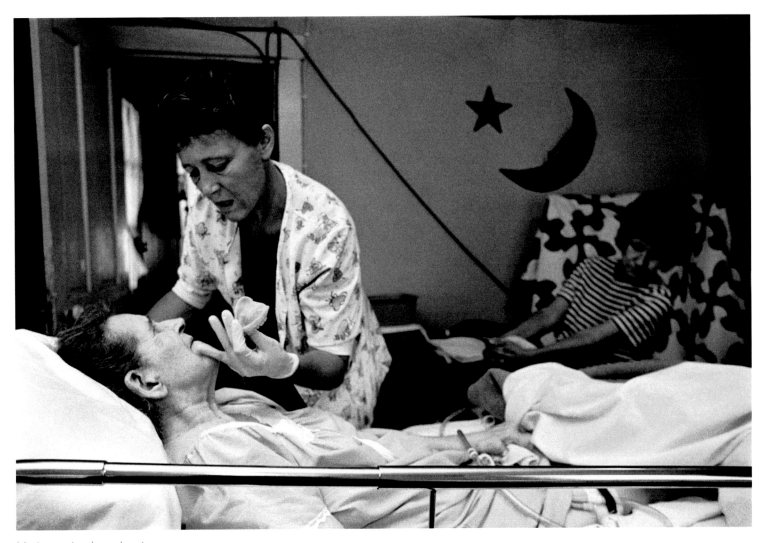

Maxine receives home hospice care.

THE TOTAL NON-REIMBURSED MONTHLY
EXPENSES FOR NON-SPOUSAL FAMILY
CAREGIVERS IS **$196 BILLION**.

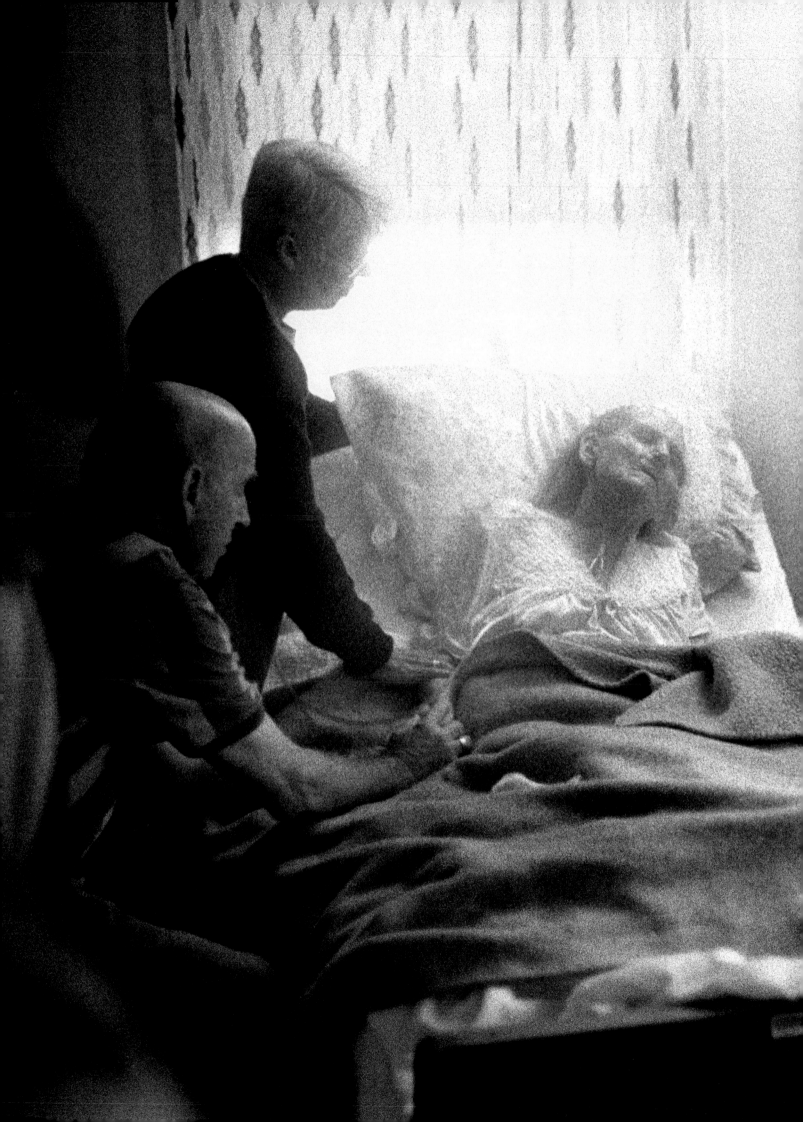

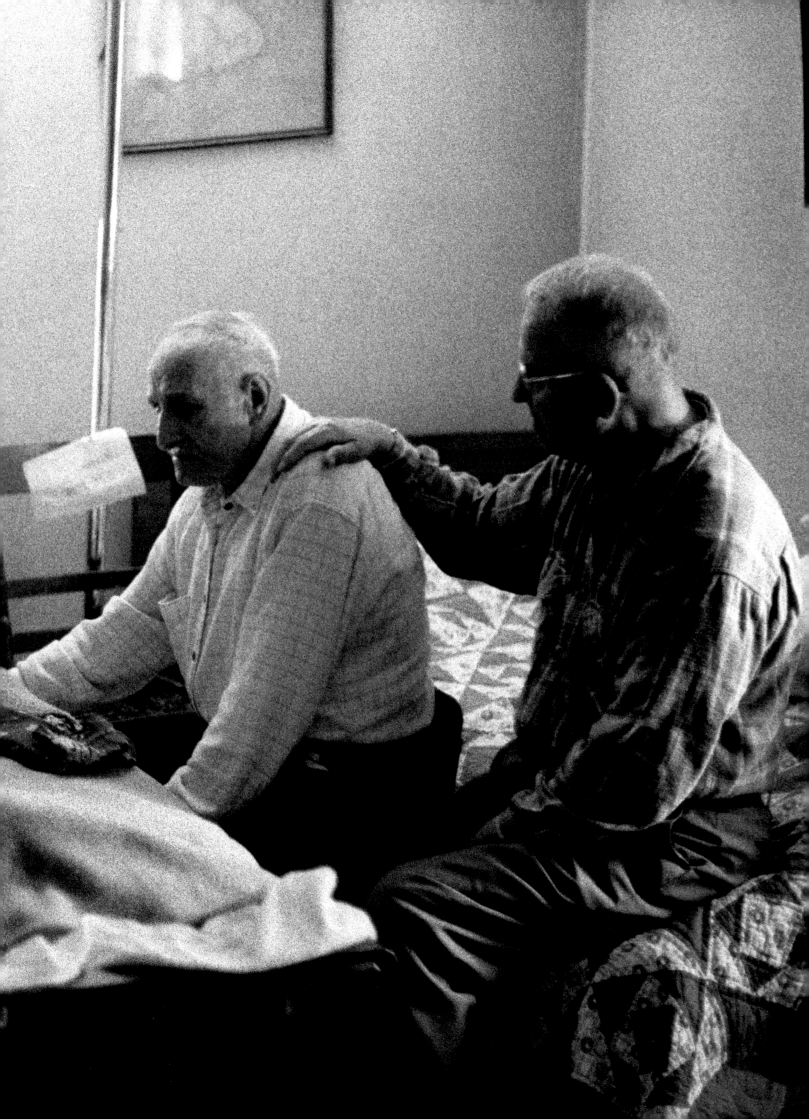

The night Maxine died, Ed slept in the bed where she had laid dying only a few hours before. Just inches away, Arden had a peaceful sleep and rose from bed before the sun came up. He claimed it was the best sleep he had had in years. Before she passed away, Maxine's last words to Arden were, "I love you."

previous pages: Maxine Peters died under the best possible circumstances—surrounded by family and friends at home.

OLDER AMERICANS HAVE A SIGNIFICANTLY **DISPROPORTIONATE SWAY** ON THE POLITICAL PROCESS. THEY HAVE THE **HIGHEST VOTER TURNOUT**, ARE THE MOST LIKELY TO **WORK ON A POLITICAL CAMPAIGN**, AND ARE THE MOST LIKELY TO **CONTRIBUTE MONEY** TO A CAMPAIGN. CONTRARY TO POPULAR BELIEF, SENIOR CITIZENS **DON'T VOTE AS A BLOCK**.

Behind bars—doing time where it stands still. Life is a sentence and longevity means eternity. America's war on crime has found its fiercest ammunition in tough sentencing laws. But in our enthusiasm to throw away the keys, we failed to recognize that longevity affects both the free and the caged; it penetrates even the highest security prisons. In fact, the increased life expectancy has stretched prison sentences so long that prisoners grow thin, arthritic, and demented.

The end of the twentieth century saw the growth of the geriatric prison ward, like this one at the Hamilton, Alabama, Prison for the Aged and Infirmed. Like many of these facilities, overcrowding is already a problem. Hamilton A&I was originally built to house seventy inmates. It currently holds three hundred prisoners, which is only a portion of the looming demand.

THERE ARE CURRENTLY MORE THAN **84,000 INMATES OVER THE AGE OF 50** IN AMERICA—THE **FASTEST GROWING** SEGMENT OF THE PRISON POPULATION.

A fast life on the outside and a grueling life on the inside take their toll on prisoners by accelerating the body clock. Alcohol, drugs, cigarettes, junk food, and captivity all consume the body with a vengeance. Over time, older inmates become more of a medical burden than a security risk, costing the state three times as much as younger inmates despite their diminished threat.

By some estimates, the growing elderly inmate population will cause a correctional crisis. Currently most prisons are prepared to handle acute conditions, not chronic illness, which is the main concern as inmates age.

While we have become highly effective at locking criminals up, we have no means for releasing these shadow inmates at the end of their lives. At Hamilton A&I, it is common knowledge that the only way out is in the back of a hearse. Inmates joke that Hamilton "A&I" actually stands for Hamilton "Lay & Die." When I returned there six years after Ed made these images, only one inmate he had photographed was still alive.

THE PHYSIOLOGICAL AGE OF
INMATES IS **10 YEARS OLDER**
THAN THE GENERAL POPULATION.

opposite: Prisoner Billy Dunn, 64, suffers from emphysema and throat cancer.

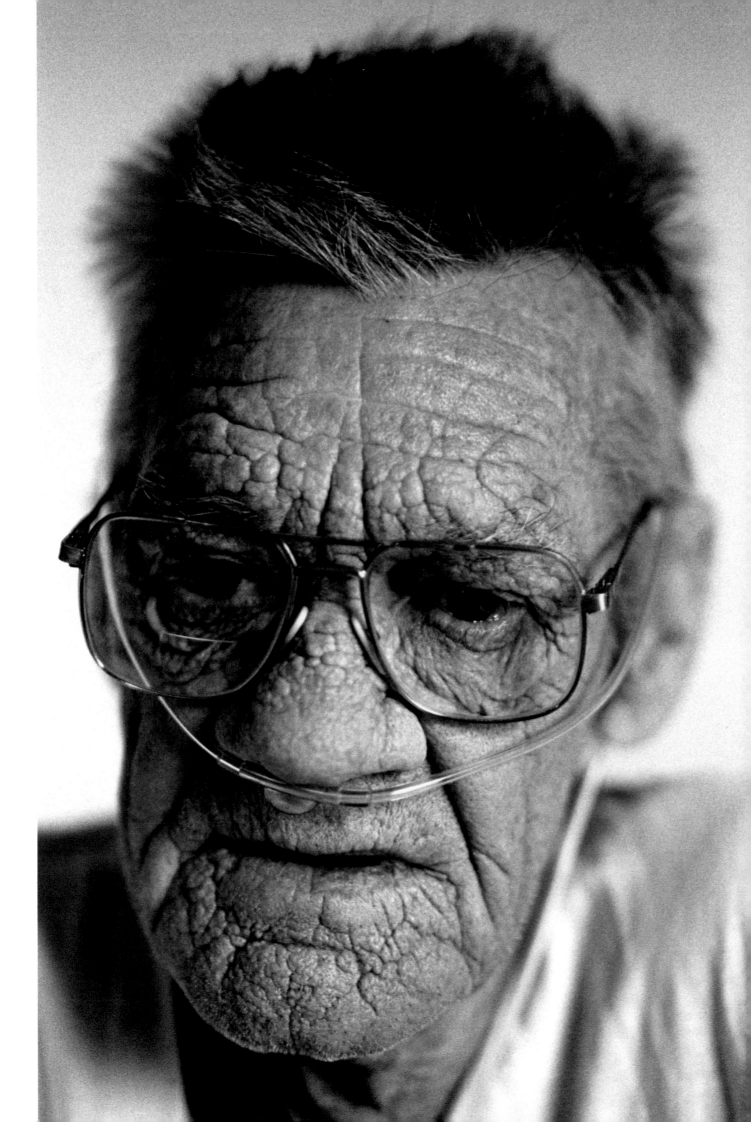

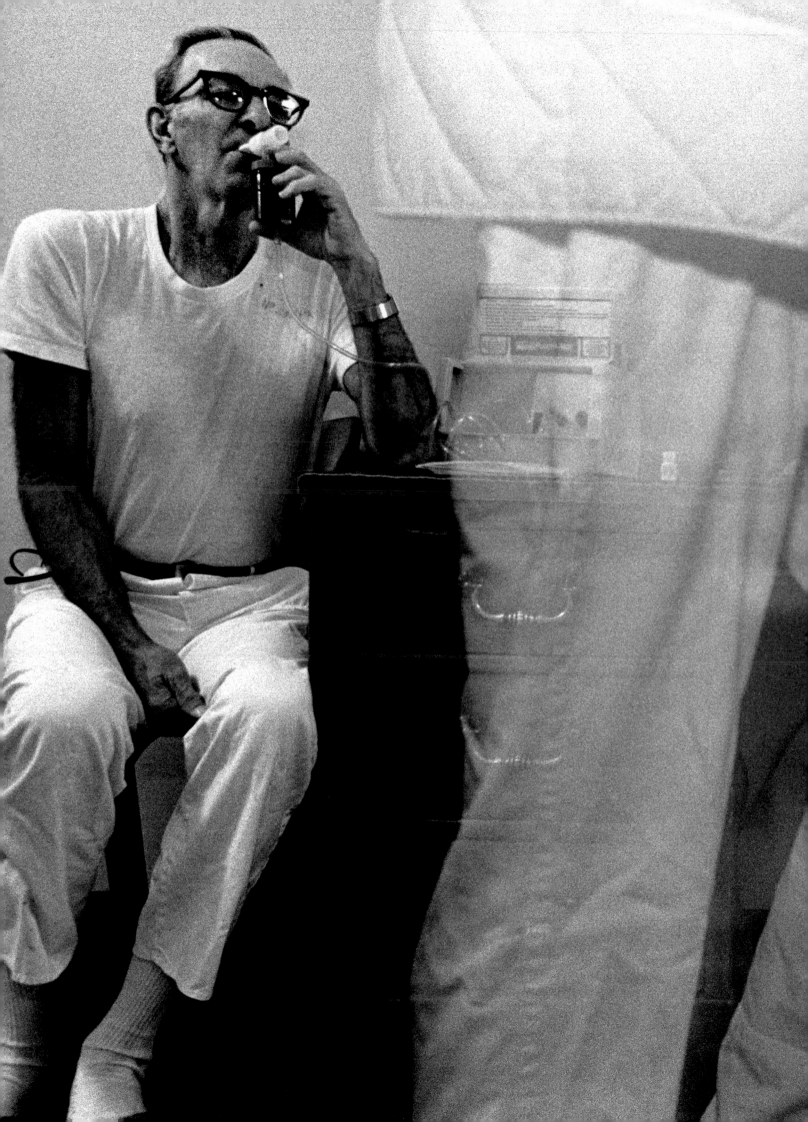

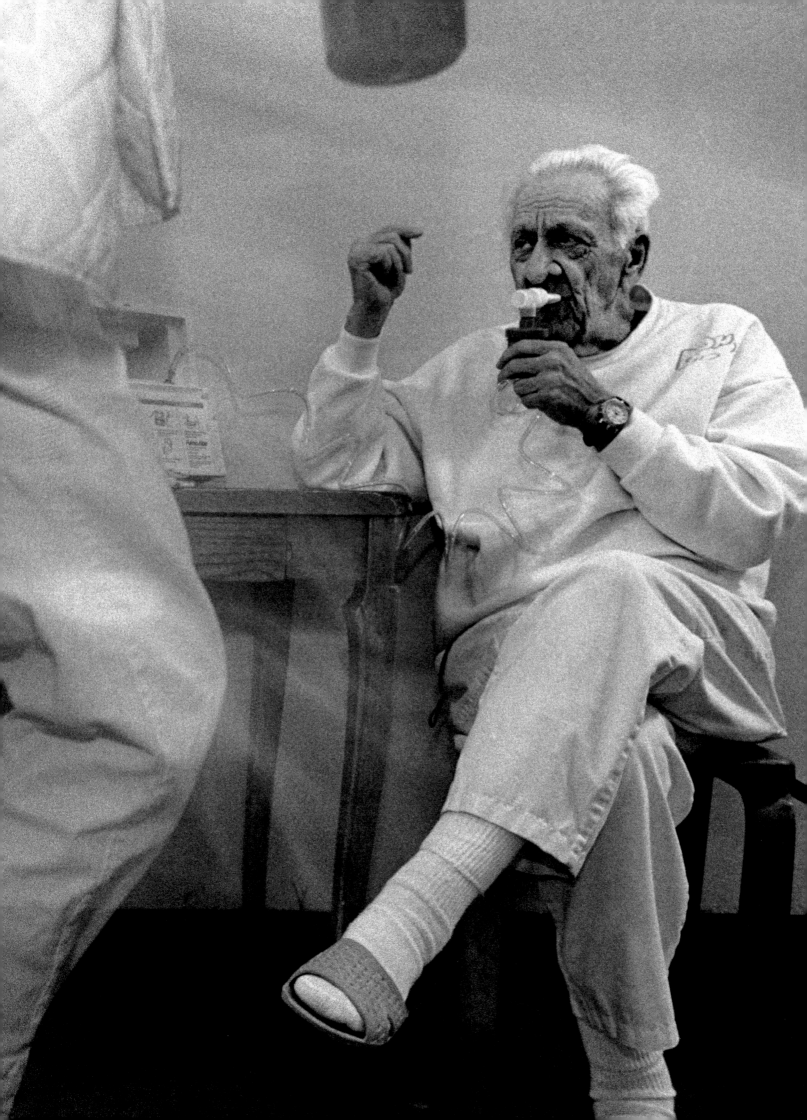

Jesse Rodriguez, 62, is blind and has been in and out of prisons since 1957. In 1988, he began serving his most recent sentence—25 years without parole for assault with a deadly weapon—in a geriatric ward in a Huntsville, Texas, prison.

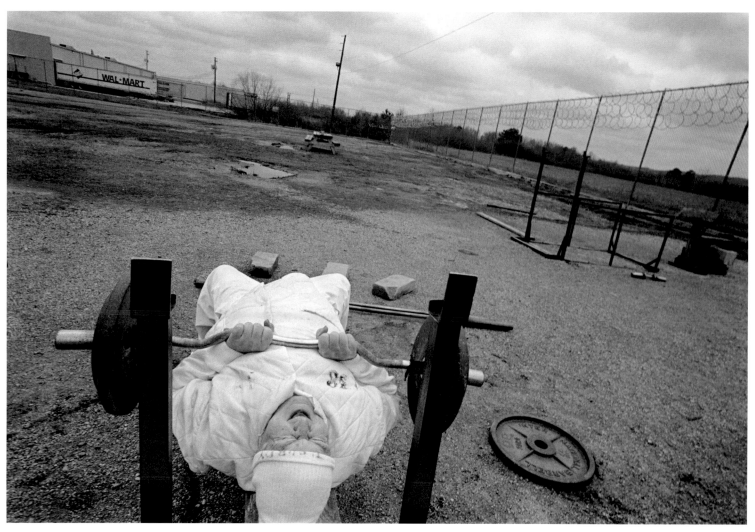

Truman Purdy, 61, is serving a 25-year sentence for sexual abuse and sodomy that began in 1992.

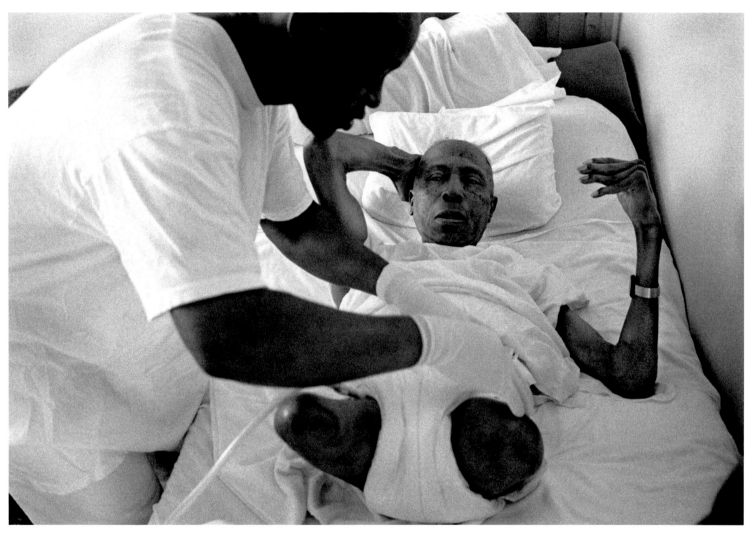

At the Hamilton, Alabama, prison for the Aged and Infirmed, a younger inmate volunteers to help take care of Adam Cook, who lost his legs to diabetes.

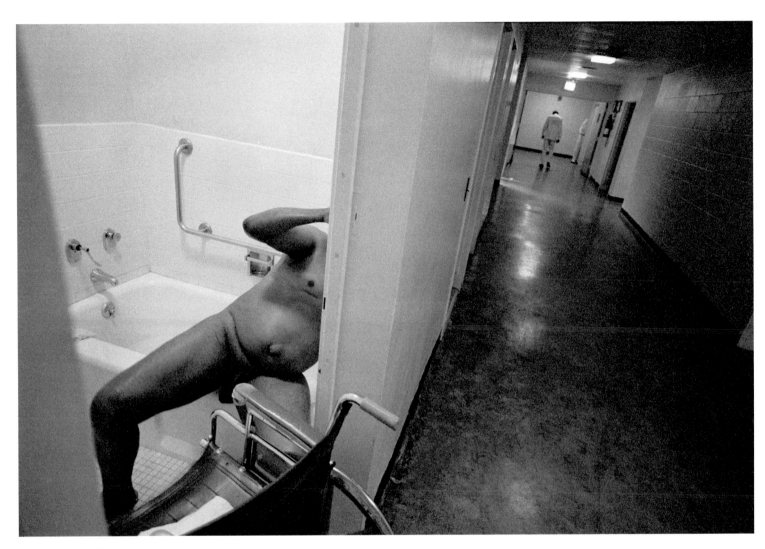

At Hamilton A&I, privacy doesn't exist.

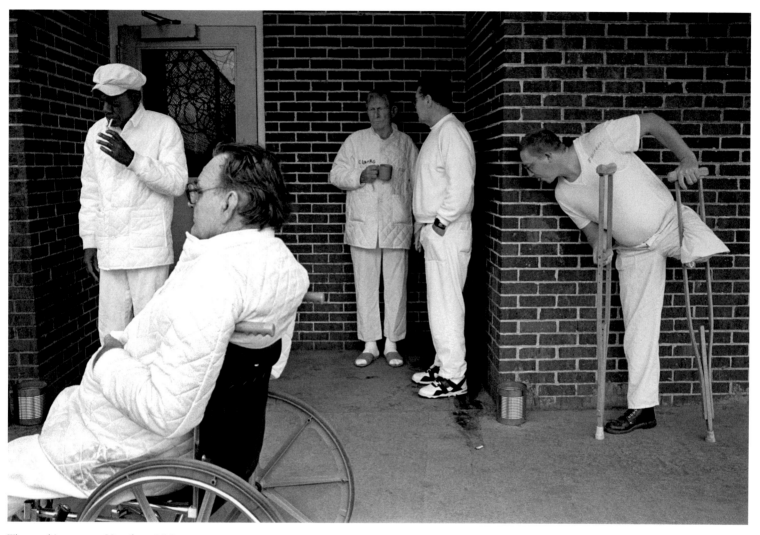

The smoking area at Hamilton A&I

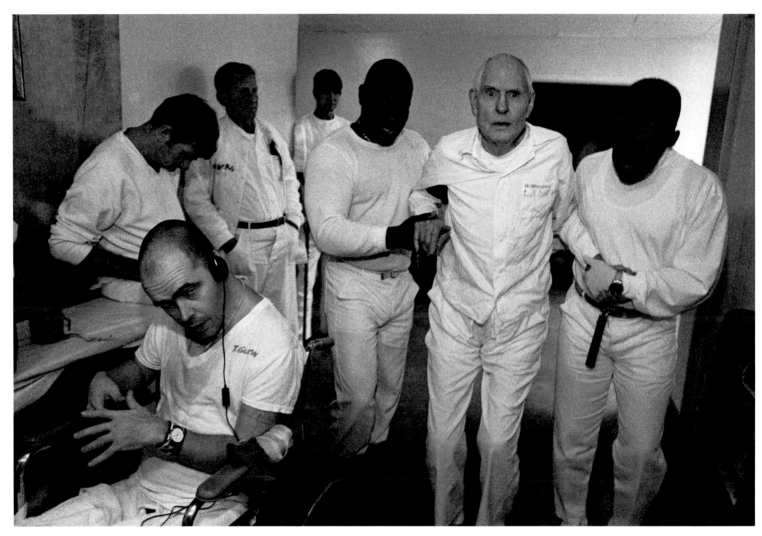

Hamilton A&I relies heavily on younger inmates who care for older prisoners.

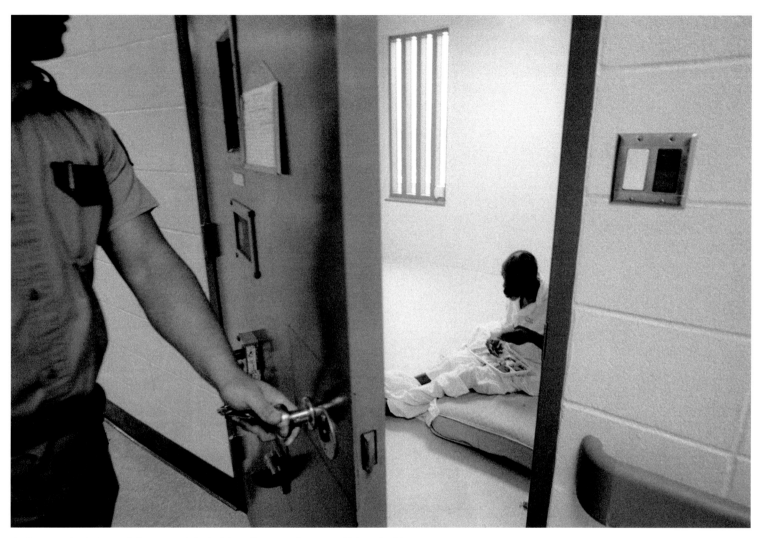

An inmate who is deemed dangerous is locked in solitary confinement. Although older inmates experience a "violence menopause," many are still hazardous to society.

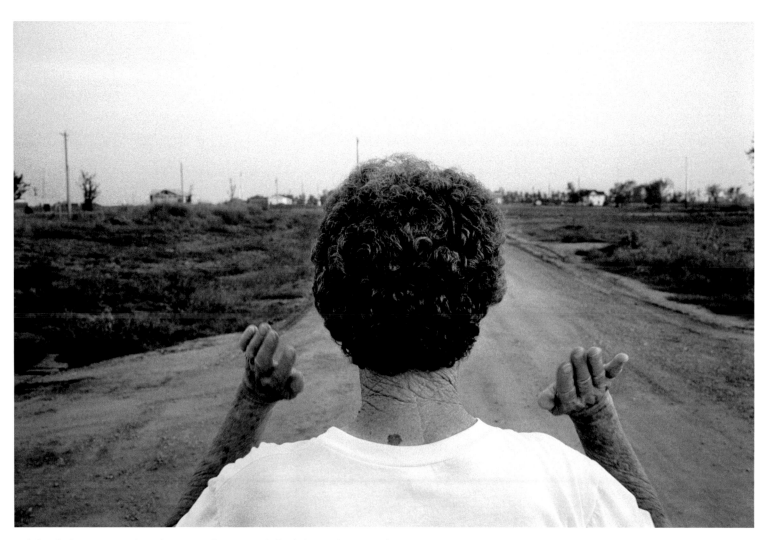

Delphia Stuby, 72, stares down her street after a tornado leveled everything in sight.
Adpoting a tornado-be-damned attitude, she was the first to rebuild her home.

May 30, 1998—A light rain fell on Spencer, South Dakota. The air hung humid like wet wool as the cows settled into the moist grass and thunder clouds drifted in from the west. These might have been auspicious signs for an ordinary day in May during the start of a good planting season, but by day's end, Spencer's residents, most of them elderly, would find themselves huddled in shelters—many of them bruised and broken, some dead.

Darkness descended that day; the light drizzle turned to heavy rain, and the sky deepened to a murky green as the wind whipped up to a ferocious speed. In its fury, it knocked out the town's electricity, leaving Spencer's only siren mute. No warning sounded when the twister, nearly half-a-mile wide, blasted across the fields and plowed directly through town at two hundred forty-six miles-per-hour. Homes were ripped off their foundations, vehicles crash-landed several blocks from where they had been parked, and bodies catapulted through the air. In a matter of seconds, Spencer was scattered into a million pieces. With six dead and one hundred and fifty wounded, Spencer experienced devastation on a biblical scale. This day in May, Spencer was nearly wiped off the map.

But truth be known, Spencer was barely on the map to begin with. If the tornado hadn't wiped out the town, old age would have. More than half of its three hundred and twenty residents were senior citizens and, like much of the heartland, the way of life there had been in steady decline for years. Even before the tornado demolished the town, Spencer was a metaphor for decimation. Abandoned businesses, random junk heaps, and shady residents who made short stay of their time in Spencer had all turned the place into a lost outpost. The town was beloved by some, forsaken by most.

In McCook County, where Spencer is located, small farmers are going bankrupt as quickly as the seasons change, and families are regularly forced to sell off land just to survive. With little or no industry to keep younger people employed, the population of Spencer is literally shriveling up.

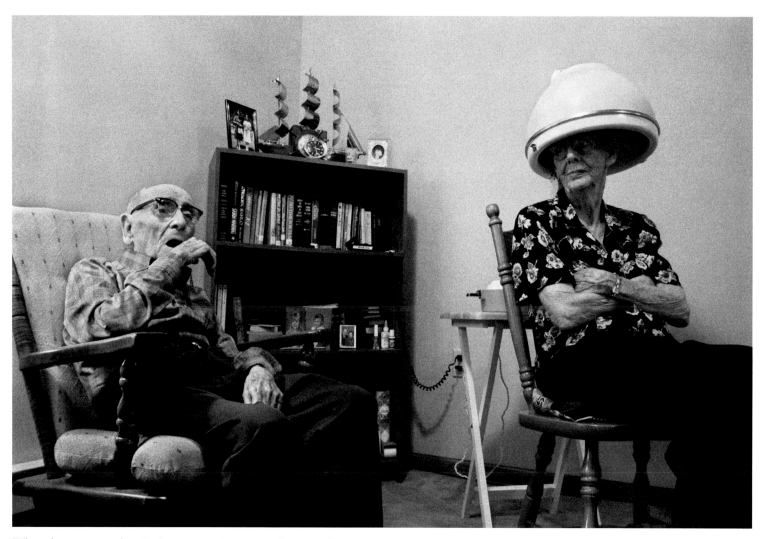

"The only property we have in Spencer now is two graves," says Lucille Mone.

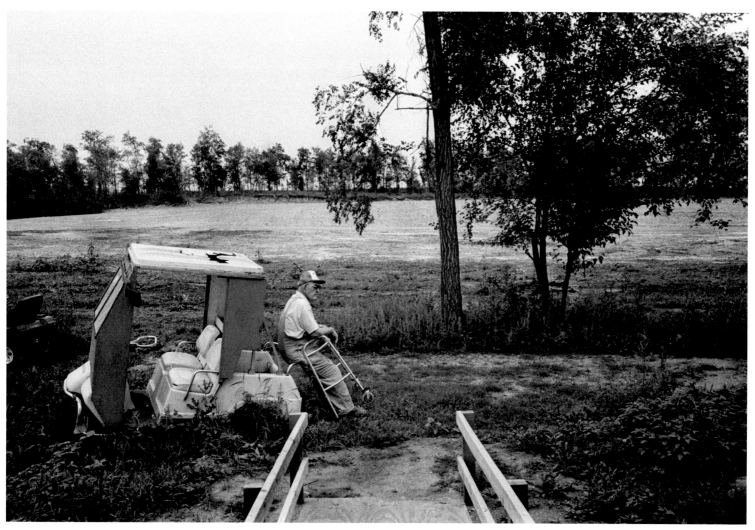

Marvin Wilson, 94, has the only house left standing on the south side of town.

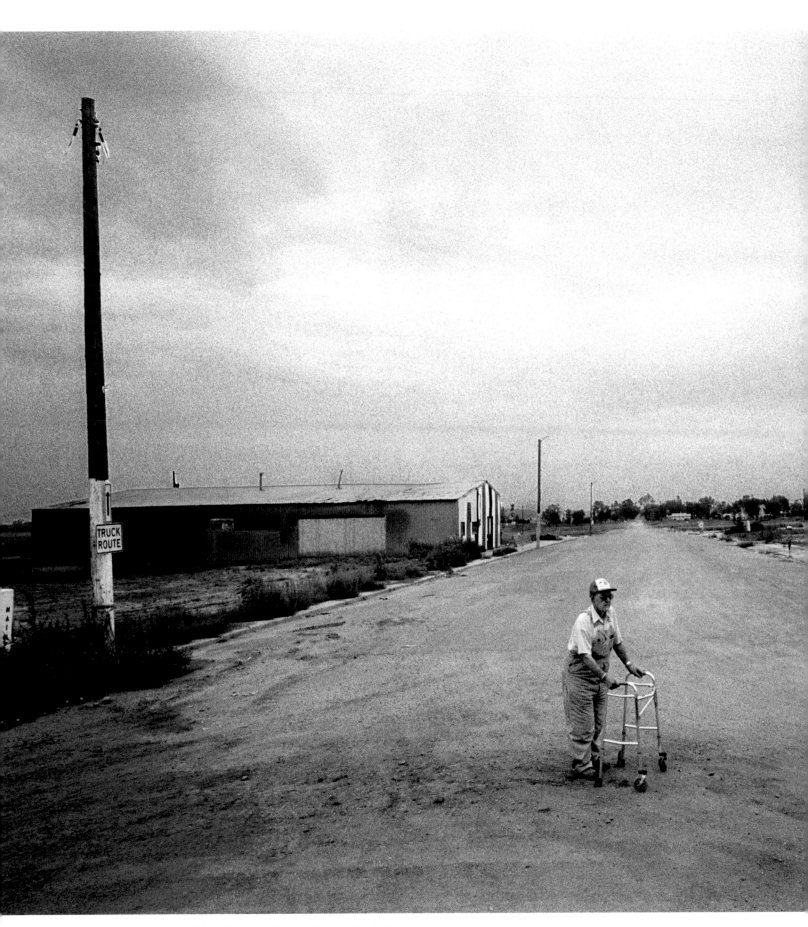

Marvin Wilson surveys what is left of downtown Spencer just two blocks from his home.

Marvin Wilson, ninety-four, moved to Spencer more than thirty years ago. We found him in the lobby of Colonial Manors, a nearby nursing home where he was waiting out repairs on his home. He sat slumped in his wheelchair, waiting patiently while "Weed of the Week" played on the big-screen TV in the corner. We signed him out at the front desk and drove the ten miles back to town.

Weeds had overtaken the driveway to Marvin's six-bedroom home, and he struggled mightily with his walker to reach the front door. With the help of a cleaning lady and neighbors who did his grocery shopping, Marvin had lived there alone since his parents died fifteen years ago. He was determined to continue living there on his own, but most of the folks who used to help him were gone now. With no grocery store in Spencer, he didn't know how he would get food. With no café, his daily routine was history. With no neighbors, his solitude would be magnified.

Marvin, the consummate loner, admitted that nursing home life had grown on him.

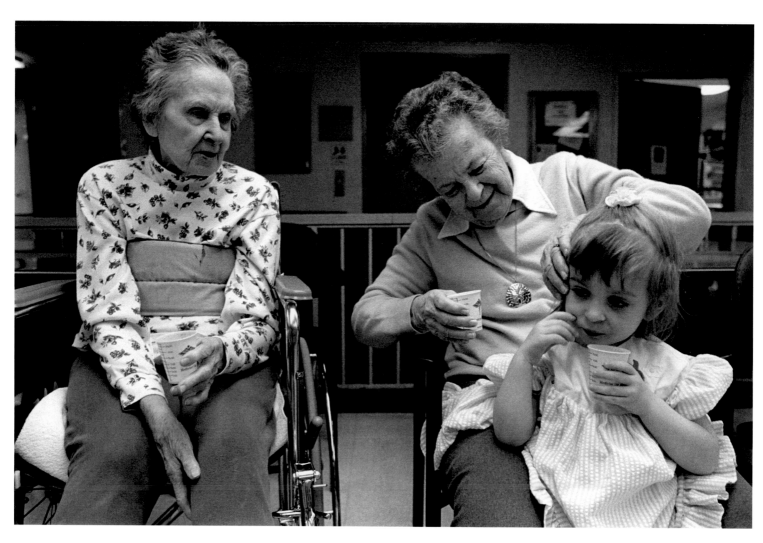

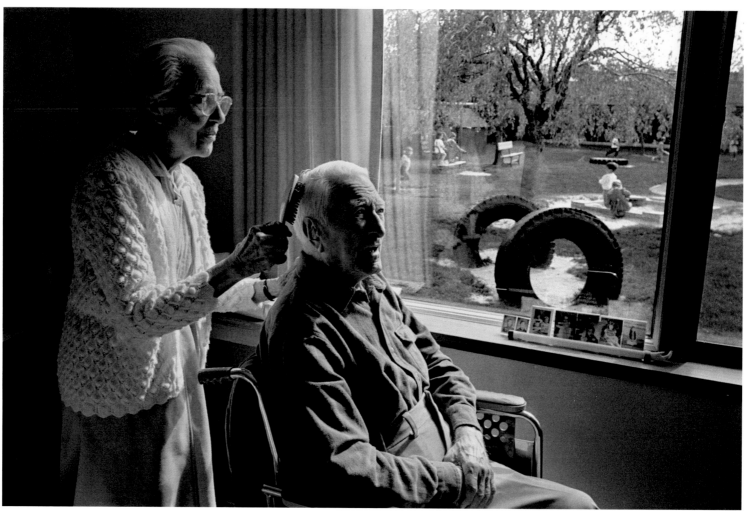

Messiah Village retirement community in Mechanicsburg, Pennsylvania has a child daycare facility on the grounds which was one of the first intergenerational programs of its kind in the country. At the Children's Family Center, the children benefit from having relationships with the elders, while the residents of Messiah Village soak in youth's life-affirming salve. The center even enlists Alzheimer's patients (opposite, top) to interact with young children.

In an era of "intentional communities," we have had to reinvent the most elemental of relationships. Bonds that used to occur naturally in multi-generational communities now have to be cultivated. Messiah Village has been on the cutting edge of creating a new social framework, one which recognizes the needs of our elders while keeping them engaged in the continuum of life.

opposite, top: Alzheimer's patients interact with children at the daycare center in Messiah Village.
bottom: A wife helps groom her husband, who has been transferred to the assisted living section of Messiah Village.
following pages, first spread: Residents compete in a favorite pastime at Messiah Village retirement community;
second spread: Children from the daycare center at Messiah Village visit a hospital ward upstairs.

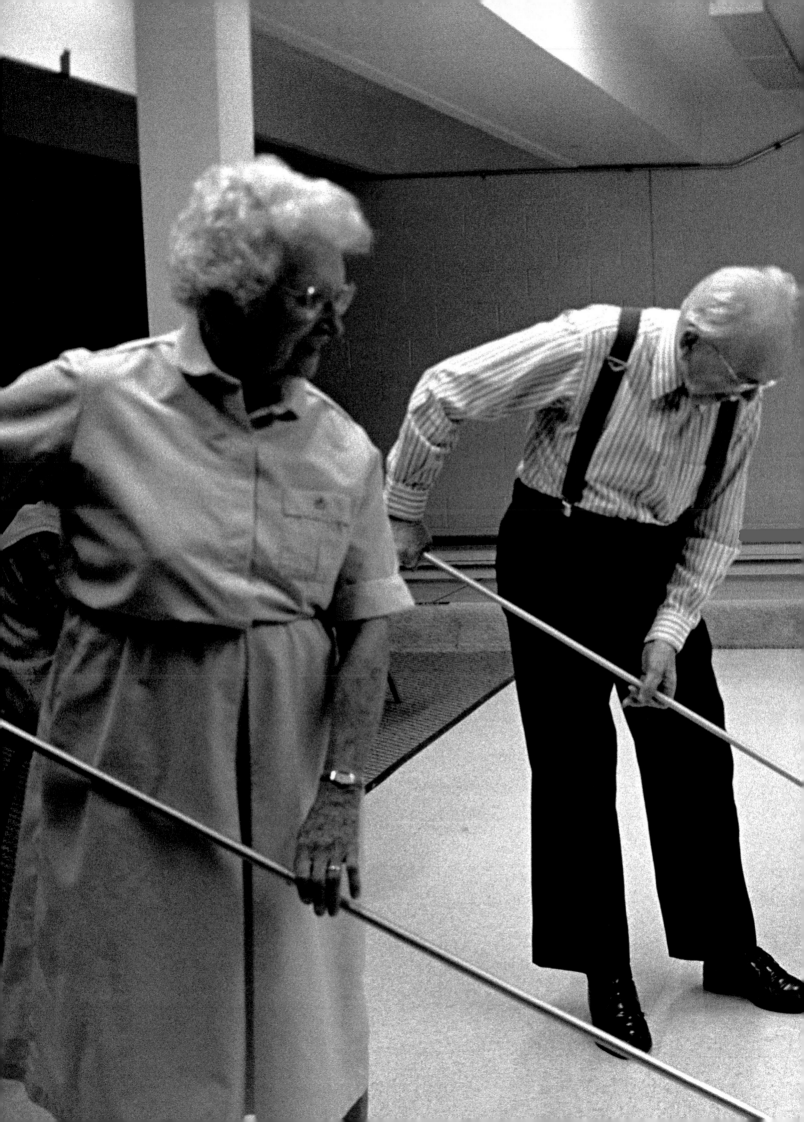

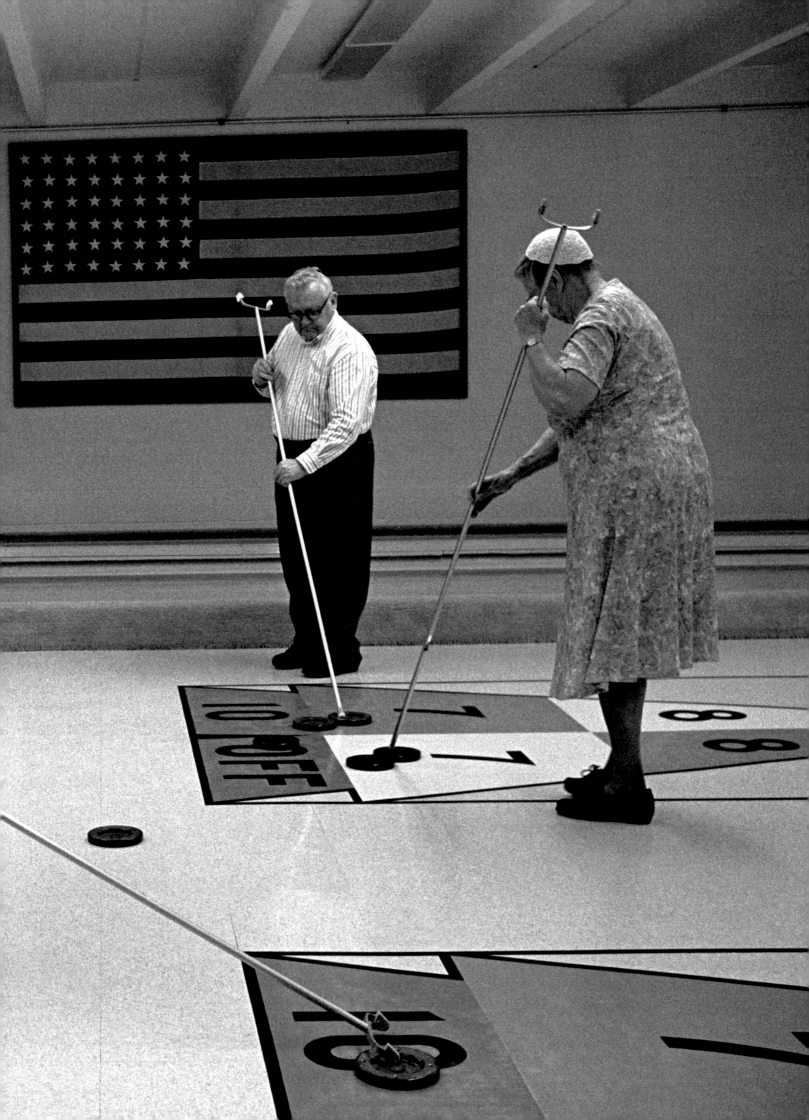

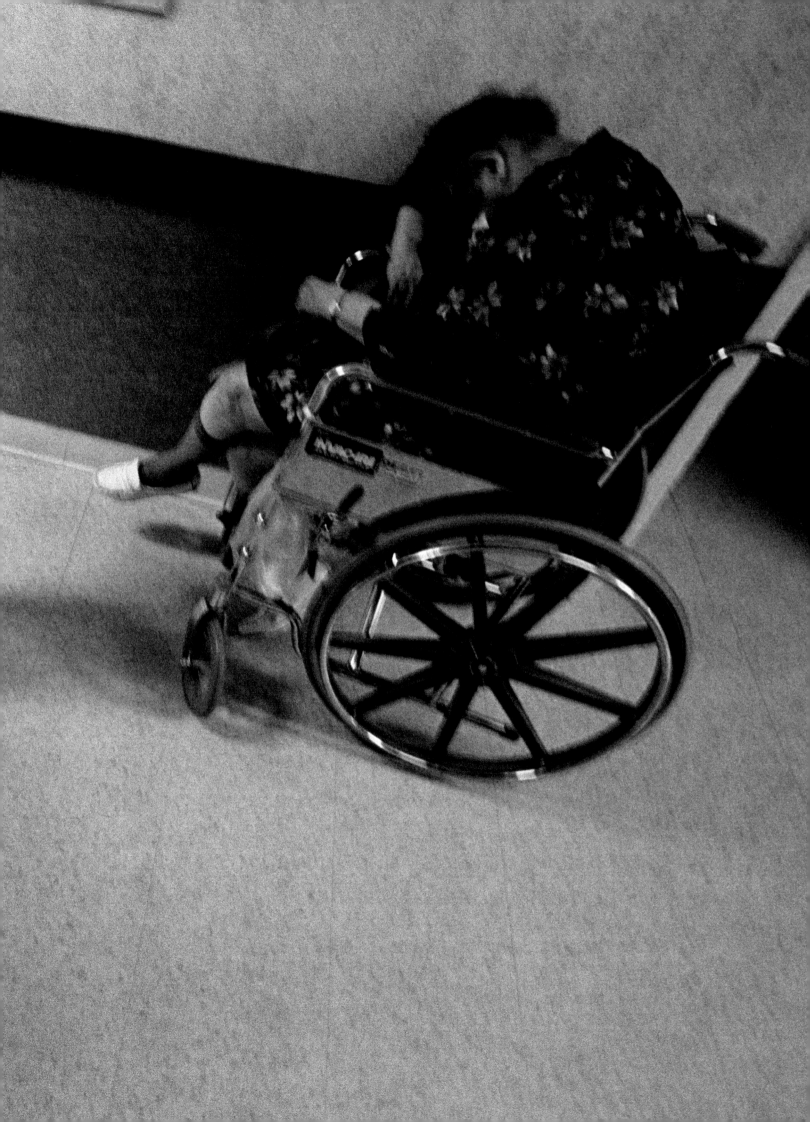

Francis Austin was in the Civilian Conservation Corps in the 1930s. He still sometimes wears his uniform as a reminder of this high point in his life. It might be said he is still reliving the Great Depression every day in his hometown in Grafton, West Virginia. This old railroad and coal mining town has fallen on hard times. Most of its main street is boarded up, its houses fallen into disrepair.

As Ed and I wandered Grafton's streets, Francis was one of the few signs of life we came across. He invited us—two complete strangers—to his house to spend hours pouring over old photographs and resurrecting the past one more time.

WEST VIRGINIA HAS THE **HIGHEST MEDIAN AGE** IN THE UNITED STATES; PRESTON COUNTY, WHERE FRANCIS AUSTIN LIVES, HAS **ONE OF THE HIGHEST PER CAPITA ELDERLY POPULATIONS** IN THE COUNTRY.

opposite: Francis Austin climbs the stairs of his Preston County, West Virginia, home. following pages: Francis gets around Grafton in his motorized wheelchair.

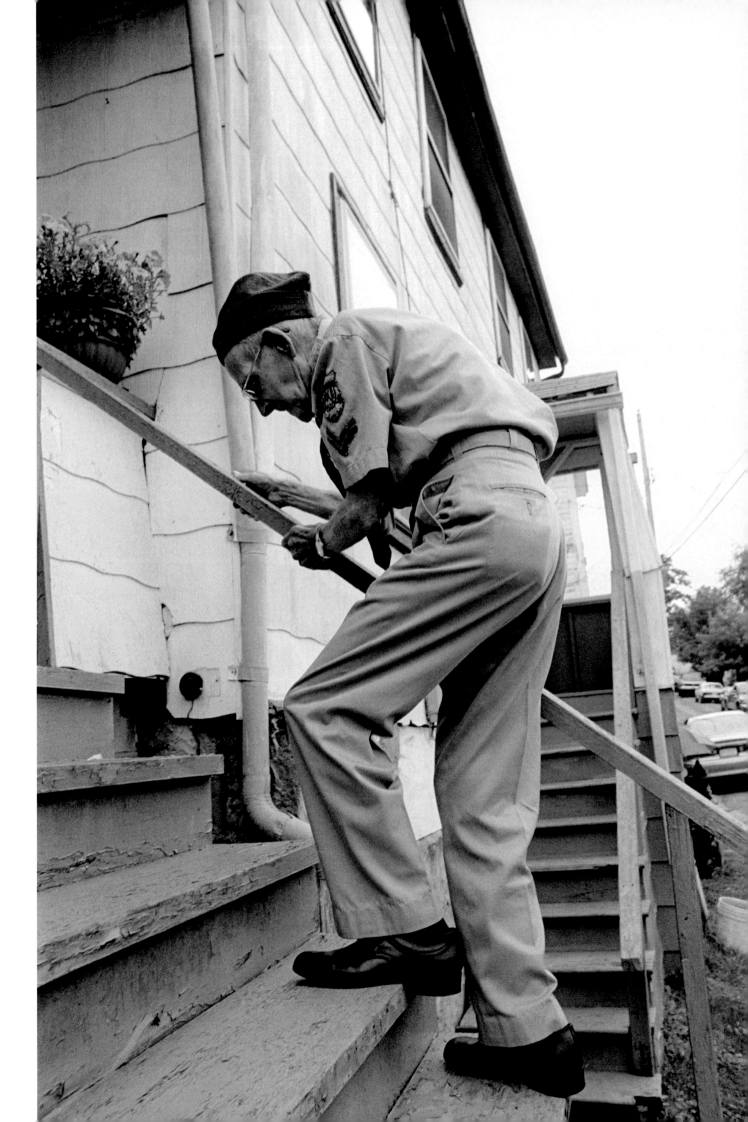

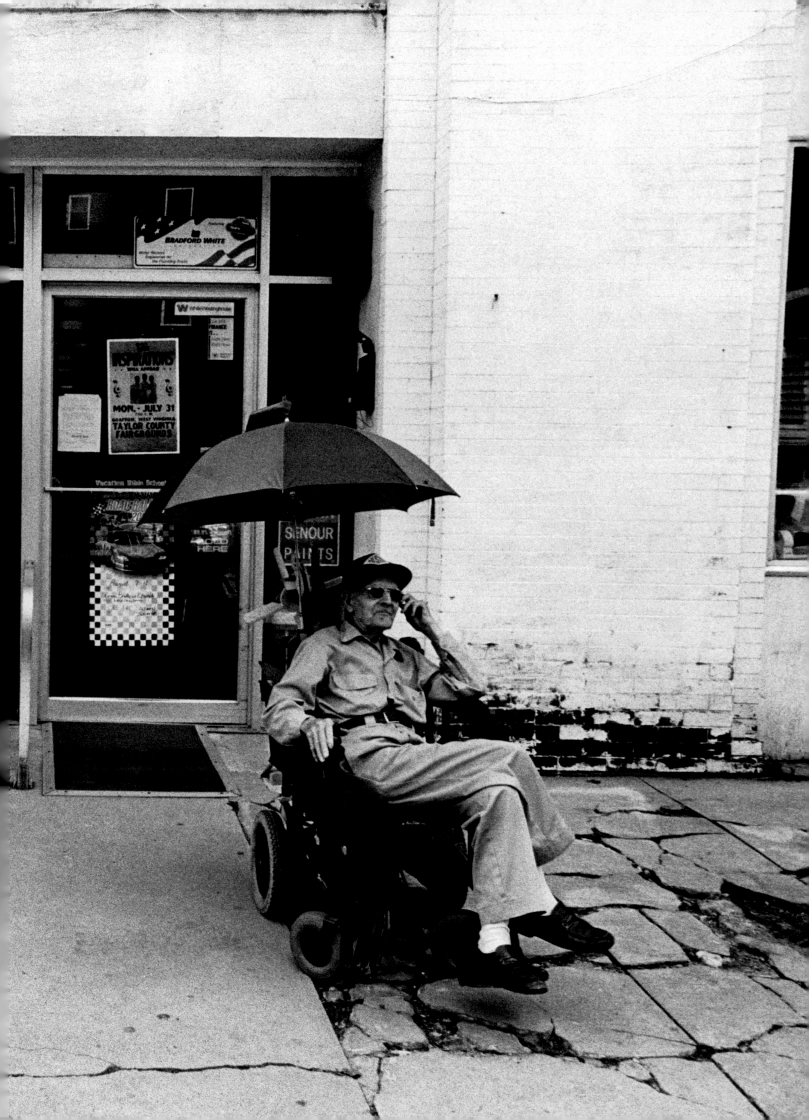

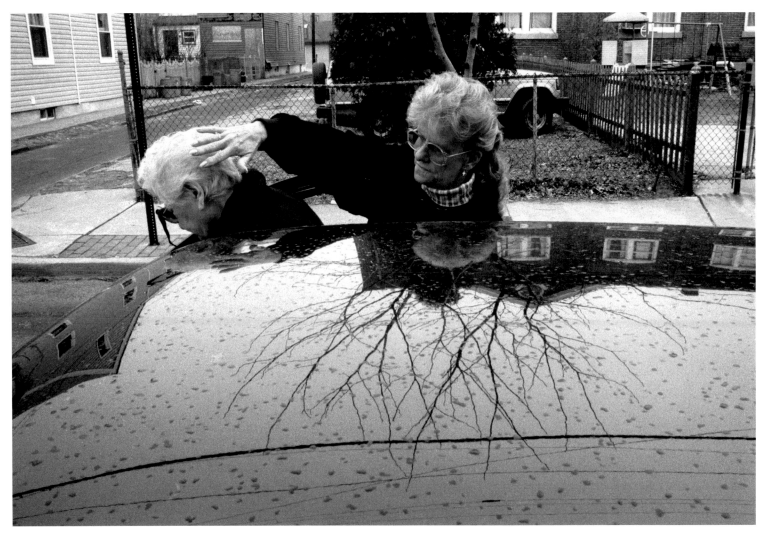

Martha Pollack assists Rose Polo into her car.

As the masses march toward old age, the needs of its frail elders are building into a tidal wave of implacable force. Today, caregiving is handled through short-term individual solutions. Tomorrow it will require long-term public resolve.

In New Jersey, one long-term solution is an innovative foster care program. Modeled after children's foster care, this program places elders who would be nursing home bound into private homes instead. This ensures that the elders will get personal attention, while saving the state over tens of thousands of dollars each year on every participant. Foster care providers receive about $1,200 per month, which is less than half the cost of a nursing home.

Rose Polo, eighty-six, was placed in the home of Martha Pollack, fifty-six, two years ago. Rose suffers from dementia and diabetes, and her health needs became too great for her own family to manage. In order to meet her mortgage payments, Martha Pollack needed the $1,200 that the state pays her to provide foster care.

THERE ARE CURRENTLY **1.5 MILLION PEOPLE LIVING IN NURSING HOMES** IN AMERICA. THE PERCENTAGE OF ELDERLY PEOPLE CONFINED TO NURSING HOMES IS **STEADILY DECLINING**.

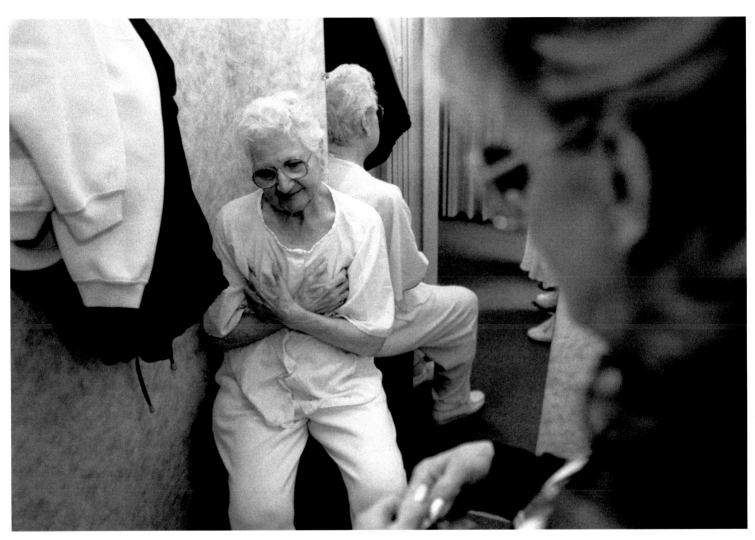
Rose Polo waits for a mammogram with her foster caregiver, Martha Pollack.

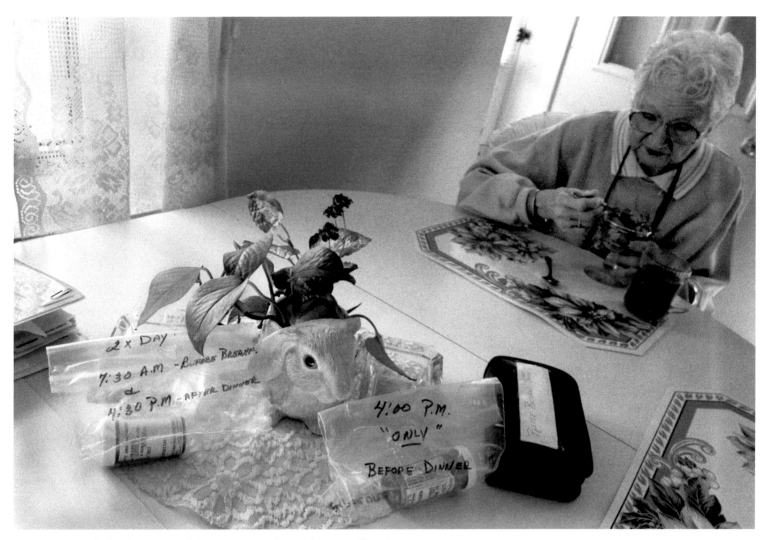

In the two years she has been in Martha's care, Rose has been able to get off insulin.

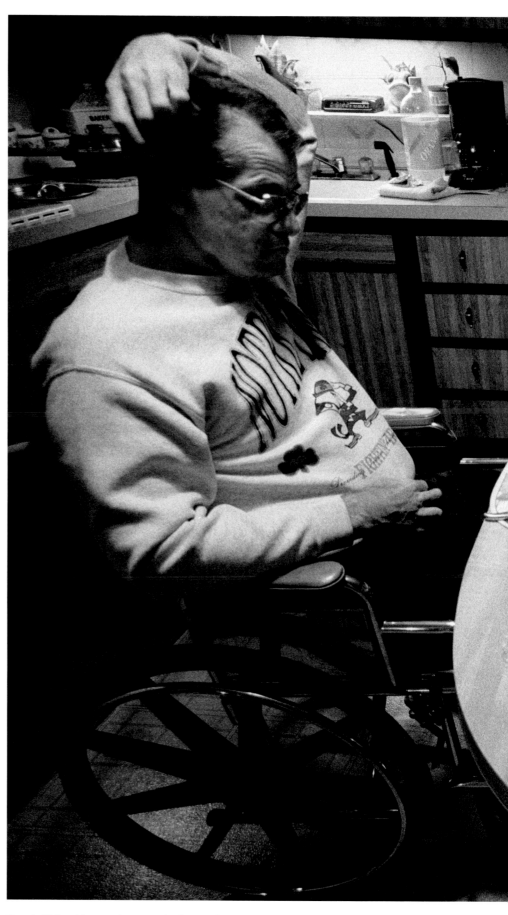

Dennis Weiss, 55, was taken into the home of Florette and Joseph Fortune (both in their 60s) after suffering a stroke.

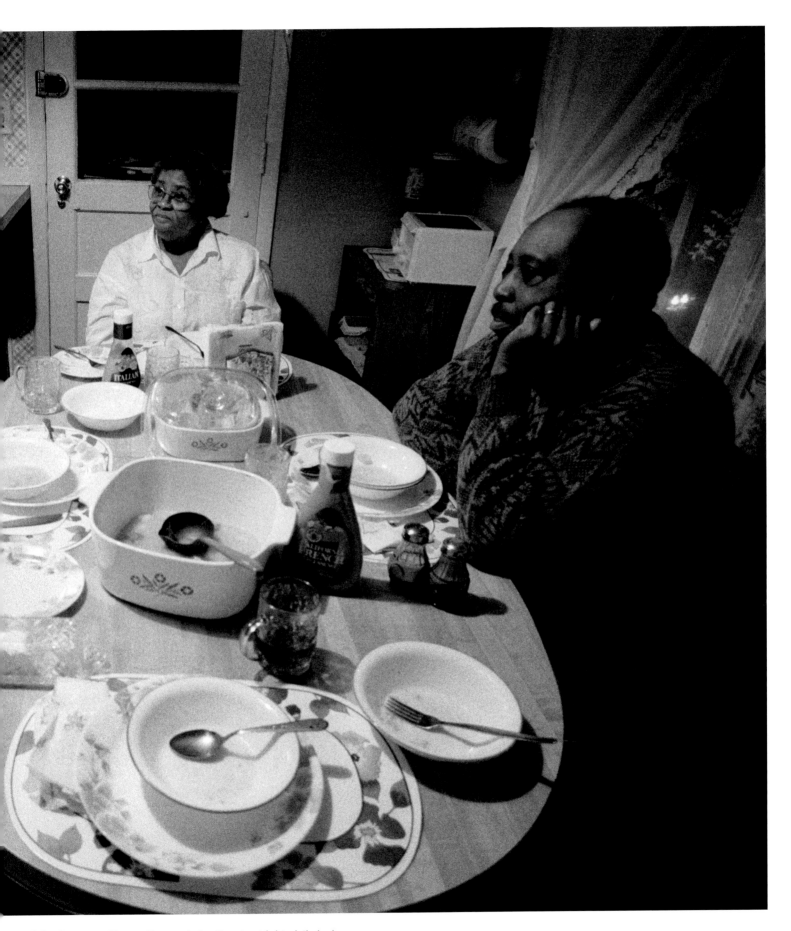

following pages: Florette Fortune helps Dennis with his daily bath.

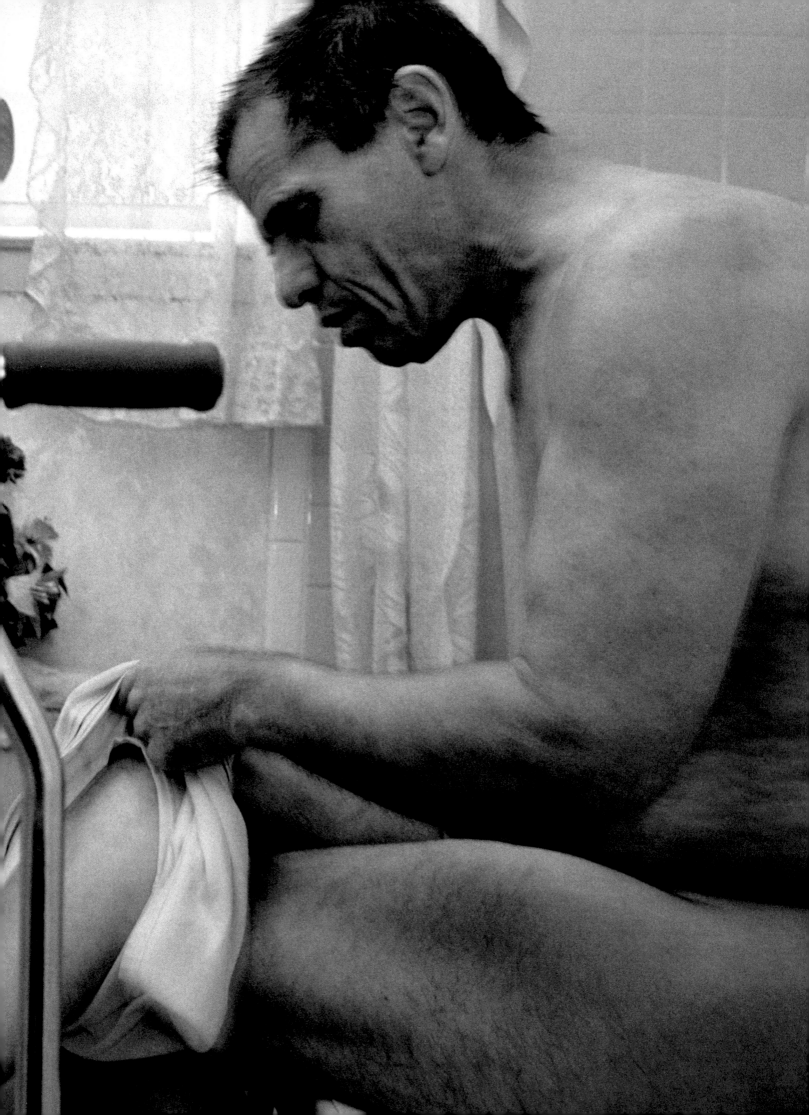

Alphonsa Joyner, eighty-four, was placed in the foster home of Frances Chandler, fifty-two, for two years before she was moved into a nursing home. Alphonsa, who suffers from Alzheimer's, has seven living children, none of whom can take care of her. Frances had to put her own mother in a nursing home before her death because she needed to work. Ironically, she can get paid to care for a stranger at home, but not for a family member.

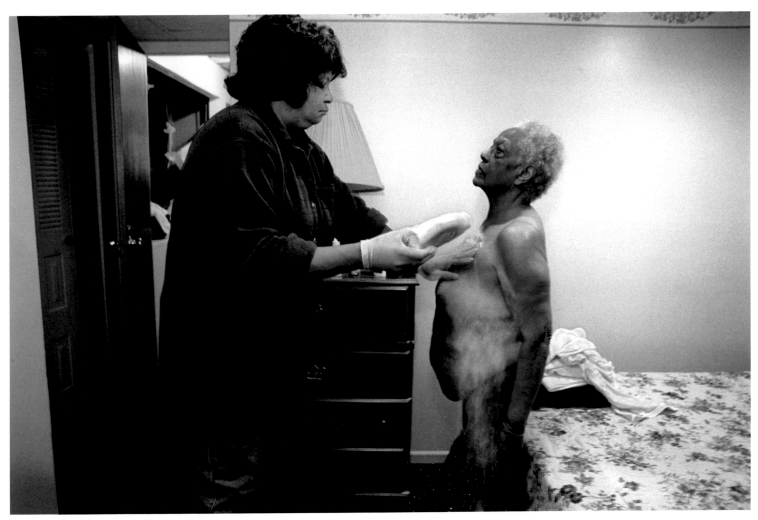

Frances Chandler powders Alphonsa Joyner after a bath.

Nilda Matias is a sixty-four-year-old grandmother and a double amputee from diabetes. She is also the legal guardian of her eight-year-old grandson, Nyco. At the time these pictures were taken, Nilda and Nyco lived in subsidized housing in New York City's Spanish Harlem, relying heavily on the social services provided in their building. Severely limited by her physical condition, Nilda could barely look after her own needs, let alone her grandson's. "It's never a good situation that brings a grandchild into a grandparent's custody," a grandparent advocate told me. In Nyco's case, his mother was incapable of caring for him.

Nilda Matias and grandson Nyco in their Spanish Harlem apartment.

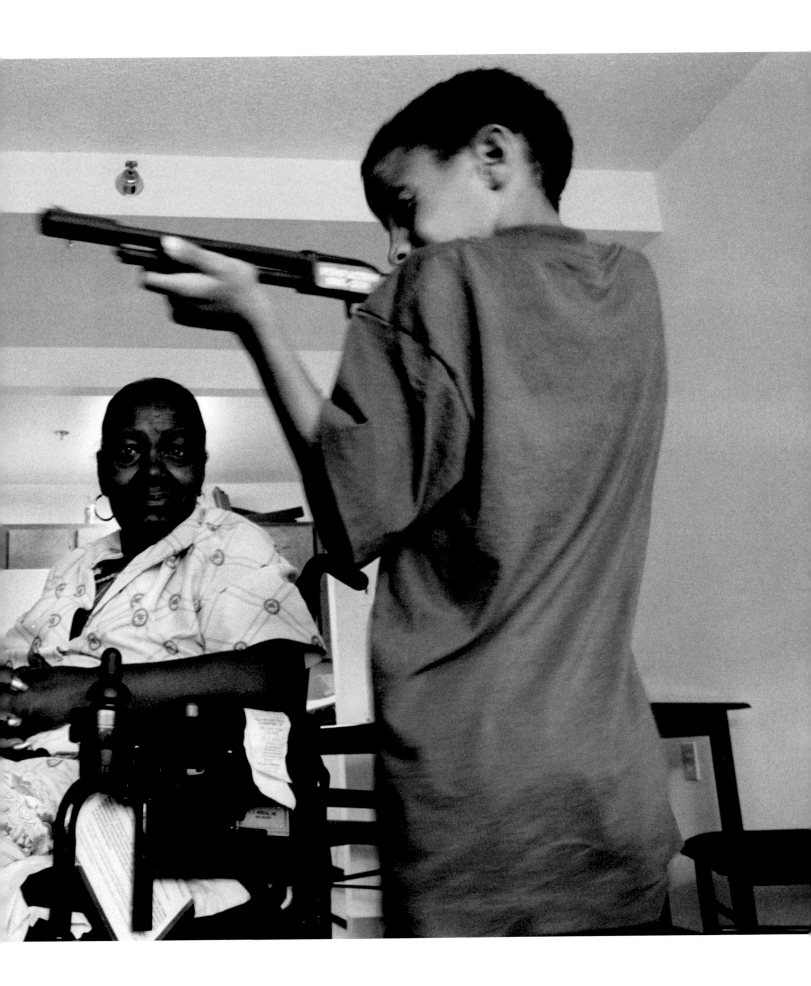

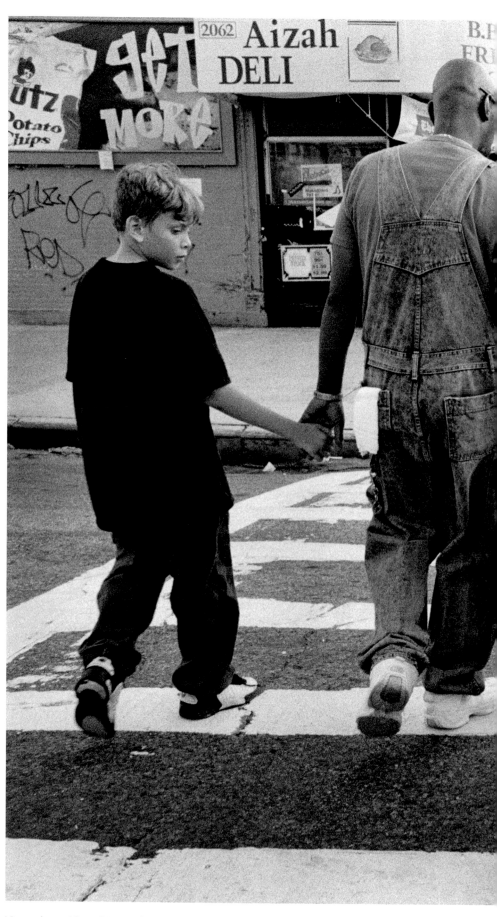

THERE ARE CURRENTLY **2.4**
MILLION GRANDPARENTS
RAISING THEIR GRANDCHILDREN.

Nyco takes a ride on his grandmother's wheelchair accompanied by his uncle and cousin.

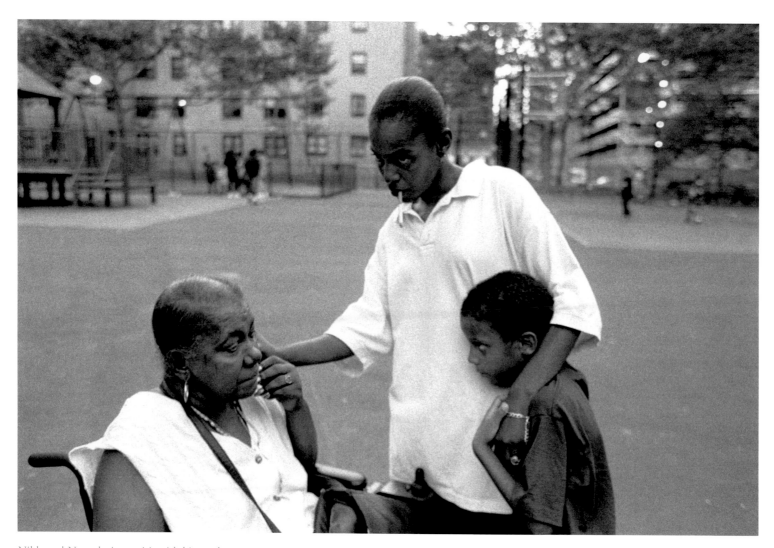

Nilda and Nyco during a visit with his mother

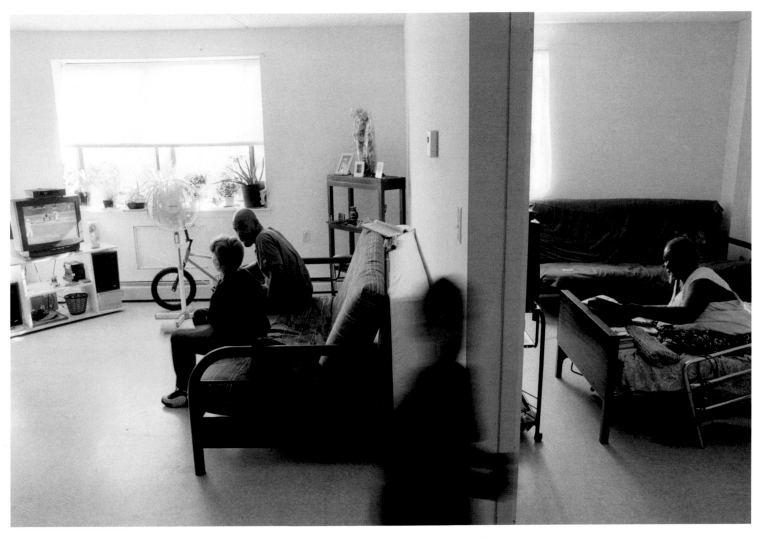

Nilda and Nyco lived in a two-room apartment in Linkage House, a senior housing complex in Spanish Harlem.

*"Old age starts with the first fall
and death comes with the second."*

Gabriel García Márquez

John Magrath prepares for a CAT scan after he fell and hit his head.

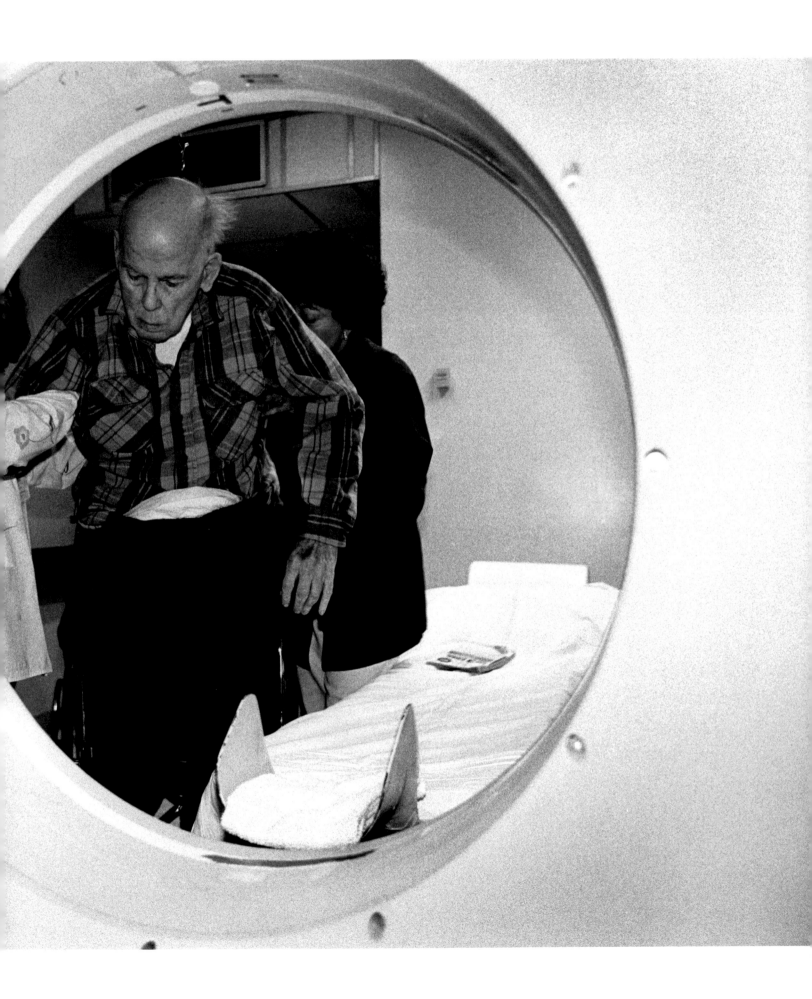

195

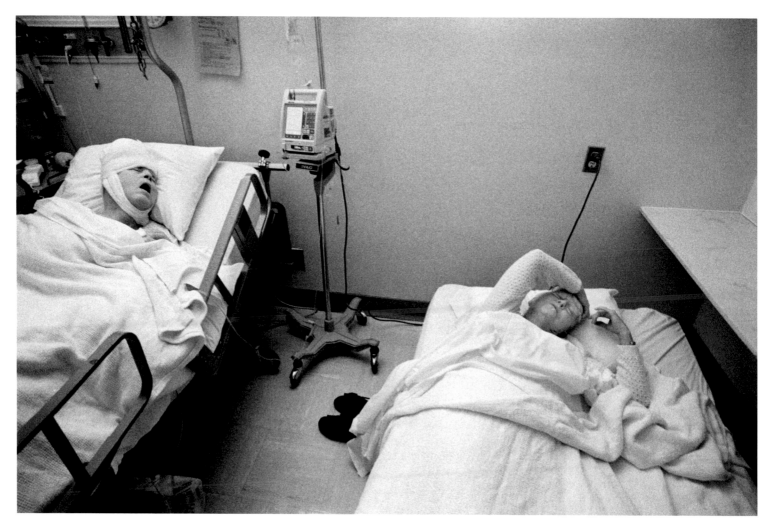

Virginia sleeps by John's side because she can't afford around-the-clock nursing care for him.

Until recently, Virginia Magrath, seventy-nine, lived with her eighty-three-year-old husband John in a single-room occupancy hotel in San Francisco's Tenderloin district. John had early-stage Alzheimer's, and other than the two days a week he went to daycare, Virginia could never leave him alone. Life moved at a glacial, tedious pace for John and Virginia—or at least it used to.

One night John fell in the bathroom and hit his head against the tub. It became a classic case of one little fall triggering an avalanche of events. John became disoriented that night; the next day a CAT scan revealed a blood clot in his brain.

Virginia, a retired nurse, waited for John to go into surgery to drain the blood clot. She complained that the doctors ignored her, despite her medical training, speaking directly to her daughters instead. "When you're old people treat you like you're invisible," she explained angrily.

After surgery, new blood clots formed and John's dementia was exacerbated. Since Virginia could not afford a private attendant, she had a cot moved into John's hospital room and she slept by his side. Virginia attended to John's every need with support from her daughters, Janice and Nanette.

When it became apparent that John would never fully recover, Virginia and her two daughters moved into hospice mode, taking over from the nurses for caring for most of his basic needs. They changed his bed liners, administered pain medication, and sat vigil around the clock. Decline came swiftly; within a week, John died.

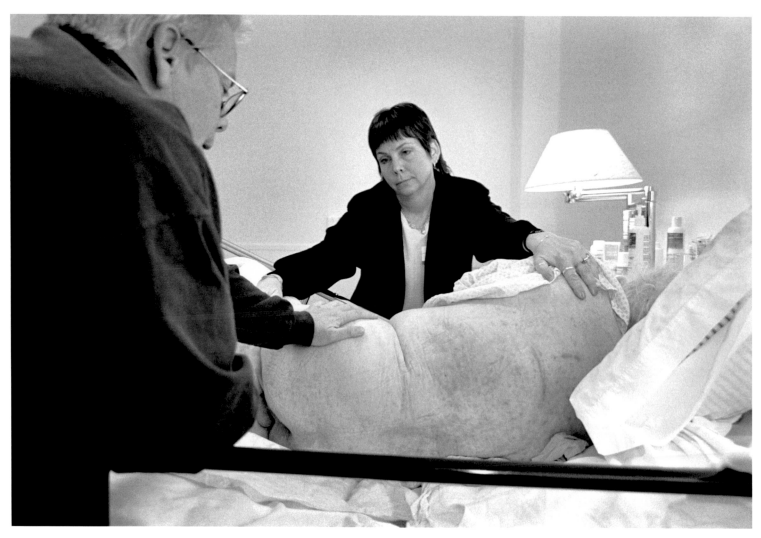

Virginia and her daughters change John's bed liners.

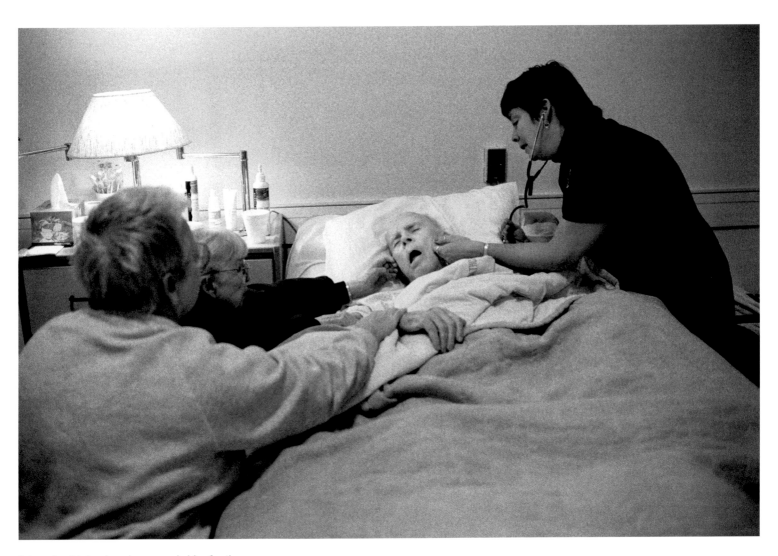

John takes his last breath surrounded by family.

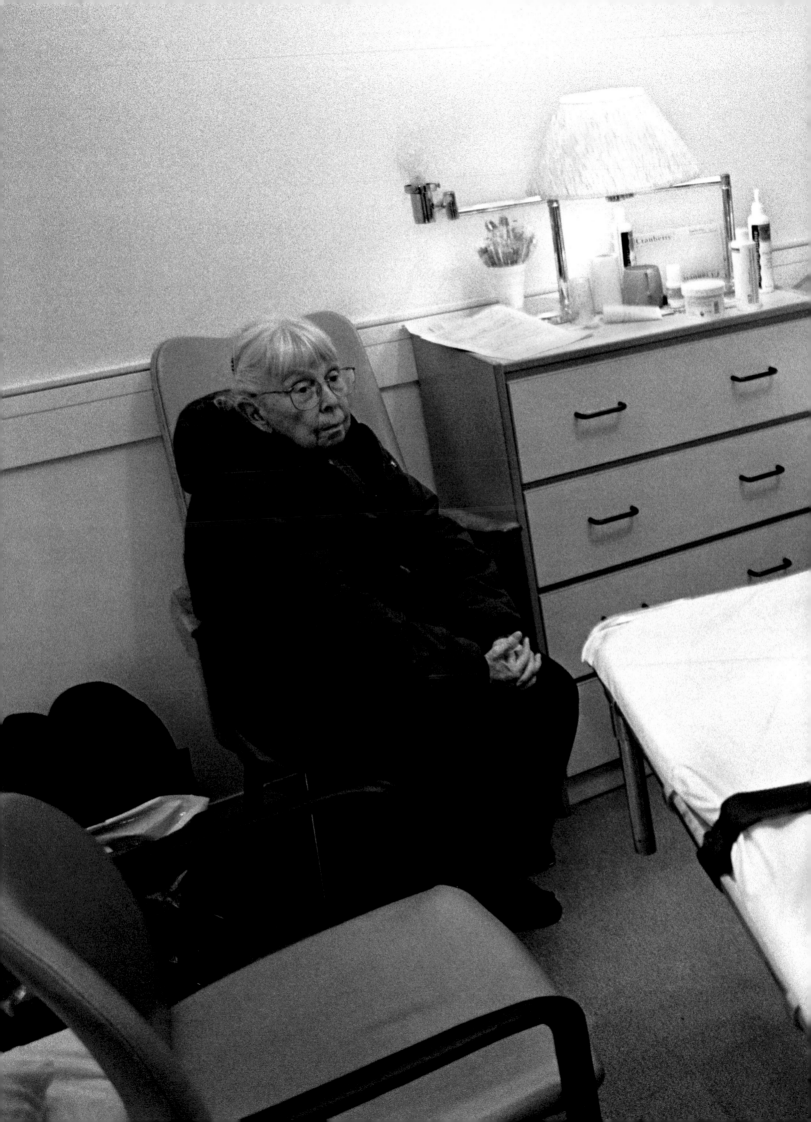

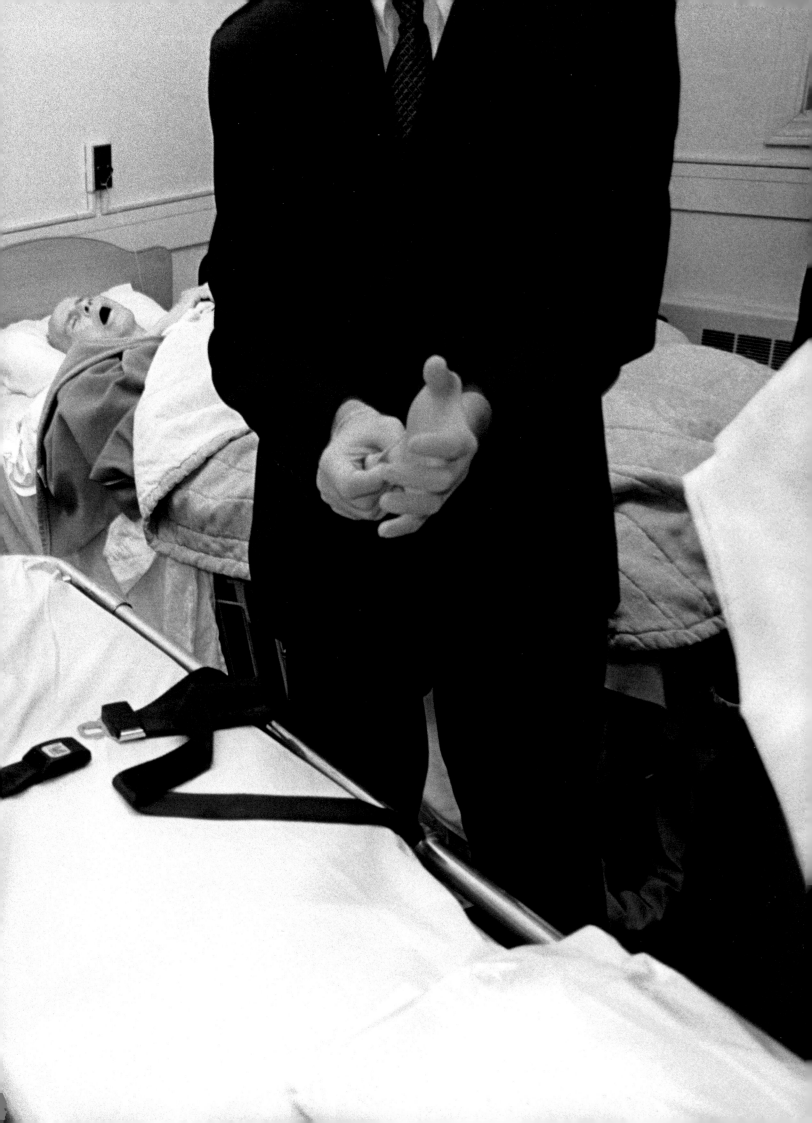

After fifty years of marriage, Virginia has no idea how she will manage without her husband. For the first time in her life she faces living on her own. "How do you cope?" she asks. "I think it's the best thing that could happen to him, for him, because if you have dementia…it only gets worse. So intellectually, that's how I cope. Emotionally, I don't know. It's really hard. My loss is going to be big."

FALLS ARE THE **FIFTH LEADING**
CAUSE OF DEATH IN OLDER ADULTS.

Virginia faces a new life as a widow.

THE **ELDERLY WHITE POPULATION** IS
PROJECTED **TO INCREASE BY 79%** IN
THE NEXT 3 DECADES, WHILE THE
NUMBER OF **ELDERLY MINORITIES**
IS EXPECTED **TO INCREASE BY 220%**.

opposite: Yan Yu Ling walks through a Chinatown alley in San Francisco.
following pages: Yan Yu Ling and her husband, Lao Jin Da in their Chinatown apartment.

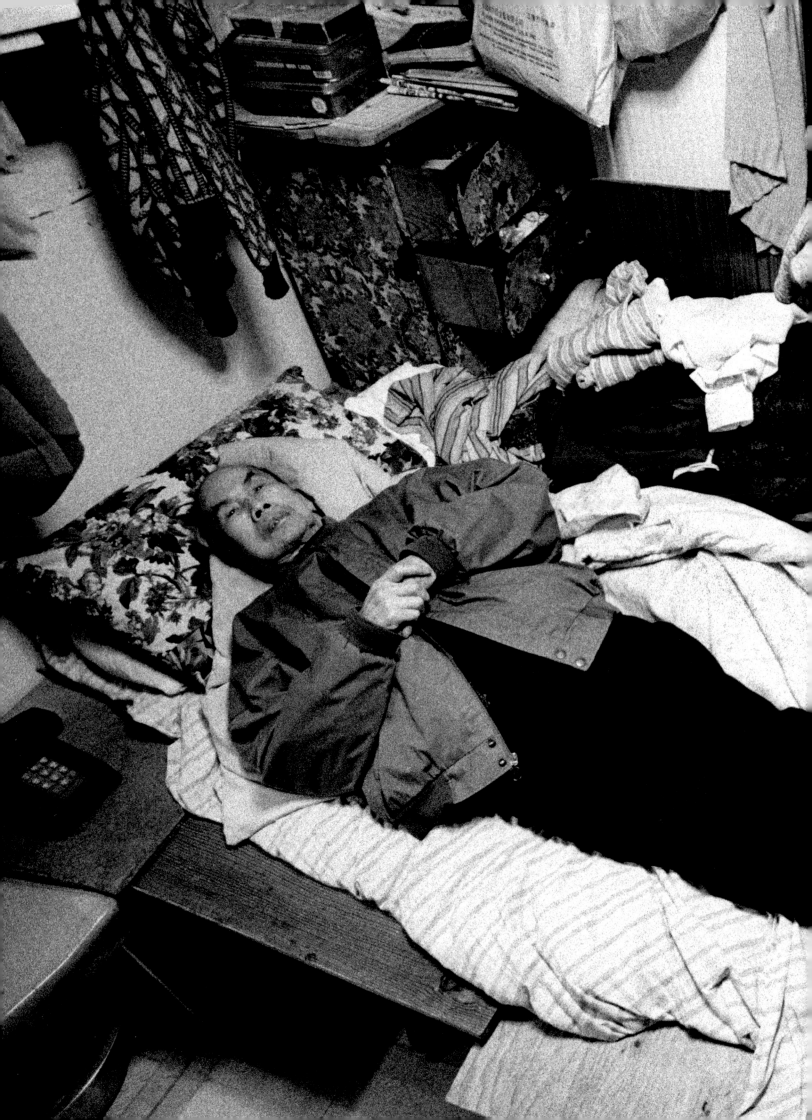

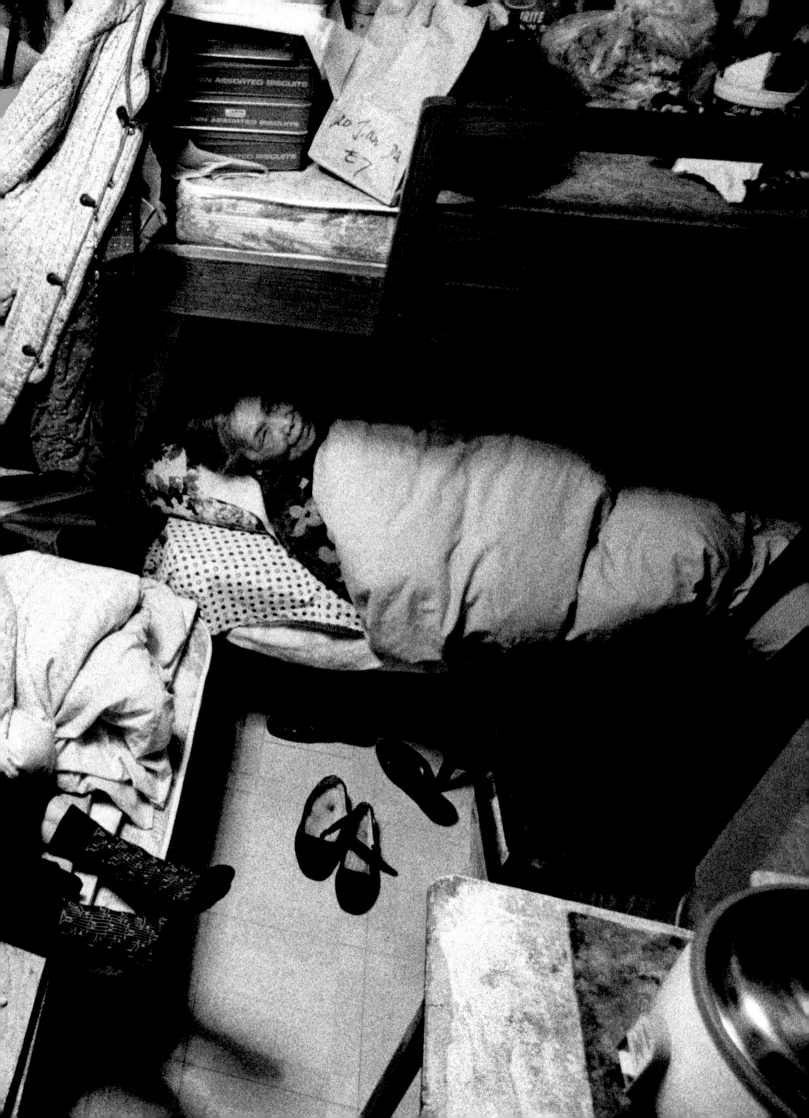

While the young-old celebrate each birthday with mounting gratitude, the old-old cling evermore tightly to their diminishing faculties. As the years pass, independence becomes one of the most tragic victims of longevity, a sacrificial lamb to modern medical advancements. Loss of independence begins with the car keys and ends with the house keys, and most elders dread this digression as much as they fear losing their minds.

On Lok, a service organization for the elderly in San Francisco, has set the standard for enabling frail elders to live at home as long as possible. It provides healthcare, social work, and daycare so that the oldest old can remain independent. On Lok has been so successful at keeping people out of nursing homes that it has been replicated in over twenty-nine states.

The profile of On Lok's clients matches those of a nursing home—their average age is eighty, over half are incontinent, and more than two-thirds suffer from mental disorders. Nevertheless, a mere seven percent are forced to live in nursing homes.

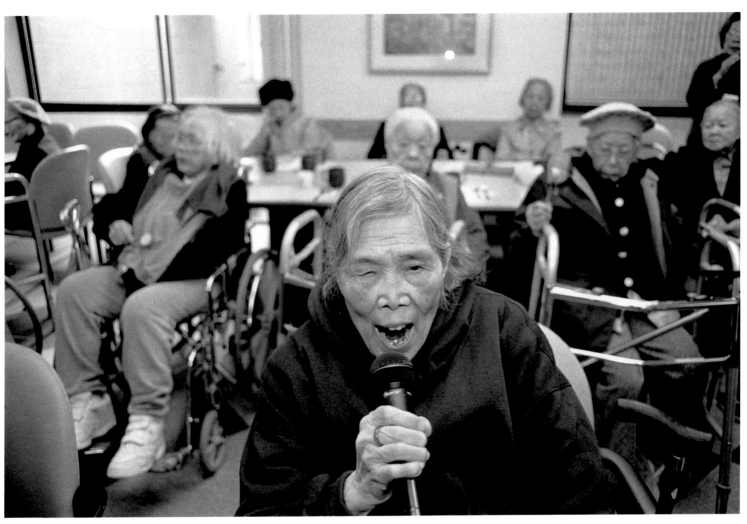

Yan Yu Ling, who is legally blind, enjoys social events at an On Lok center in San Francisco.

The old days were the New World days, when young immigrants came to America to claim their futures. It was a time when elders sent their children off with the implicit understanding that they would never see each other again. Today, the life span has grown so long and transportation has become so easy that even an octogenarian can travel thousands of miles, across continents and oceans, to start over.

Senior immigrants now account for five percent of the immigrant population. While the number might seem negligible, their presence in this country has set off a passionate debate. On the one hand, they contribute immeasurably by helping to keep families intact—for instance, providing childcare for their grandchildren, thereby enabling more young women to remain in the work force. On the other hand, their reliance on Supplemental Security Income and Medicaid costs American taxpayers billions of dollars each year. The controversy over whose responsibility these immigrants are rages on.

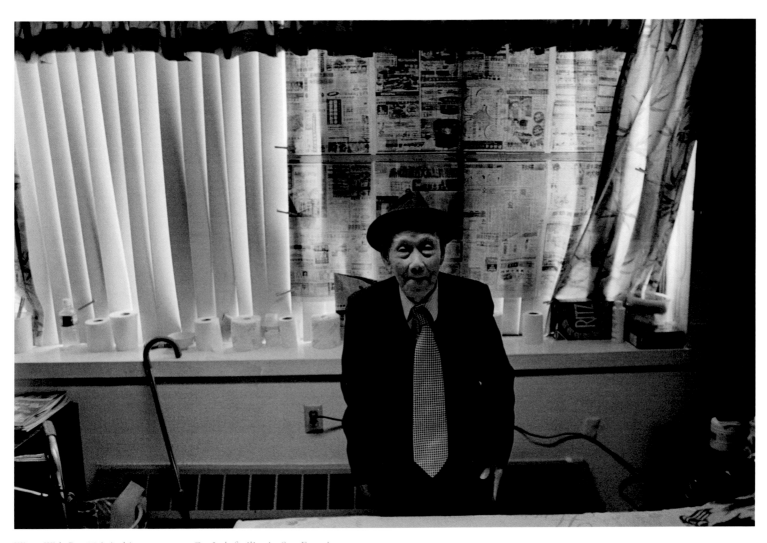

Wang Wah Po, 104, in his room at an On Lok facility in San Francisco.

Wang Wah Po explains that in China, it is the family that typically takes care of its elders. "The next generations are so busy in the U.S.," he says. "They work several jobs, they have their own children. It would be a burden to care for elders." He adds that his great-grandchildren, who were born here, don't speak Chinese, and they are raised ignorant of Chinese philosophy. "They have virtues, but not Chinese virtues. They don't respect elders as much as people in China. And they don't give me pocket money when they visit," a traditional gesture of respect.

Wang Wah Po, center, during physical therapy at On Lok.

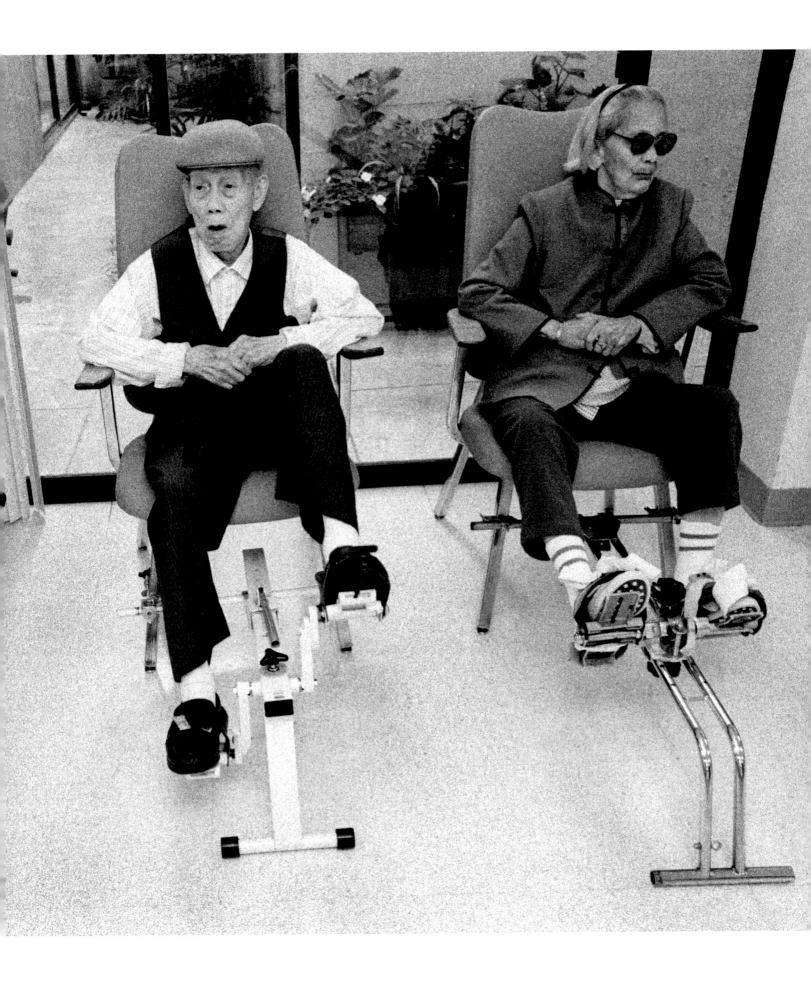

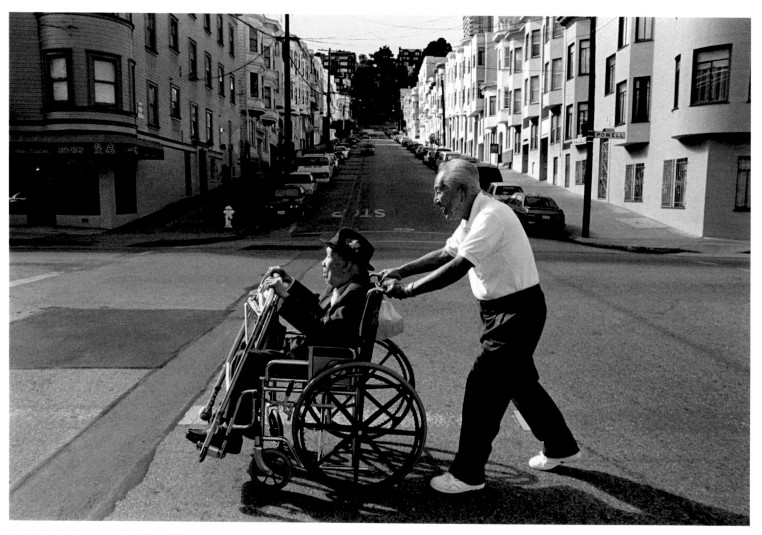

An On Lok volunteer takes Wang Wah Po to a men's lunch at a nearby restaurant.

At one hundred and four, Wang Wah Po likes to dress immaculately in a dapper gray suit and a fedora. A native of mainland China, he emigrated to the States nearly twenty years ago, bringing with him only his most prized possessions: his paint brushes and a detailed, hand-calligraphied family history that traces back twenty-two generations. In his room at the On Lok senior center, he pulls out his latest prized possession: a naturalization certificate that shows he became a U.S. citizen in 1997, at the age of one hundred and three.

Isaac Donner lives alone in a single-room occupancy hotel.

THE NUMBER OF **CENTENARIANS** IS
EXPECTED TO **QUADRUPLE** BY 2030.

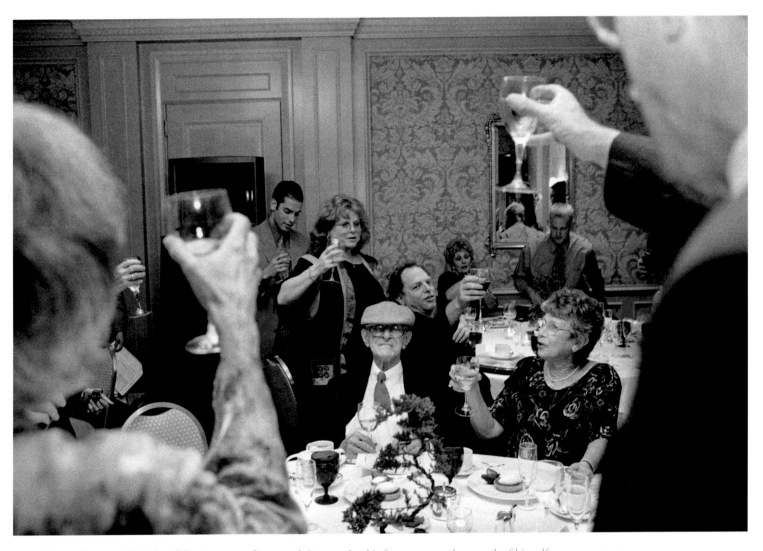

Isaac celebrates his 100th birthday; following pages, first spread: Isaac washes his face next to a photograph of himself as a young man; second spread: Berta Lopez, 103, waits for a chest X ray.

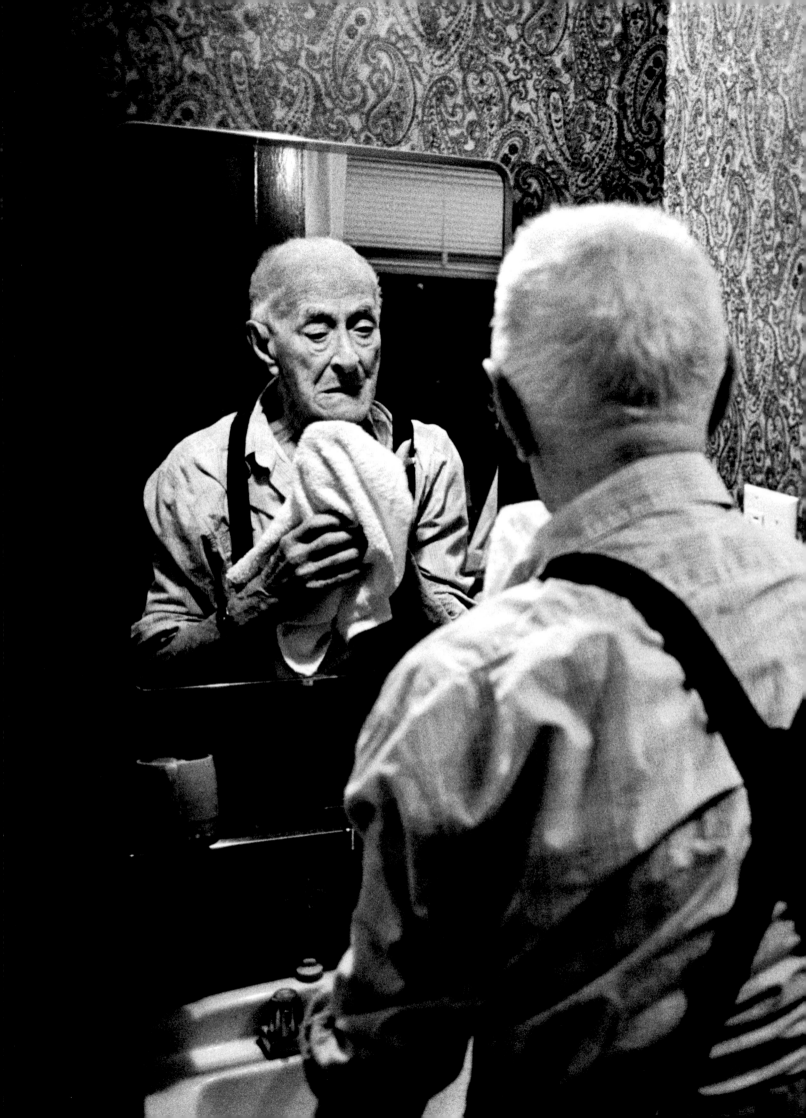

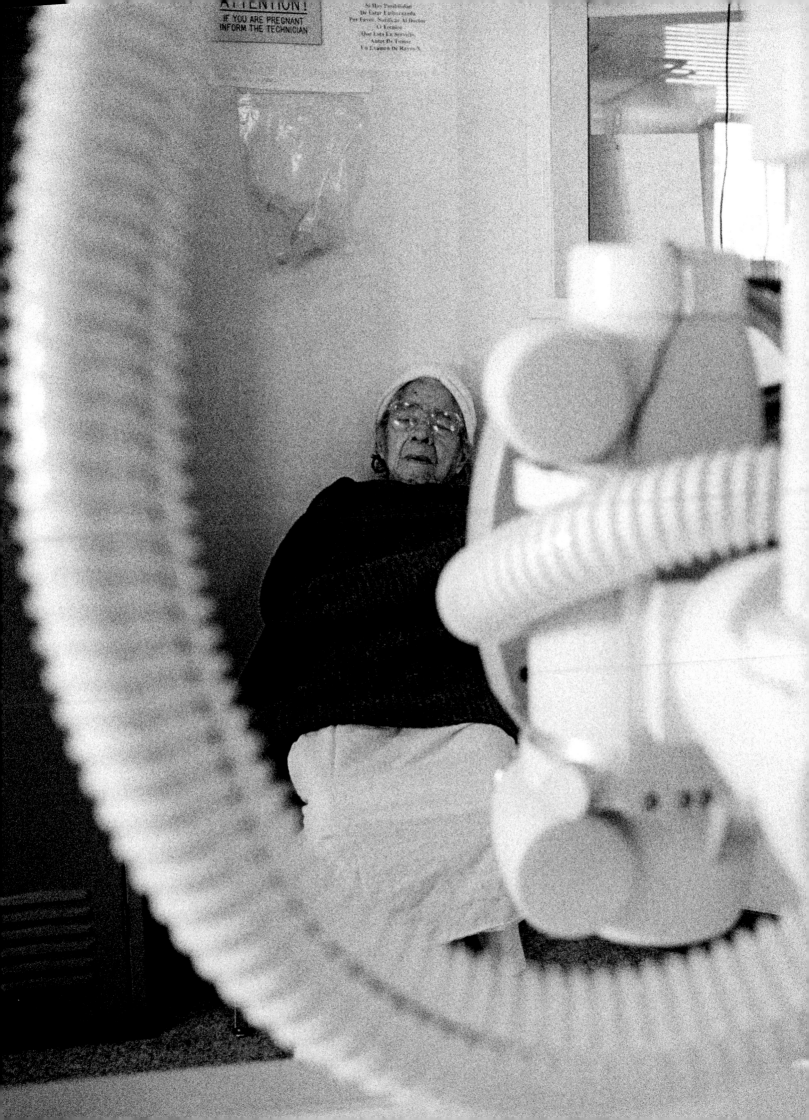

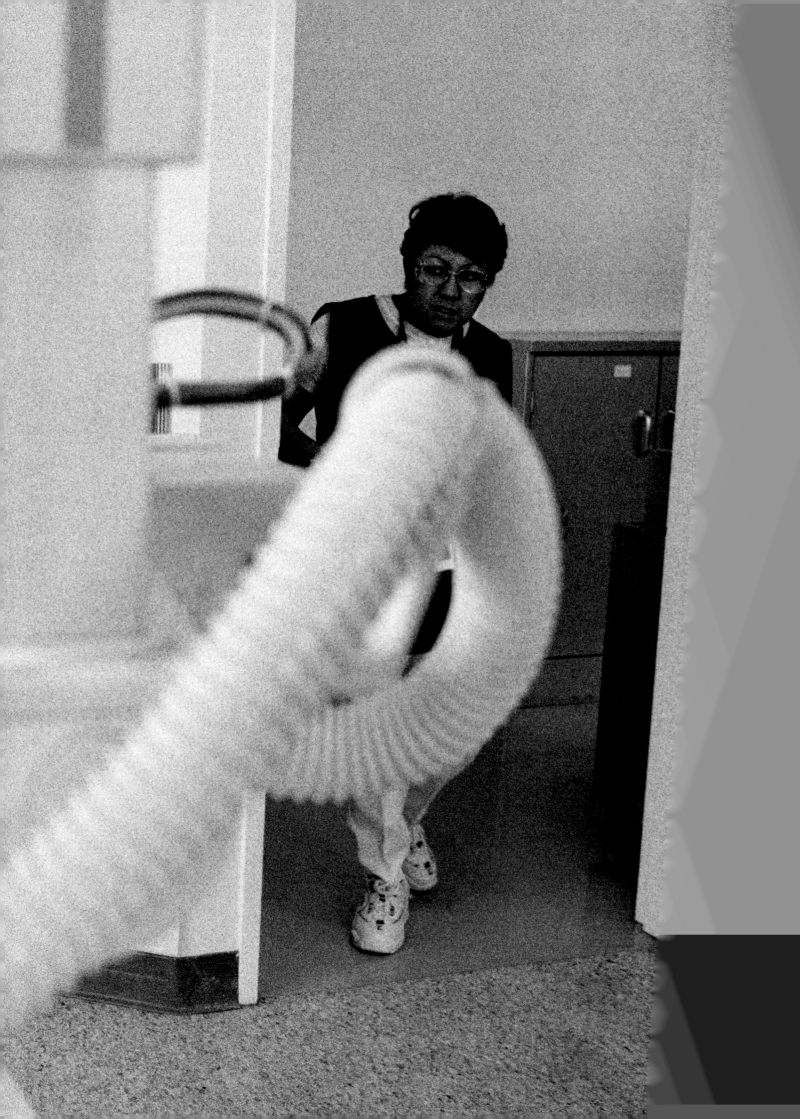

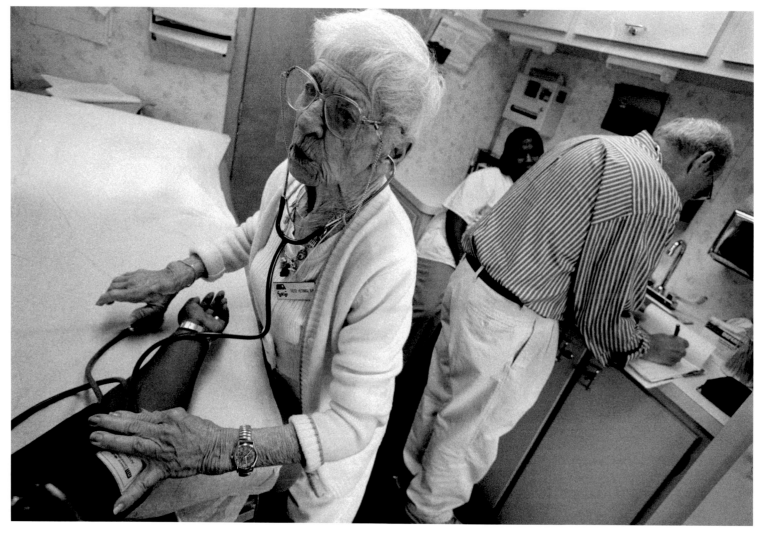

Henry Friedman and Rose Herman are a retired doctor and nurse who volunteer for the MediVan Project. Their mobile clinic provides healthcare to indigent people in the Ft. Lauderdale area who would otherwise go without basic healthcare.

By the time Henry Friedman hit his fifties, he had lost his love for medicine. While he hadn't lost his passion for helping patients, he hated his profession in the era of managed care. In 1994, at the age of fifty-eight, he retired and moved to Florida. Like thousands of Americans, he had decades ahead of him, but no road map to make those years productive or gratifying. For many like Dr. Friedman, the appeal of leisurely afternoons playing golf and catching up on reading wore thin quickly, and even travel grew tedious.

With thirty extra years on the average lifespan, people today have an unprecedented opportunity for reinvention and personal renewal. Retirement is no longer a time to retreat. In fact, for many seniors, retirement has become a time to do the most personally engaging work of their lives. This is when goals once thought unattainable can be reached, and profound, substantive rewards can be realized from altruistic pursuits.

For Henry Friedman, his savior came in the form of a mobile clinic called MediVan. Staffed by retired doctors and nurses, MediVan provides healthcare to underserved communities in south Florida. For many of these patients, Dr. Friedman is the only healthcare professional they will see other than at an emergency room visit. Suddenly, Dr. Friedman discovered a renewed passion for medicine. He was serving people who desperately needed his help, he was able to practice without red tape and piles of paperwork, he could work part-time, and he was so greatly appreciated for his efforts that the lack of pay was more than compensated.

Retirees are America's single greatest untapped resource. They are perhaps the only natural resource that is guaranteed to grow in the coming decades. In their hands lies the key to a social revitalization, one in which civic engagement becomes a widespread aspiration and personal fulfillment becomes the ultimate compensation.

Managed care changed Dr. Henry Friedman's private group practice "from a caring group of doctors to a money hungry group that was willing to step over each other to earn a few more dollars. The patients suffered for it," he says. "They became by and large a commodity."

Now he practices on a volunteer basis with MediVan, a mobile clinic serving indigent elders, most of whom are immigrants. "These are people who would die much sooner without my care," he says, "They are appreciative patients and they follow my instructions better than my private patients ever did. We get hugs, we get kisses, we get mangos, we get avocados.

"My vision for retirement was to enjoy myself, do a lot of recreational reading, and take trips around the country. But as I got into retirement I realized that I still wanted to do something in medicine. Reading wasn't enough. I like helping people and I love the patient contact. I'm happy now. I'm doing what I want to do, the way I want to do it."

opposite: Dr. Friedman, a retiree, examines one of his patients, a Haitian immigrant. following pages: Katherine Pener, 84, has been a breast cancer survivor for the past 22 years. She is on her way to counsel another cancer patient after surgery.

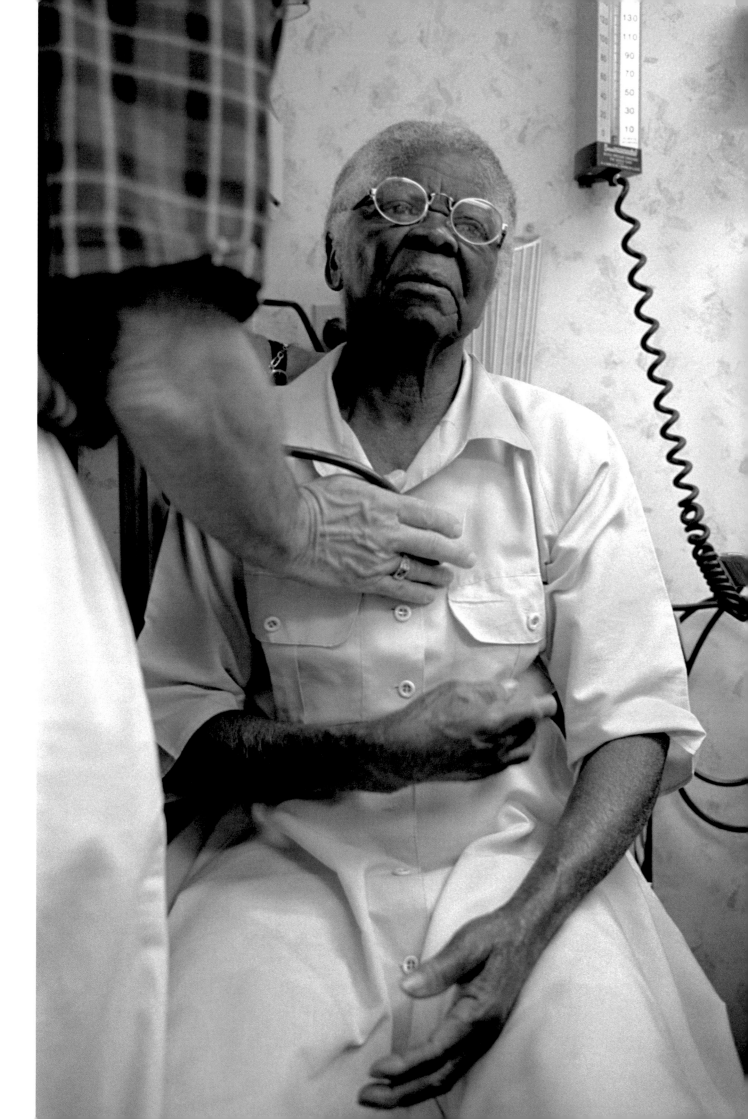

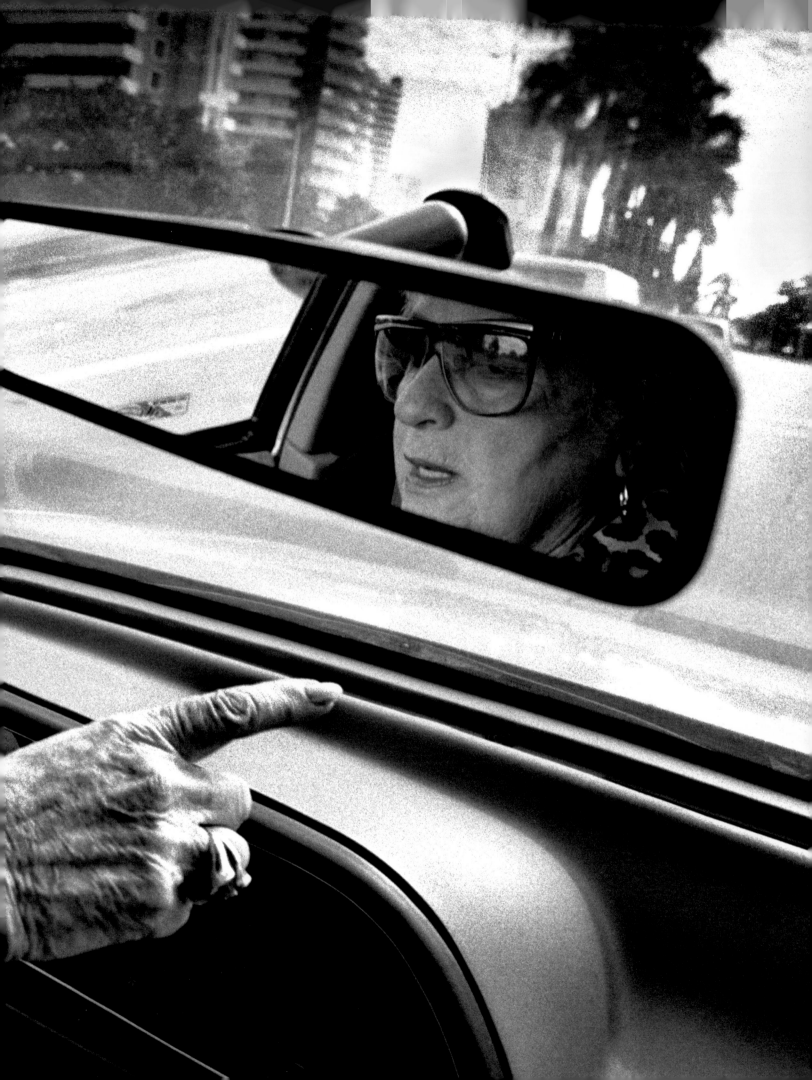

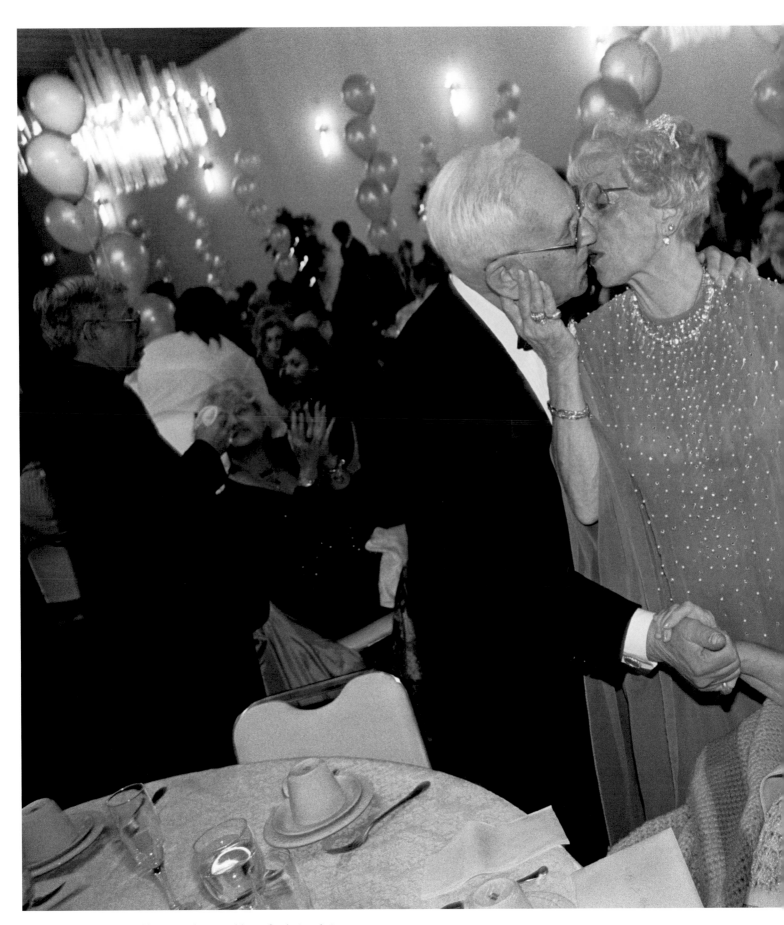

Ricki Caminetti and Gerald Gross rediscovered love after losing their mates.

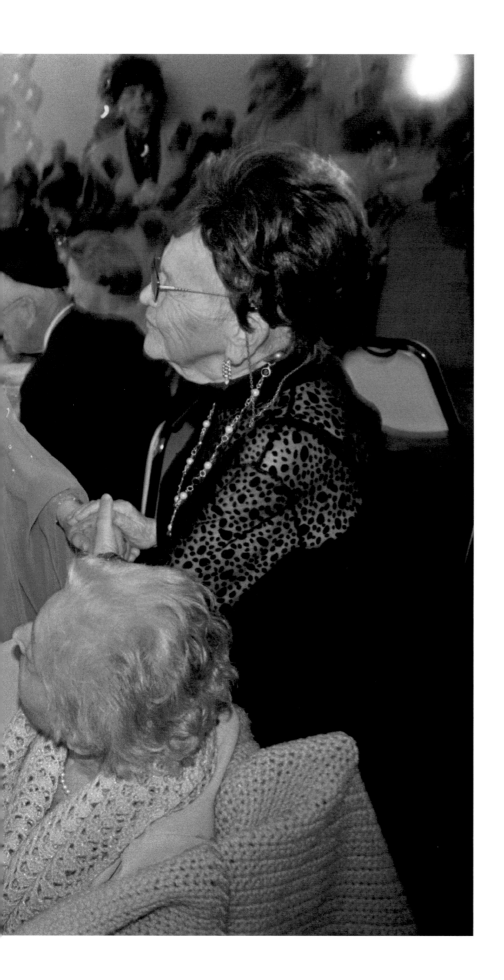

Gerald Gross and Ricky Caminetti fell in love in their eighties. She refused to sleep with him before they got married, so he proposed within a week of their first date. Their wedding was held at a synagogue in North Miami, and over two hundred guests attended.

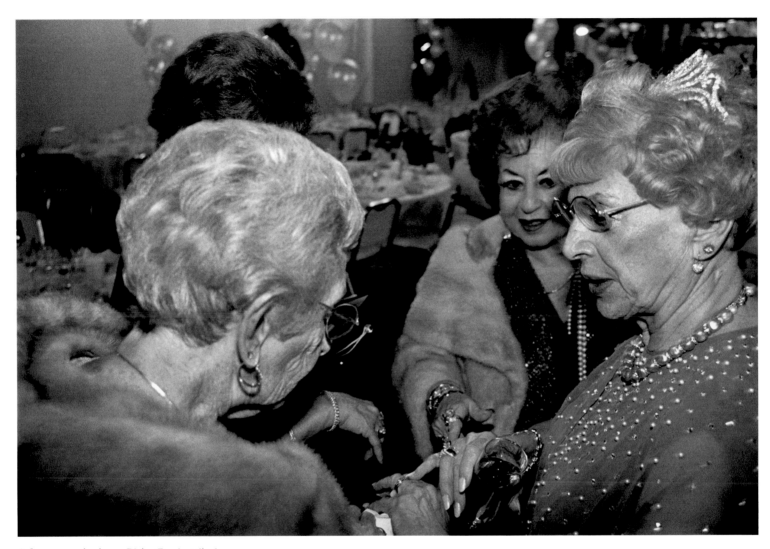

A few guests check out Ricky Caminetti's ring.

"When we went down to get our license, they couldn't believe that a 1914 was marrying a 1919. They made a big to-do. They didn't have anybody applying for a license at that age. But we don't care what other people do. We do it our way.

"We don't know of anybody eighty years of age or better who are getting married. They live together because with marriage there's a lot of legal complications. You've got social security to fight with. You've got income tax to fight with. You have these legal papers…what's yours before this marriage belongs to your children. You don't want to take it away from them."

Gerald Gross

ALMOST HALF OF WOMEN AGE 65+ ARE WIDOWS. NEARLY 700,000 WOMEN LOSE THEIR SPOUSES EACH YEAR AND WILL BE WIDOWS **FOR AN AVERAGE OF 14 YEARS**.

"For nine months I used to go to bed at night and say, 'Why do I have to wake up in the morning?' I didn't care to. I didn't want to. Now I go to bed and say, 'Give me some life.' I want years. I didn't want them three, four months ago. I'm eighty-six, don't forget. How much longer can I live? Five years if I'm lucky. But now I've got somebody to do it with. It's a pleasure."

Gerald Gross

MEN WHO LOSE THEIR MATES ARE **MORE LIKELY TO REMARRY** THAN WIDOWS.

Ricky Caminetti toasts the last guest at her wedding.

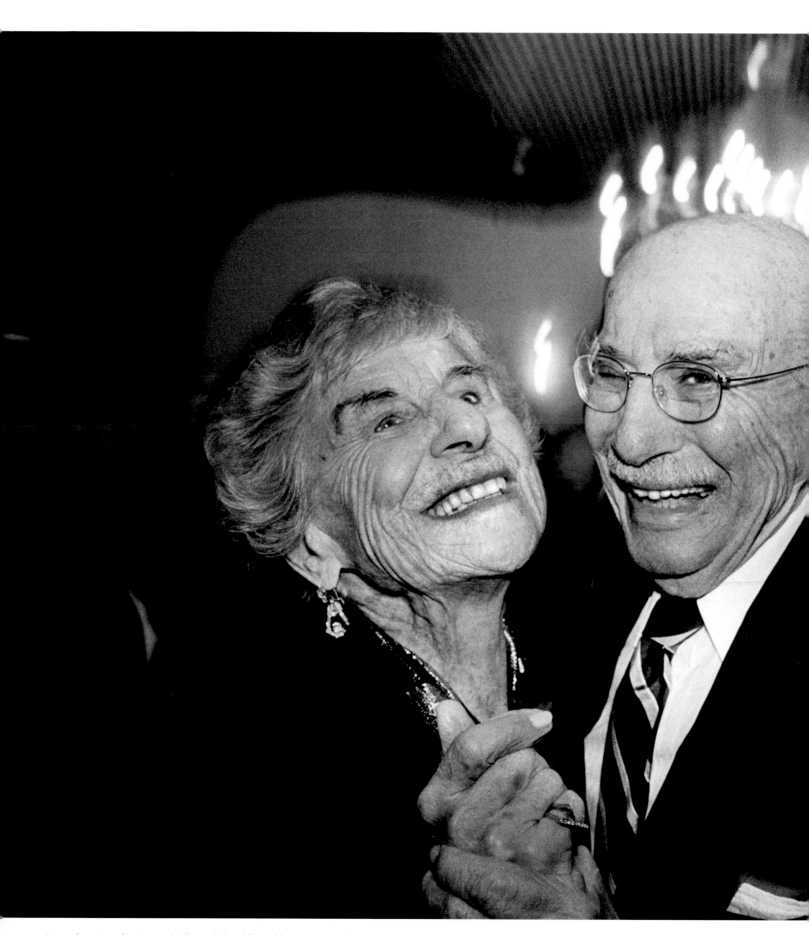

A couple enjoys dancing at Ricky and Gerald's wedding.

THERE ARE **143 OLDER WOMEN**
FOR EVERY **100 OLDER MEN**,
A RATIO THAT INCREASES WITH
AGE. IN THE 85+ CATEGORY THERE
ARE **241 WOMEN PER 100 MEN**.

The Loners of America have three rules: you must love to travel, you must own a vehicle that you can live in, and you must be committed to staying single. This group of "mature" singles tours around the country, combating the loneliness of divorce and widowhood by embracing life on the road. According to their rules, "If you marry (or adopt that lifestyle), your membership automatically will be terminated."

With chapters in almost every state across the country, LOA members meet for monthly rallies in their home states and at national gatherings that are hundreds, sometimes thousands, of miles from home. For some of these modern nomads, home is where they park; they have no permanent address. They follow the weather, the direction of the wind, or whatever mood strikes their fancy. As one Loner in her eighties said, "We have two gears—slow and stop." She had just undergone surgery, but it had not deterred her from driving two hundred miles to a Loners rally.

When the Loners gather, they fill their days playing bingo, eating, line dancing, eating, putting on comical skits, and eating. Many of these people are what Americans affectionately call "snowbirds." They chase the warm weather south in winter—heading as far as Baja, Mexico—and then turn around and go back up north during the cool summer months. They are also among the swelling ranks of Americans who drive to Mexico to buy prescription drugs. They are free spirits, iconoclasts, and anything but alone.

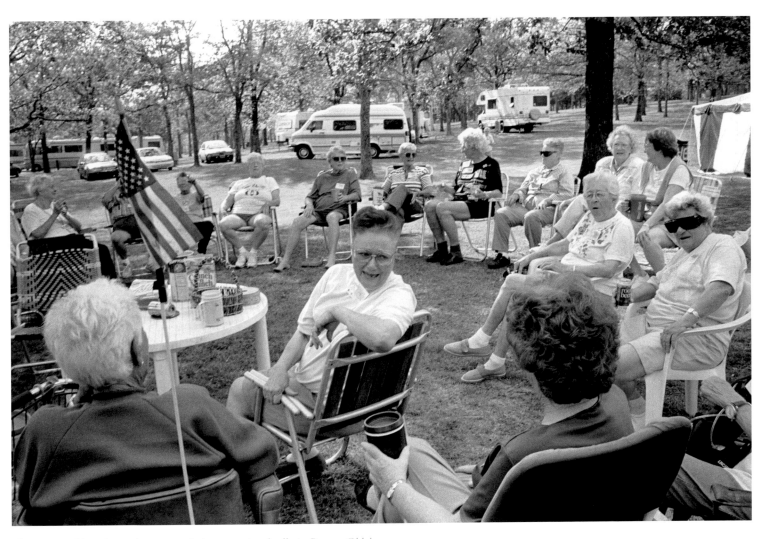

The Loners of America make a camp circle at a national rally in Braggs, Oklahoma.

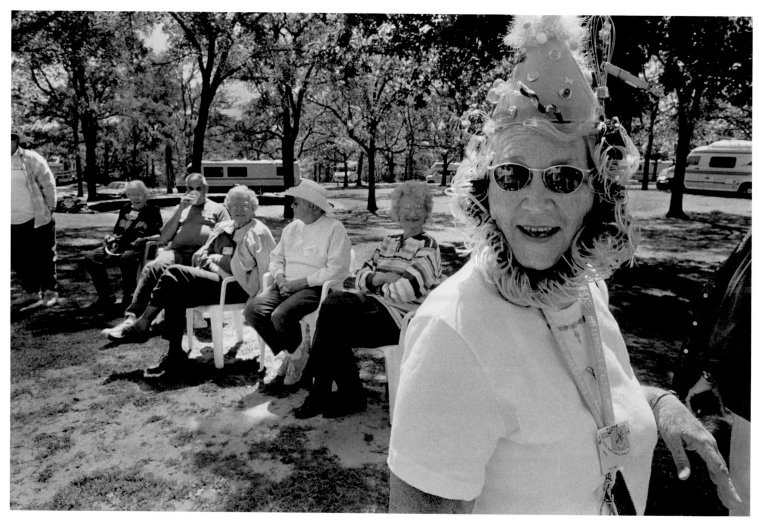

A silly hat contest at the Loners of America rally in Braggs

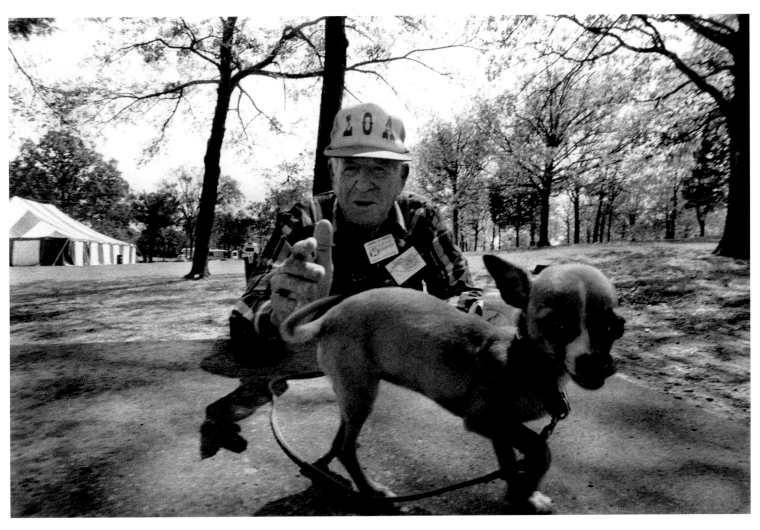

A member of the Loners of America RV club

Mary: I went camping with my kids for years. Once they left I said, "All right. No more tent. I'm gonna go buy me an RV." I also have a house that I won't desert. In 1985, I got an RV. In 1986, I went to visit the single groups, and I've been with them ever since. I spend about six months at home and six months on the road. Last year I went 8,830 miles by myself. I wasn't one bit afraid. None of us are nervous. We advertise, "If you're looking for a mate, go elsewhere." We're not looking for men…Honey, I'm damned near seventy-four—what do I need a man for? They're only good for one thing.

Yvonne: I'm not so sure they're good for that. I don't mean when I was younger, I mean now. You want to know why? Because of AIDS.

Mary: I went with a guy for six years. He was hard to get rid of. I don't want to marry again. No. I wouldn't want to have to compromise with a guy. It's my turn to be nurtured. I once belonged to the Single Sophisticates social club. A lot of the men I met there also felt like they had supported a wife and kids and didn't want to do it anymore. But many want a wife to take care of them. Get it? Take care of them. Not me. One of my kids bought me a plant, and I said, "Please take it home. I don't want to have any living thing to take care of." I think most of us feel that way.

Yvonne: When I decided to go full time, I was sixty-six. I had a lot of heirlooms. I had to let go. Now I live my life like I really want to live it. I got rid of everything. I kept my family pictures and three small antiques and that's it. Most of my friends, the older they get the more they want to hold on. I don't know if I've got six months, six years, or twenty years left. I can't be tied down with family or my past. But I'll never really be alone. After joining the club, you have friends all over the country. For the first time in my life I can just think about me.

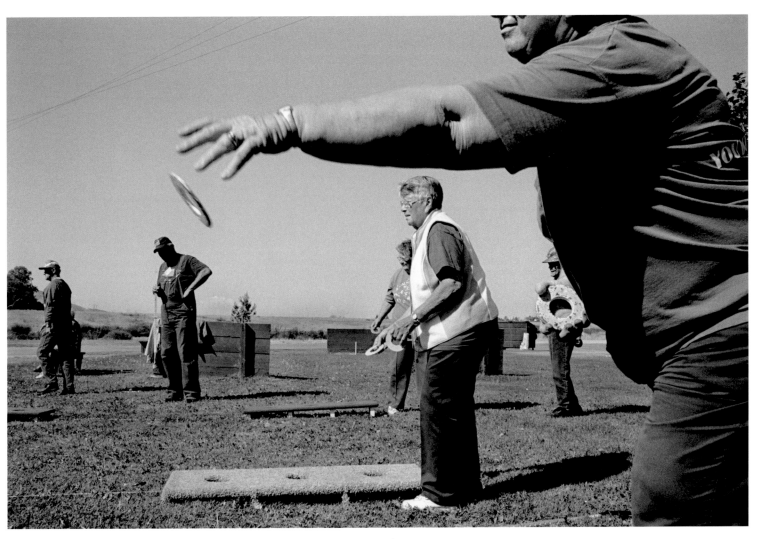

Loners rallies are filled with games and activities aimed at keeping the agenda social.

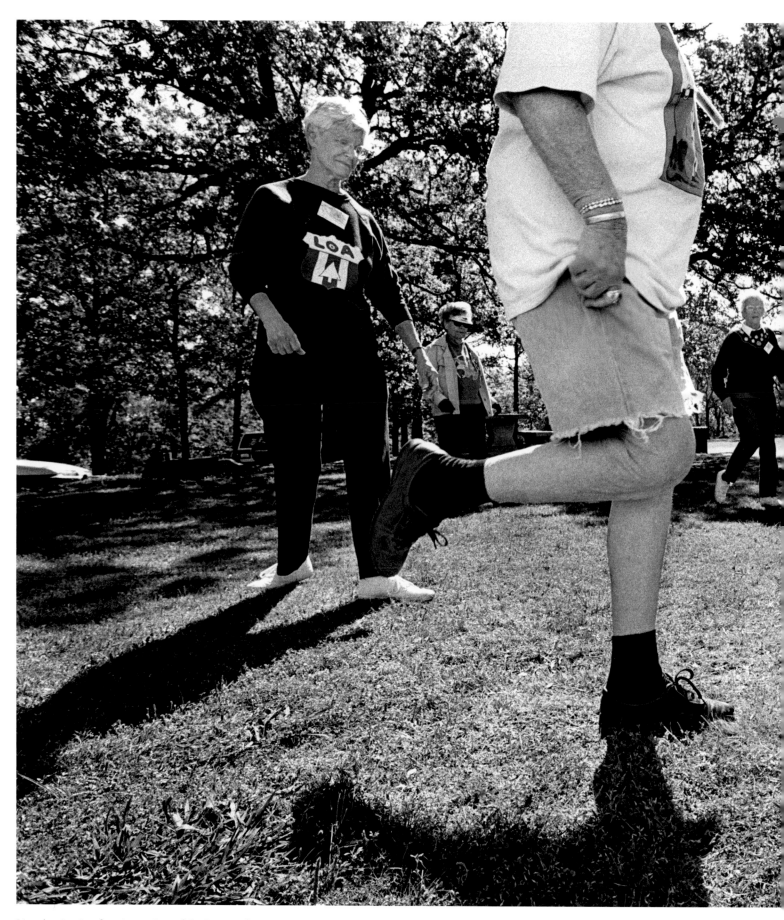

Line dancing is a favorite pastime of the Loners of America.

Although the Loners of America is predominantly made up of women, some single men join too.

One of the Loners near his trailer

Dan Raher at a Loners rally in southern California

"After my wife died, I traveled with the Elks for a while—that's a travel organization—also the Escapees. I found the Elks were one hundred percent couples; the Escapees were eighty to ninety percent couples. Then I found the Loners and joined this. Everybody is single and intends to stay that way. I was married fifty years, I was half a couple all that time. Now I'm not. So many guys my age, when they're widowed, they look for someone to fill in. I don't feel that way. I'm single and I'll stay that way. I like the freedom to come and go as I please…to do as I damn well please.

"I take care of myself just fine. I have insurance for long-term care. I don't intend to have a mate take care of me. Not my daughter either. Professionals can do it. I wouldn't want to be a burden on anybody. My mother lived at home, and my sister took care of her until she couldn't anymore. It was a burden.

"I have a pact with my daughter: When I get to where I really shouldn't be driving, she'll tell me and I'll stop. I expect I can go another ten to fifteen years, maybe twenty. I used to think by my mid-seventies I would have to get off the road. But I travel all the time with people in their eighties."

Larry Johnson

THE **FASTEST GROWING SEGMENT** OF SOCIETY TODAY IS PEOPLE OVER 85.

ARTIST'S NOTE

In 1995, after nearly a decade of working around the world as a photojournalist, I began to feel a deep sense of responsibility to turn my camera toward my own society. I set about looking for one of the great themes of my time. If it had been the 1930s, it would have been the Great Depression; if it had been the early 1960s, it would have been the Civil Rights Movement. I was looking for a defining subject that would resonate for generations to come. I wanted to find one that would allow me to explore the human condition through some of the important political and social issues of the day. I was seeking a subject with a diverse range of stories that could be explored in depth. When taken as a whole, I wanted those stories to serve as an advocate for a pressing societal shift.

One theme presented itself repeatedly during this time of soul-searching and media gazing: Aging. What an unlikely topic. It was something the demographers were screaming about, but not something that attracted my serious interest at first. The more I paid attention, however, the more I came to realize it presented an unexplored world, a place I could venture into with a fresh point of view. Although the whole world is going gray, America seemed like the perfect place to explore this phenomenon. America is a social laboratory, and it often leads the trends of change. It is a place where innovation is the norm, and society lives on a steady diet of reinvention. Where aging was concerned, the potential for proactive change was enticing.

During this pursuit, I not only took on the theme of an aging society, but I confronted my own story, and the story of every single member of society. It required complete immersion. It enabled me to reach a level of understanding and personal involvement that was at times breathtaking. I had to peel back the layers in both my subjects and myself in order to reach a level of intimacy that allowed me to make these photographs. Whether lending a hand in changing a bed liner, taking the time to listen to a story, or bearing witness to someone's death, this project was rich with personal engagement. In the past seven years I have come to learn about the world and myself anew.

There were times when I became a social worker, a caregiver, a witness, an advocate, or a much-needed attentive ear. The story of Arden and Maxine Peters was particularly challenging and empowering. As a photographer and a human being, this story presented a rare opportunity. My role was to document these moments in the most unobtrusive way, but I was also thrust into the role of surrogate family member. I not only witnessed a beautiful death, but also took part in an intimate and profound moment in these people's lives.

This project also cured me of my cynicism about America and its people. Cynicism all too often taints the media and the messages it doles out. After working in twenty-five states over this seven-year period, I have gained a new sense of what Americans are and can be. In a strange way, I rediscovered my innocence about this great and often confusing country.

From a purely visual point of view, this work presented frustrating challenges. I consistently found myself in situations that had no inherent drama. I had to learn to slow down, listen, converse, and look for the nuance, the moment, the revealing little action that would make a photograph with

storytelling power. An extremely important goal of this work from the start was to avoid clichés. I was also very determined not to make photographs that poked fun, or used irony to show my subjects as "the other." I pushed myself to make images imbued with dignity, humanity, strength, vulnerability, and poignancy.

In the course of making this work, I have come to see aging as a matter of conscience and responsibility. This work is a wake-up call to the boomer generation to grasp the urgency of what lies around the bend. There is still so much that needs to be done to prepare for the millions of people who will live exceptionally long lives. This body of work provides many questions and only some answers. My sincere hope is that it will add to the growing chorus of concerned geriatric professionals, academics, caregivers, healthcare practitioners, and civil servants who already are alarmed at what the demographics portend.

This is also a call to action for youth to get involved, either with their own family elders or those in their communities. I have been impressed on numerous occasions at how visceral an impact these photographs have on young viewers. We must not assume that Generation X, Y, and beyond are blinded by pop culture and have no interest in their larger stake in society. Old and young must interact far more than they do today, otherwise both will miss out on the richness of life and the real gains of longevity.

This enlightened future requires a fundamental shift in our values. My hopes for change and increased awareness are tempered by the reality I witness every day living in America. It's not enough to have a society that merely tolerates our senior population as part of the day-to-day landscape. They must also be viewed as an asset, and a segment of our society that deserves appreciation and integration. Moreover, we have a responsibility to care for our elders. I see this as part of the "rehumanization" America and the rest of the industrialized world must undergo. Once we have done this, the benefits will be incalculable.

There are many changes we need to make and actions we need to undergo for our society to survive and flourish as the population ages. It begins with a reincarnation of both our families and communities, which is already beginning to happen. Now is the time for alchemy to transform what is a daunting situation into a brilliant opportunity. I envision a "Care Corps"—something like an army of minimally trained but maximally inspired citizens who help out with the growing needs of caring for our elders. It's a solution that is community-based, people-based and not medical or solely governmental. Through this kind of an organization we would provide all the care that will be needed, while bringing people and communities closer together. We would also imbue citizens with a sense of common destiny and shared experience.

This work is not just about challenging the culture of aging, it's also a call to our elders-to-be to consider what kind of world we want to live in. We have a responsibility to remake this society in the image we desire. I hope this book will inspire some to learn more, others to get involved, and many to step back from their frenetic lives, slow down, and take a moment to reflect on how they can make a difference in their own lives and that of their elders.

Ed Kashi
San Francisco, 2003

RESOURCES

Administration on Aging
1 Massachusetts Avenue, Suites 4100 & 5100
Washington, DC 20201
(202) 619-0724
www.aoa.gov
This government agency, part of the U.S. Department
of Health and Human Services, oversees
Older Americans Act programs.

AARP
601 E Street, NW
Washington, DC 20049
(800) 424-3410
www.aarp.org
Formerly known as the American Association for Retired
Persons, AARP is a membership organization for people fifty and
older that advocates for seniors and provides information and
resources. The web site has links to information on current news
and political issues, cooking, exercise, health tips,
computers, technology, and research results.

AARP Guide to Internet Resources Related to Aging
www.aarp.org/cyber/guide1.htm
This is a very thorough internet guide for information about aging.
The site includes links to resources such as news-groups, electronic
magazines, and search engines of interest to seniors.

American Society on Aging
833 Market Street, Suite 511
San Francisco, CA 94103-1824
(415) 974-9600
www.asaging.org
This non-profit organization works to educate seniors, their
families, and aging professionals on aging issues. The ASA web
site has links to publications and resources.

BenefitsCheckUp
www.benefitscheckup.org
Run by the National Council on the Aging, this web site guides
users through a questionnaire that ends with a detailed explanation
of all the government benefits they or a loved one are entitled to.
The benefits are explained in great detail with instructions on
how to apply.

Eldercare Locator
(800) 667-1116
www.eldercare.gov
This free service offered by the U.S. Administration on Aging
is useful for those seeking services for older family members who
do not live nearby. By entering a zip code on the web site or calling
the toll-free number, users can locate community
services in their neighborhoods. This site also features links
to other caregiving resources.

ElderWeb
1305 Chadwick Drive
Normal, IL 61761
(309) 451-3319
www.elderweb.com
This web site links users to information about everything
from elder law to little known benefits for veterans. It also
provides useful links, such as the one directly to the Veterans
Administration site where users can apply for benefits.

FirstGov for Seniors
www.seniors.gov
This web site, maintained by the Social Security Administration,
provides users with accurate information about government ser-
vices and benefits for seniors. It links users to information about
varied topics such as retirement planning, tax assistance, and
consumer protection.

International Longevity Center
60 East 86th Street
New York, NY 10028
(212) 288-1468
www.ilcusa.org
This non-profit organization is dedicated to raising public aware-
ness for aging issues and promoting healthy aging. The ILC
offers excellent topical information on such subjects as the anti-
aging industry, the plight of poor seniors, and the global aging
phenomenon.

Meals-on-Wheels
1414 Prince Street, Suite 302
Alexandria, VA 22314
(703) 548-5558
www.projectmeal.org
Meals-on-Wheels, a national program with local chapters
throughout the country, strives to eliminate malnutrition and
hunger in the elderly population. Seniors can attend congregate
meal sites or sign up for home-delivered meals.

National Council on the Aging
300 D Street, SW
Washington DC 20024
(202) 479-1200
www.ncoa.org
The NCOA is a national organization dedicated to improving the
lives of older Americans. It conducts research, fights for drug
benefits, increased funding for support services, and better
access to care. The NCOA's Benefits Checkup, available on the
web site, is invaluable for determining what benefits you qualify
for and how to apply. The Consumer Information Network on the
web site is also a valuable resource.

**National Resource Center on Supportive Housing and
Home Modification**
USC Andrus Gerontology Center
3715 McClintock Avenue
Los Angeles, CA 90089
(213) 740-1364
www.usc.edu/dept/gero/nrcshhm
This non-profit organization is dedicated to supportive housing
research, education, and training. The web site has a large data-
base of publications, newsletters, and on-line courses.

Social Security Administration
Office of Public Inquiries
Windsor Park Building
6401 Security Boulevard
Baltimore, MD 21235
(800) 772-1213 / TTY: (800) 325-0778
www.ssa.gov
This is the official web site of the Social Security Administration.

CAREGIVING
**Administration on Aging Internet guide to caregiving
Because We Care: A Guide for People Who Care**
1 Massachusetts Avenue, Suites 4100 & 5100
Washington, DC 20201
www.aoa.gov/wecare
This is a resource guide for caregivers with links to information
on topics such as caregiver well being, hiring home care
employees and housing options.